IMAGES
of America

COLLEGE STATION

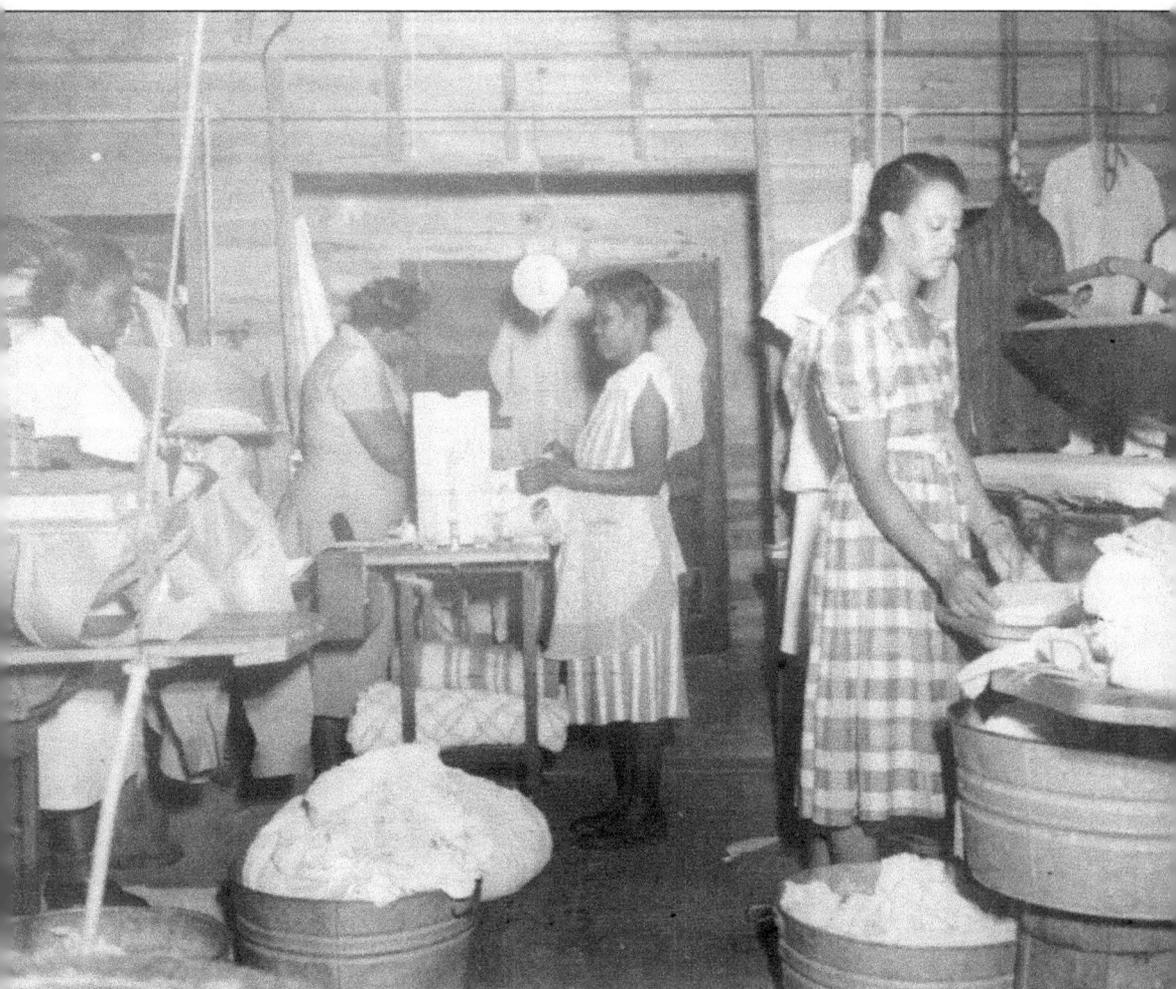

THE TOLIVER LAUNDRY. The Toliver family, descended from sharecroppers, pooled their funds and established the Toliver Laundry, one of the first in College Station. All work was done manually. It was the first laundry to deliver freshly laundered shirts on wire hangers to the professors on the A&M College campus. Mary Toliver is third from left. (Eleanor Williams.)

ON THE COVER: Peggy Campbell, also seen as a little girl on page 48 at the station with her brother and dog, is shown here as a grown woman with the College Station population sign in the late 1940s, when an economic boom reached takeoff. The population has soared ever since and will soon reach 100,000, thanks to the constant expansion of Texas A&M, now the nation's seventh-largest university. (Project HOLD.)

IMAGES
of *America*

COLLEGE STATION

Glenn D. Davis

ARCADIA
PUBLISHING

Published by Arcadia Publishing
Charleston, South Carolina

Library of Congress Control Number: 2010932158

For all general information, please contact Arcadia Publishing:
Telephone 843-853-2070
Fax 843-853-0044
E-mail sales@arcadiapublishing.com
For customer service and orders:
Toll-Free 1-888-313-2665

Visit us on the Internet at www.arcadiapublishing.com

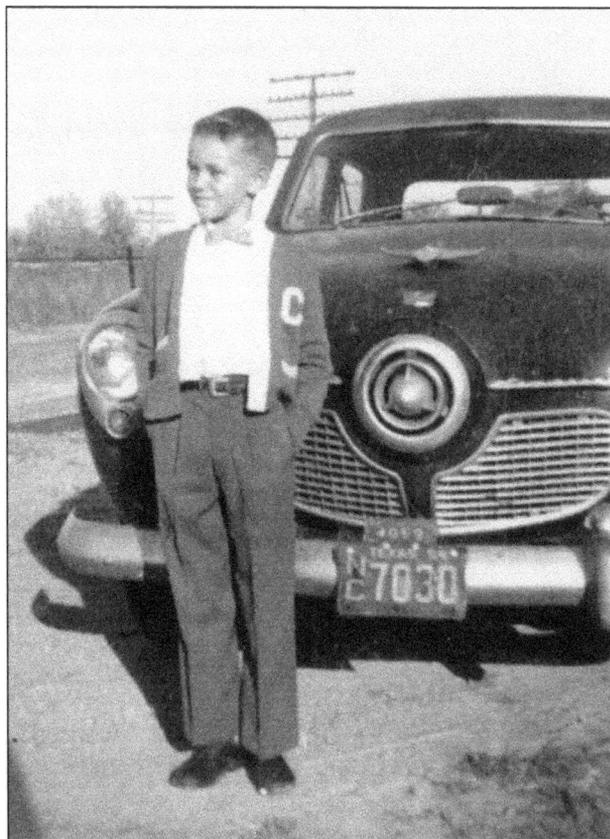

GLENN D. DAVIS, 1956.
Davis is pictured in an A&M
Consolidated sweater standing
beside his brother's Studebaker on
Wellborn Road, a mile south of
Neelley's Store. (Glenn D. Davis.)

CONTENTS

ACKNOWLEDGMENTS

It would probably be impossible to thank everyone who has contributed to this project. First and foremost, a big thank-you goes to Luke Cunningham and Winnie Rodgers and Arcadia Publishing for launching the book. I owe a huge debt to Anne Boykin of the College Station Heritage Programs archives—the Project HOLD database—for the help and support she continuously offered. Her immense knowledge and moral support were greatly appreciated. A big thank-you also goes to the Cushing Memorial Library on the Texas A&M campus, which houses numerous collections of historical materials. Evans Library on the campus also provided supporting materials, and I would like to thank Brazos County historian Bill Page, who works there, for his continuous input. Librarians at the Bryan Public Library and especially those at the Carnegie library were particularly helpful. A big thank-you is extended to the historical photographs database folks at Carnegie. Thanks also to Lisa Kalmus, museum curator of the Sam Houston Sanders Corps of Cadets Center, for her extensive assistance. Many other individuals contributed photographs from their personal collections. In this category are Bill Lancaster, Noel Wilson, and the late Larry Stewart; thank you very much. The sage advice of Texas A&M's official historian, Henry Dethloff, was also greatly appreciated as well as the online chatters about Texas A&M and College Station history, known as the TexAgs. Thanks, guys! What you all are doing is very interesting indeed, especially the writer known online as FossilAg. You are a living treasure. Please keep posting as long as you can. Last but not least, a big thank-you goes to Jay Brakefield for proofreading this manuscript.

Unless otherwise stated, all photographs came from the Texas A&M University Cushing Memorial Library (CL). Other sources attributed in the courtesy lines throughout use the following abbreviations: City of College Station archives on Project HOLD (PH), hold.cstx.gov; Carnegie Center of Brazos Valley History (CC), Bryan, Texas; and the Sam Houston Sanders Corps of Cadets Center archives (SC).

INTRODUCTION

George E. Adams, mayor pro tem of Bryan, said in 1950, "If it weren't for A&M, College Station would be pastureland and Bryan a whistle-stop." Adams meant that both Bryan and College Station were stops on the railway as it moved northward in the 1870s, but the state's first land grant college, the Agricultural and Mechanical (A&M) College of Texas, was the catalyst for the development of College Station. The railroad actually named the stop "College," and the "Station" part was added later. Established a few miles from the city of Bryan, the college went up in the middle of nowhere, starting from a dewberry patch.

College Station did not incorporate until 1938, and only then due to the threat of being annexed by Bryan. As Deborah Lynn Parks writes in her master's thesis titled *The History of College Station, Texas 1938–1982*, "On October 19, 1938, citizens voted 217 to 39 to incorporate the city of College Station, a community which had existed for more than 60 years. The designated polling place, the Southern Pacific depot, added a symbolic touch to the election since the city derived its name from that of a railway station."

On February 25, 1939, the College Station City Council held its first meeting in the Administration Building on campus, and not surprisingly, all the councilmen elected were faculty members. The fates of College Station and Texas A&M were thus intertwined from the very beginning. "Where the university goes, College Station pretty much follows" used to be the old saying, but the winds of change are blowing across the central Texas plains.

The city of College Station, however, has developed its own unique character. A flood of returning military men from World War II used the G.I. Bill to go to college or to finish degrees, which gave the small college and fledgling town a huge boost. The takeoff stage was achieved in the mid-1960s when women were allowed in the previously all-male college (1963) and Corps of Cadet membership was made voluntary (1965). As the population of the college grew, so did the population of the city.

Growth also meant changes to the close relationship between the college and the city. "The development of an incorporated town relieved the college of one of its greatest burdens, that of housing its own personnel, which throughout the years abetted the charges that the college was 'poorly located' and required the duplication of facilities which one might ordinarily find in a more urban setting," wrote the dean of A&M historians, Henry Dethloff, in *A Centennial History of Texas A&M University, 1876–1976*. The end of college-supported housing and the dismissal of a requirement for faculty to live on campus opened the door to a vibrant real estate industry for College Station.

Luther Jones, who was on the first city council, thought that College Station could not call itself a true city until it had an independent distribution system and managed its own utility services. Once the housing market opened, Jones recalled that growth became constant: "The council always got pleasure in every new house that was built. It was surprising how fast people flocked in and built new homes. Fortunately, we had a very ideal community, and everybody worked for the same purpose."

Northgate, the business district near campus, led the growth. New additions soon sprang up there—the Campus Theater, Luke's Campus Grocery, a hardware store, a dentist's office, and a Methodist church. Early off-campus residential areas such as College Park and College Hills Estates started recording phenomenal growth. Schools were combined into A&M Consolidated, which was integrated with Lincoln High in the 1960s. College Station also became the first city between Houston and Dallas to establish zoning laws to prevent loss of land values and to reduce strife among the citizenry.

The Brazos Area Planning Corporation, a pioneering effort that evolved in the late 1950s, set the stage for economic growth in the Bryan–College Station nexus as well as in all Brazos County. The corporation also encouraged growth of the college into a university. In 1958, the corporation became a nonprofit organization, the first of its kind in the state of Texas. Although the ambitious effort had broken into various entities concerned with their own growth by the early 1960s, one result was an improved infrastructure, particularly a better system of roads. In her book *College Station, Texas 1938–1988*, Deborah Lynn (Parks) Balliew writes, "During the 1960s, College Station officials focused their attention on accommodating the growth of their own city. The Planning and Zoning Committees had been combined into one in 1958, giving it more ability to direct development."

The small military college was growing fast and changed its name to Texas A&M University. Balliew writes, "Between 1965 and 1975, student enrollment more than doubled, escalating from 9,521 to 25,247. The Bryan-College Station community was recognized as the main growth center for the Brazos Valley." Reversing a previous stance, city officials started using federal funds to finance municipal projects. College Station was transforming itself from a small college town into a major Central Texas city that was off and running. One newspaper in the early 1980s described College Station as the "fastest growing city in Texas."

Growth continues, and 2010 census figures may well show the population reaching the 100,000 mark. The city retains its "college town" character, but also attracts a large number of retirees wanting to live out their lives near their beloved Texas A&M campus. The opening of the George Bush Presidential Library and Museum on November 7, 1997, legitimized College Station as a city on the move rushing toward a bright future. The city is now preparing for a second high school to open in 2012. In 2013, College Station, no longer a whistle-stop, will celebrate its 75th anniversary.

COLLEGE STATION 50TH ANNIVERSARY SEAL. This seal was commissioned by the City of College Station in 1988 to celebrate their 50th anniversary. (PH.)

One

COLLEGE STATION
PIONEERS

HARVEY MITCHELL. Mitchell came to Texas from Tennessee in 1839 and joined minutemen protecting the northern frontier from the Trinity to the Brazos River. He moved to Brazos County and served from 1842 to 1853 in county offices—deputy clerk, county clerk, surveyor, and chief justice. He taught school, owned a store, farmed, and led the building of churches as well as the Brazos County courthouses of 1846, 1853, and 1878. During the Civil War, Mitchell was assessor of Confederate state taxes. As a member of a local committee, he used determination and tact to secure the location of the A&M College of Texas for his county. He rightly deserves the title "Father of Brazos County." (CC.)

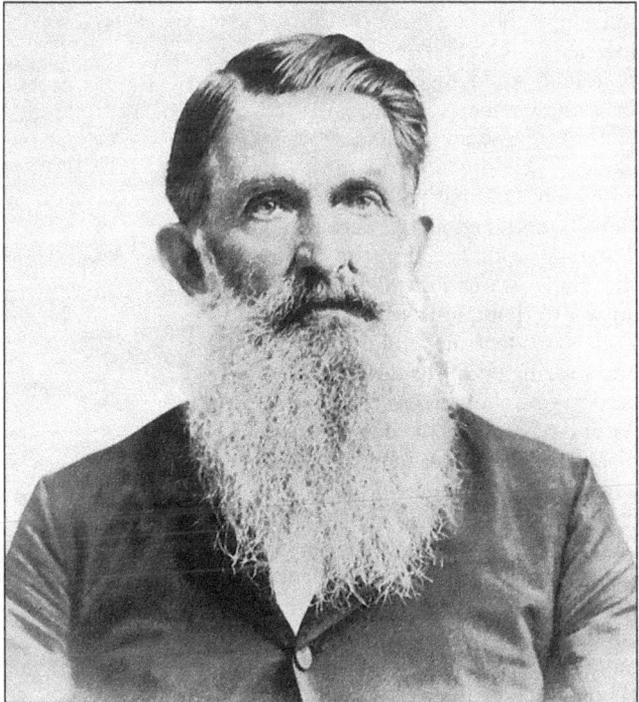

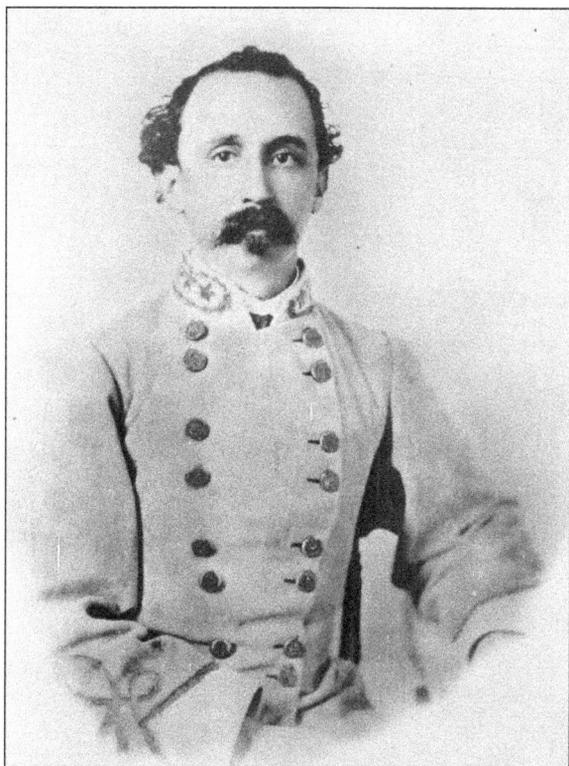

LAWRENCE SULLIVAN "SUL" ROSS. An Indian fighter and brigadier general in the Confederate Army, Ross saved the A&M College of Texas from closure in the 1880s, when many in Texas argued that there was no need for two land grant colleges, the other being TU (an Aggie's term of endearment for the University of Texas). Largely because of Ross's reputation, many Texans sent their sons to the all-male college, and its enrollment doubled to 467 cadets by the end of that decade. The former Texas governor instituted several reforms while he was president, and many enduring traditions were born, including the advent of the famous Texas Aggie graduation ring, the world-famous Aggie marching band, and the football team. Ross died in 1898 at the relatively young age of 59.

THE ROSS STATUE. Standing proudly in front of the Academic Building, the inscription reads, "1838–1898 Soldier Statesman and Knightly Gentleman, Brigadier General C.S.A., Governor of Texas, President of the A.&M. College." It is arguably the most prominent landmark of the sprawling campus, and if an Aggie were asked to designate ground zero on the campus, the "Sully" statue just might be the answer to that question. The Corps of Cadets (students in military training and wearing uniforms on campus) used to give the statue a bath every Saturday, and students of any stripe place coins at its feet to ask for luck when taking exams. It was after Ross's death in 1898 that students held the first Silver Taps ceremony to honor their fallen president. In the event of the death of a student, the tradition continues on the first Tuesday of the month within yards of Sully's statue. (Photograph by Glenn D. Davis.)

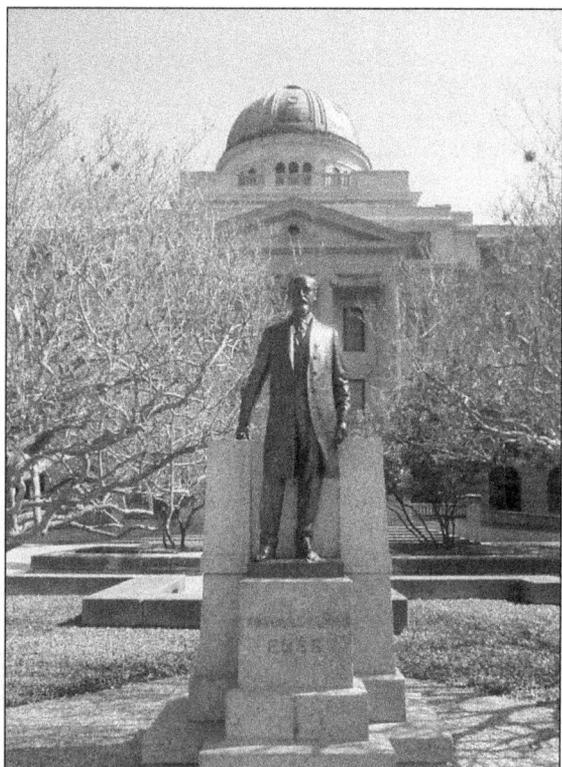

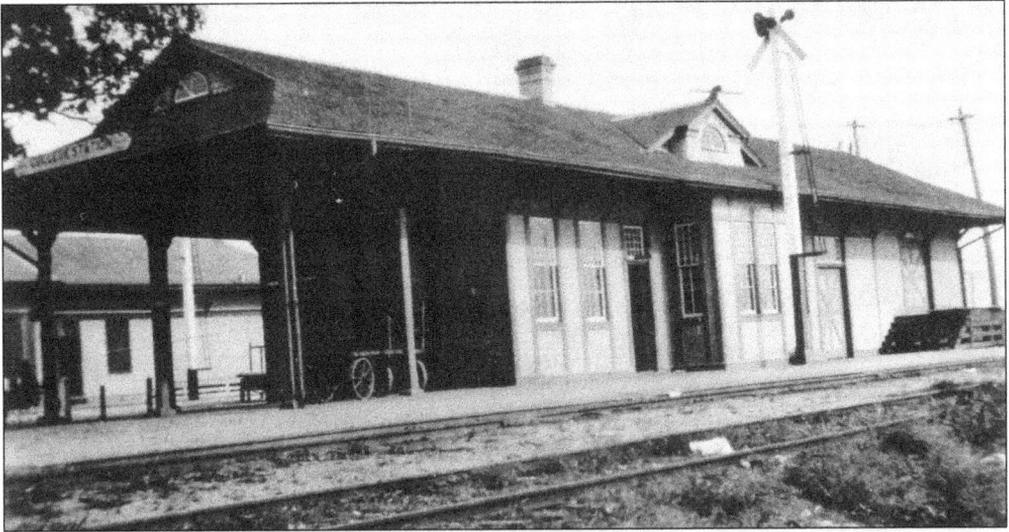

COLLEGE STATION. The name came from a railway station established near the A&M College of Texas to serve its needs. The Houston and Texas Central Railway (HT&C) constructed the station and depot, simply called "College," a year after the college opened its doors to classes in 1876. A post office was set up there in 1877 as well, putting the college and its railway station on the map. The train ran through the campus, stopping at the station twice daily. The name "College Station" evolved a bit later. Shown above is the Southern Pacific depot; below is the original HT&C station. (CC.)

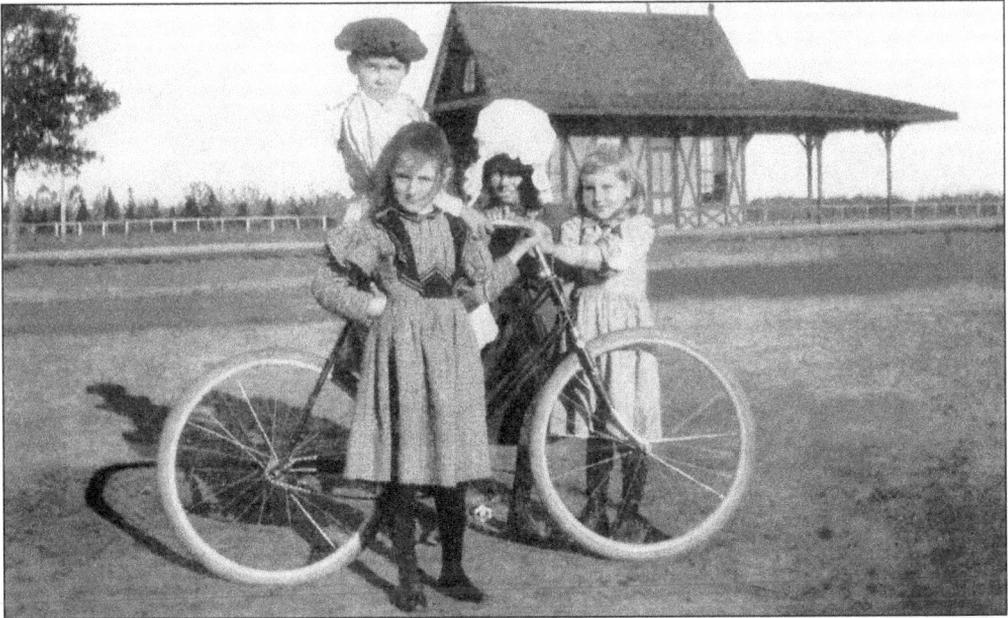

CHILDREN AT THE DEPOT. This 1898 photograph suggests emerging possibilities for the new college town. These unidentified children symbolize a young, energetic potential, and the bicycle (a rather new technology then) symbolizes the embracing of new technology, which became the hallmark of the A&M College of Texas. A new bicycle path was established alongside the railroad. Having become a state in 1845 and gone through Reconstruction following the Civil War, Texas was in a mood to grow, and its first land grant college was in the vanguard.

11

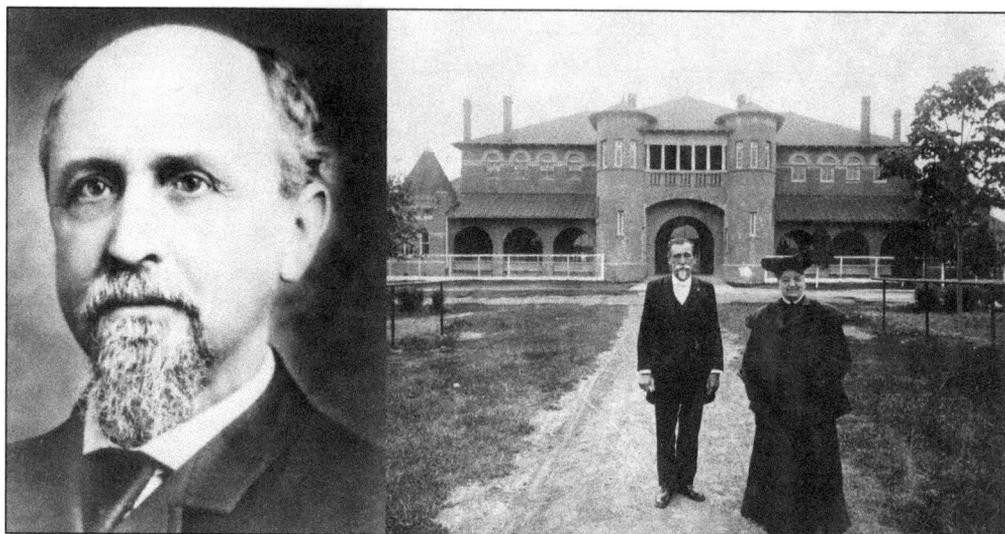

BERNARD SBISA. This Austrian-born chef, who previously worked in New Orleans, prepared hearty and delicious meals for Aggies for more than 50 years. Sbisa came to the A&M College of Texas in 1878, and it is said the only time he was ever late with a meal was when the kitchen at the mess hall caught fire in 1911, moving operations to a temporary facility. The new mess hall was named in his honor and is still used by some Aggies, although there are now many other eating places on campus. At right, the seemingly no-nonsense Sbisas stand in front of the original mess hall in 1911. Mrs. Sbisa is wearing a short jacket over her long dress, most likely to ward off the cold. It is her hat that gives an unusual flair to the ensemble.

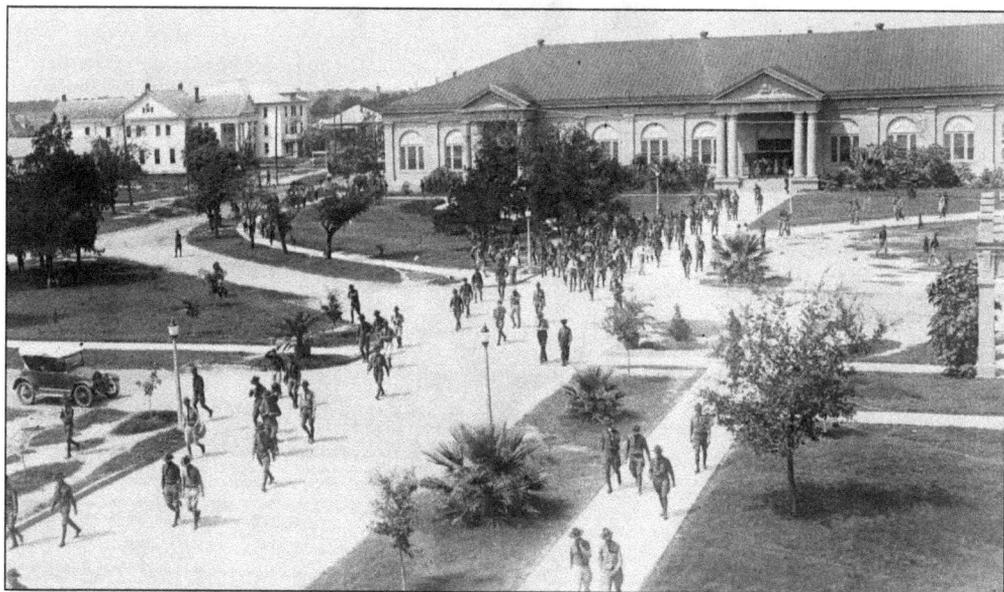

SBISA HALL, 1951. This one-story brick dining hall was designed by architect F. E. Giesecke. It was purposefully placed at the end of Military Walk, which connected the old Assembly Hall and the dining hall so that Aggie cadets could march to the mess hall for their meals. The building was designed in the Classical Revival style with Doric columns supporting the main entrance. Sbisa Hall is still one of the most historical buildings on campus. The building was also used as a central location for class registration. A family-style meal with the corps is unlike any other.

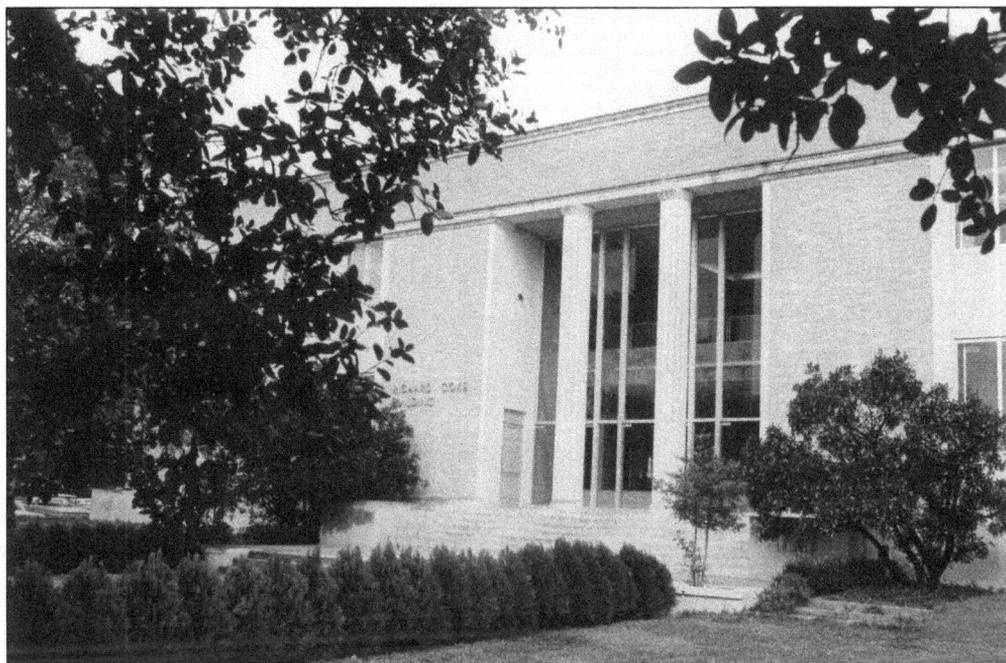

RICHARD COKE BUILDING. The peculiar orange tint of the building has long perplexed generations of Aggies. But the university archives prove that it was not the work of an architect from TU. In fact, a company led by one of A&M's own former students, Herbert Voelcker, class of 1909, designed the structure. The *Texas Aggie* reported in its February 1952 issue that the proposed administration building would be built out of "pink Roman brick with the trimming around the windows in white Indiana limestone." Another article called the bricks a "salmon pinkish color." The Coke building—pink bricks and all—was dedicated in 1957, named after the Texas governor who pushed through the appropriation bills to make the opening of Texas A&M possible.

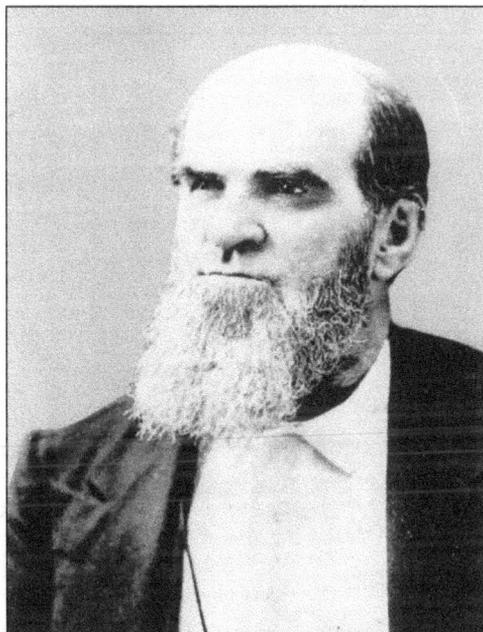

RICHARD COKE. Like many other Texans of the time, Coke came to Texas from another state. He was born in Virginia, educated in law at William and Mary, and made the trip to Texas in 1850, settling in Waco. The former governor and U.S. Senator from Texas was instrumental in forming the A&M College of Texas in 1876. It was later renamed Texas A&M University, now the seventh-largest university in the country, with more than 49,000 students.

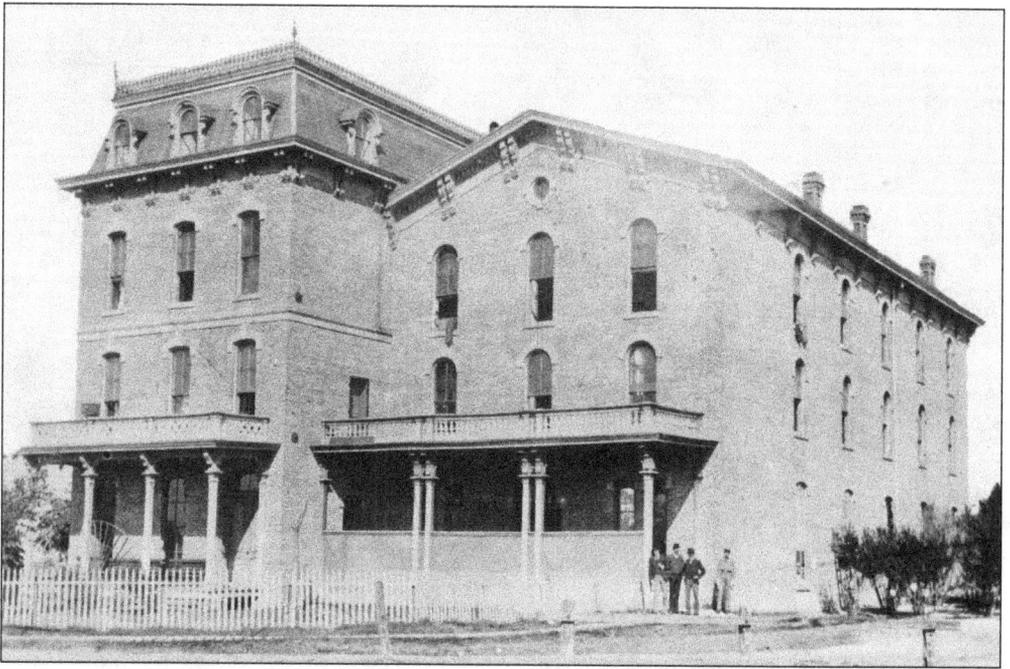

GATHRIGHT HALL. The second building constructed on the A&M College campus after Old Main was designed as a boarding hall for students, since Old Main did not feature such facilities. The late architect, archivist, and onetime mayor of College Station Ernest Langford said of Gathright Hall, "The same kind of bricks [as in Old Main] were used; the walls were load-bearing, interior walls, floors and roof framing were of timber construction. The dormitory portion had a simple gable roof over it while the four-story annex, described first as the 'president's residence' had its fourth floor under a mansard roof." In 1889, the building was named in honor of A&M's first president, Thomas S. Gathright. It was torn down in 1933 after it had aged beyond repair. A small area to the left of the current Leggett Hall marks the original site of old Gathright.

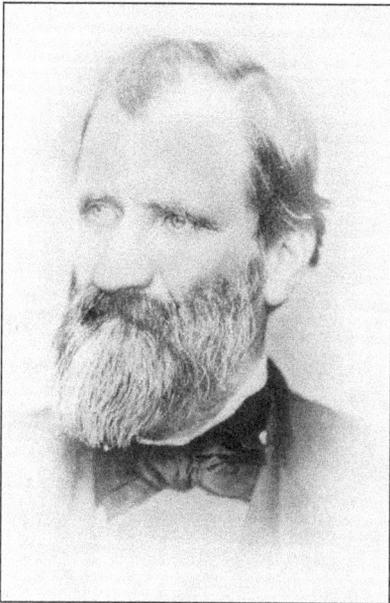

THOMAS S. GATHRIGHT. Jefferson Davis, the former president of the Confederate States of America, recommended a friend, Thomas S. Gathright, for the presidency of the A&M College of Texas after declining the post himself for "health" reasons. Although born in Georgia, Gathright was serving as the superintendent of public instruction for Mississippi at that time. Gathright accepted the A&M post, thus becoming the college's first president in July 1876. Classes began in October with 40 students and six faculty members. According to the *Handbook of Texas Online*, "In 1878, the board of directors increased Gathright's duties to include the steward's responsibilities and the presidency of an A&M–sponsored college for blacks (later Prairie View A&M); this first effort under Gathright failed. In 1879, the entire administration was dismissed. Subsequently, Gathright served as the president of Henderson Male and Female College until his death on May 24, 1880."

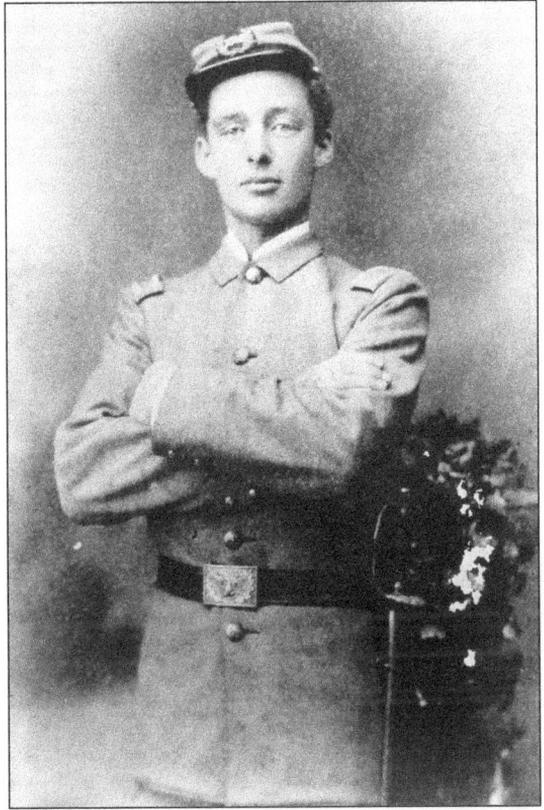

WALTER WIPPRECHT, CLASS OF 1894. Pictured here in a Corps of Cadets uniform, Wipprecht took the first postgraduate course offered at the A&M College of Texas. He was active in the Corps of Cadets and helped organize many on-campus activities. The son of a German immigrant, Wipprecht became very prominent in Bryan politics and business. A leader of the Texas Democratic Party, he served as Bryan's precinct chairman and was elected as a city alderman in 1901. Wipprecht left his mark on A&M history by serving first as secretary and then as the head of the Association of Former Students between 1890 and 1891. In 1913, he was sent to Austin by the city of Bryan to defeat Senate Bill No. 18, which threatened the independence of A&M College. His wife, S. Ethel Read Wipprecht, was very active in the Daughters of the American Revolution (DAR). (CC.)

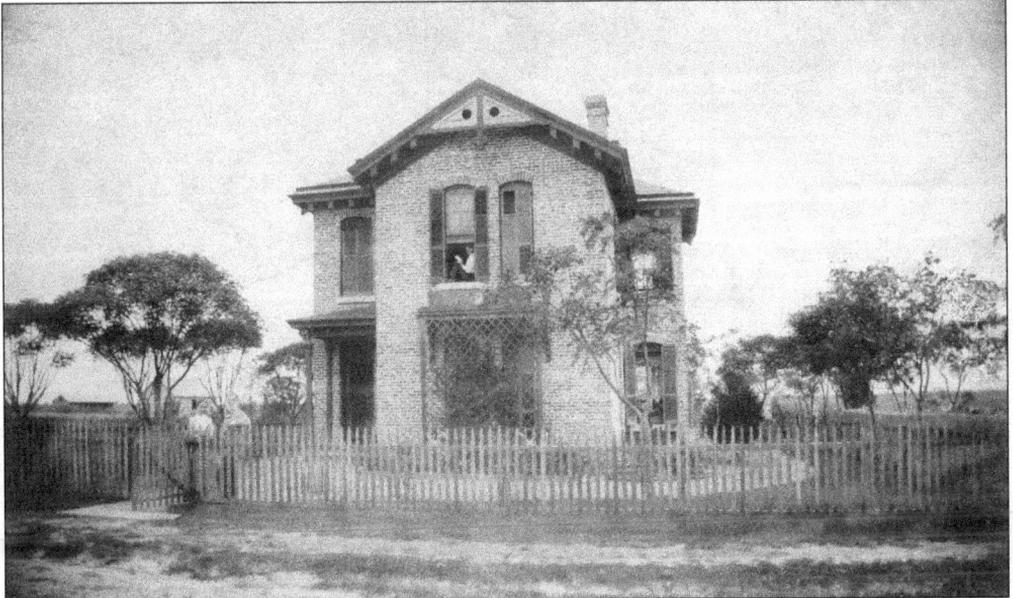

THE WIPPRECHT HOME. One of the oldest homes in Bryan is the Wipprecht home. The openness of the home to the outside is a noticeable feature; one person is sitting in the window while two more chat at the picket fence, which was almost mandatory in those days. The house still stands in Bryan on Twenty-ninth Street, across from the old Bryan Police Department. (CC.)

HARDAWAY H. DINWIDDLE. Born in 1844 in Virginia, Dinwiddle was called into service for the South in the Civil War while attending Virginia Military Institute. He came to Texas in 1869 and became a prominent professor at the Texas Military Institute in Bastrop and Austin. In 1879, Dinwiddle was invited to A&M to become the chair of chemistry and, in 1883, was elected chairman of the faculty. Dinwiddle also served as president of A&M from 1883 to 1888. Louis L. McInnis took over the helm when Dinwiddle died in 1888.

LOUIS L. MCINNIS. Sole survivor of a faculty firing in 1879, McInnis became chairman of the faculty because the board of directors had eliminated the position of president. McInnis immediately carried out a series of reforms, reorganizing the college into 11 departments. McInnis also reformed the Texas Agricultural Experiment Station, created by the Hatch Act of 1887 and approved by the 20th Texas Legislature. As the college came out of a dark period, creativity began to surge. The Scott Guards, a crack cadet team, was formed and later renamed the Ross Volunteers. The 1890s became a watershed in A&M's history.

16

Two

FIRST LAND GRANT COLLEGE OF TEXAS

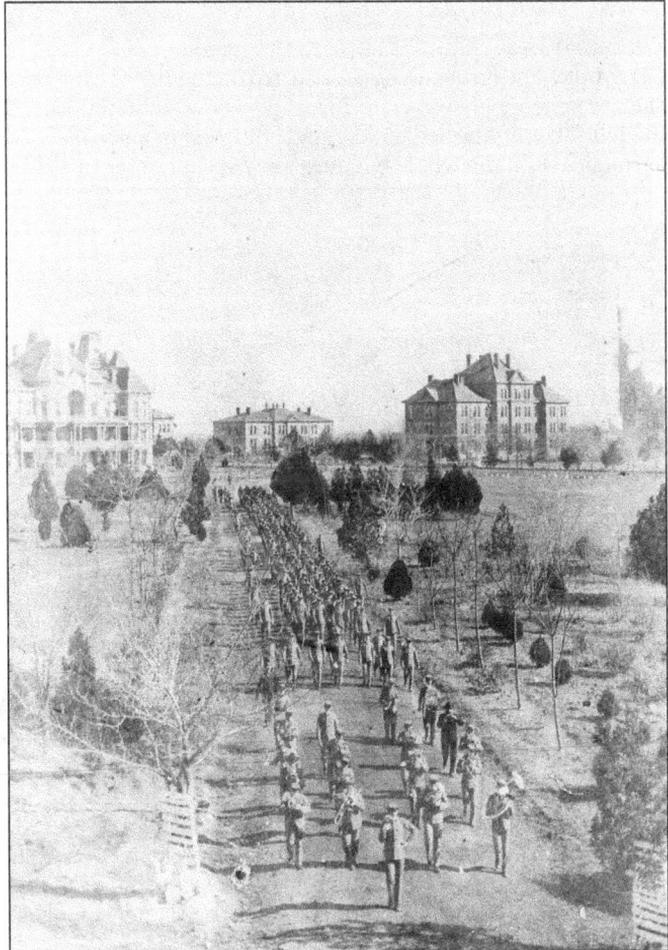

MILITARY WALK, 1903. Cadets march across the A&M campus, which by that time had developed mature tree growth. Several early buildings are visible in the background, such as Old Main (left), Gathright Hall (center), and Assembly Hall (right). A small band is playing out in front of the marching cadets. (CC.)

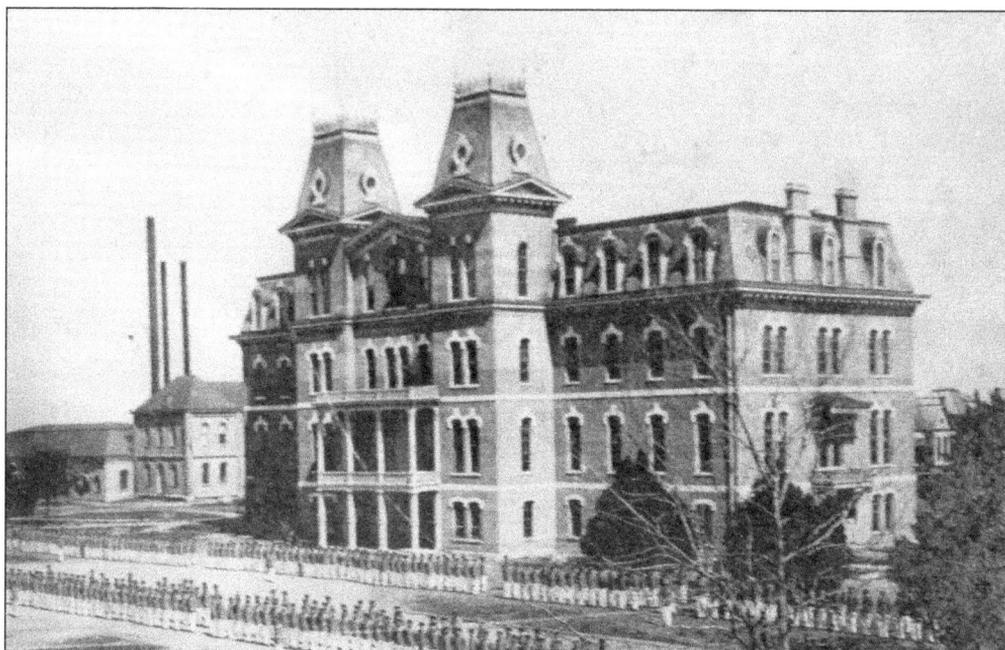

OLD MAIN. The first building constructed on the A&M campus was Old Main in 1871. Construction faults were found, however, in 1873, and a new architect, Jacob Larmour, was brought in to finish the job. The refurbished building was finished in early 1875. Although it stood as a testament to Larmour's skill, the whole building went up in flames in 1912.

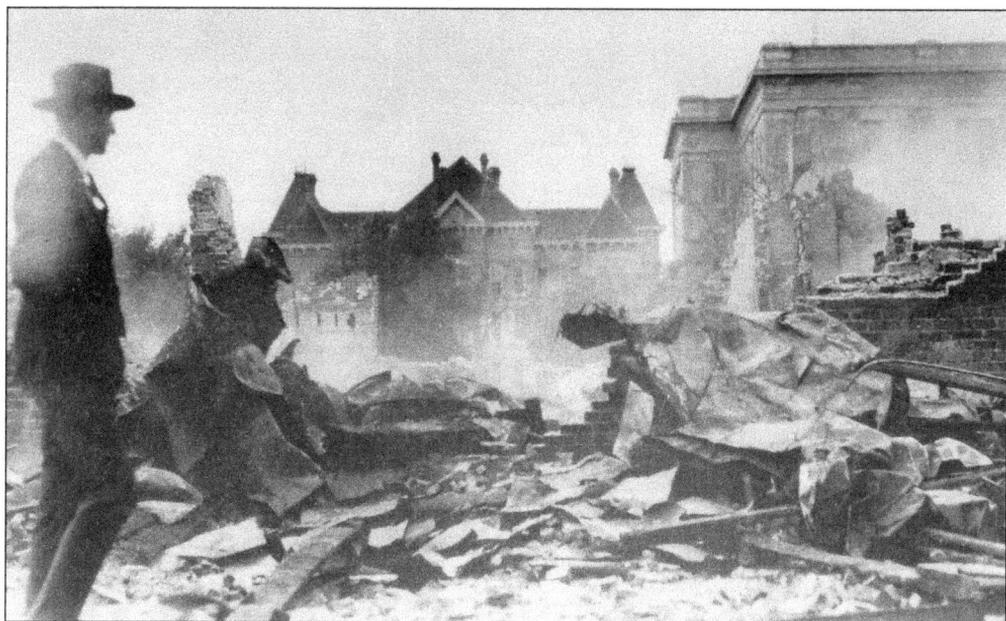

OLD MAIN BURNS. In the early hours of May 27, 1912, Old Main burned to the ground despite the feverish efforts of cadets and volunteer firemen to save the building that had doubled as a dorm and a classroom for many Aggies since classes began in 1876. Just about all offices related to students were gone, including those for the *Battalion* (college newspaper), the *Student Farmer*, and the *Longhorn* (yearbook).

PFEUFFER HALL. Built in 1887, Pfeuffer Hall was the first separate dormitory on the A&M campus. It had 25 large rooms but no bathrooms, which were added later over the stairway on the second floor. It was torn down in 1954 to make way for more modern and expansive facilities. Waves of students studying on the G.I. Bill were lapping over the campus, causing a tidal wave of growth.

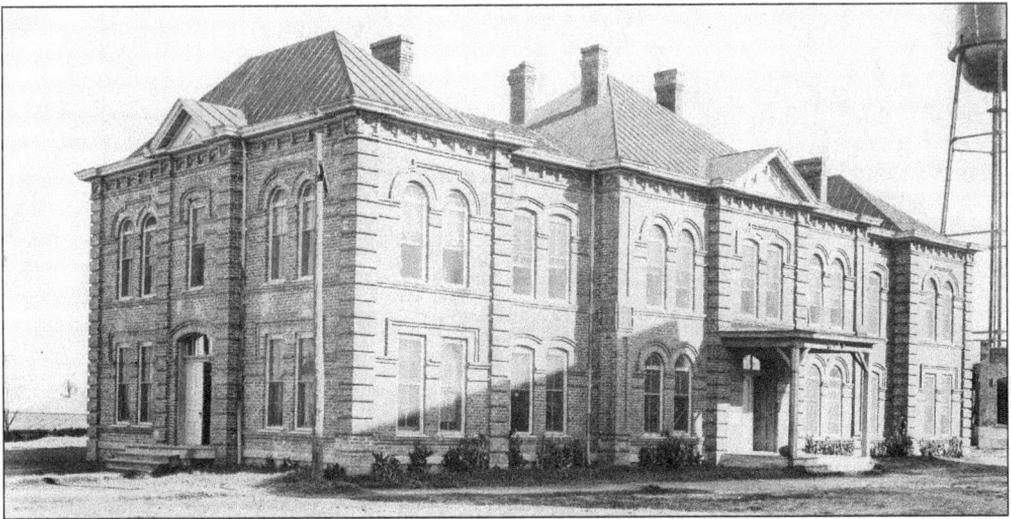

AUSTIN HALL, 1888–1954. This was one of two little two-story dormitories built to alleviate overcrowding in Gathright Hall. Other than being obviously a favorite hangout for early students, Austin Hall had one unique feature: At an odd angle to the other three buildings on campus at the time and to all future buildings on campus, it was built to face due south with its other sides oriented to the cardinal directions. All original construction on the A&M campus (except for Austin Hall) was oriented to be parallel to or perpendicular to Wellborn Road and the railroad tracks west of campus, with no consideration to the directions on a compass. The railroad does not travel north and south, but northwest and southeast. (Only the entry door to Austin Hall pointed south.) This rule is still true today in all recent construction.

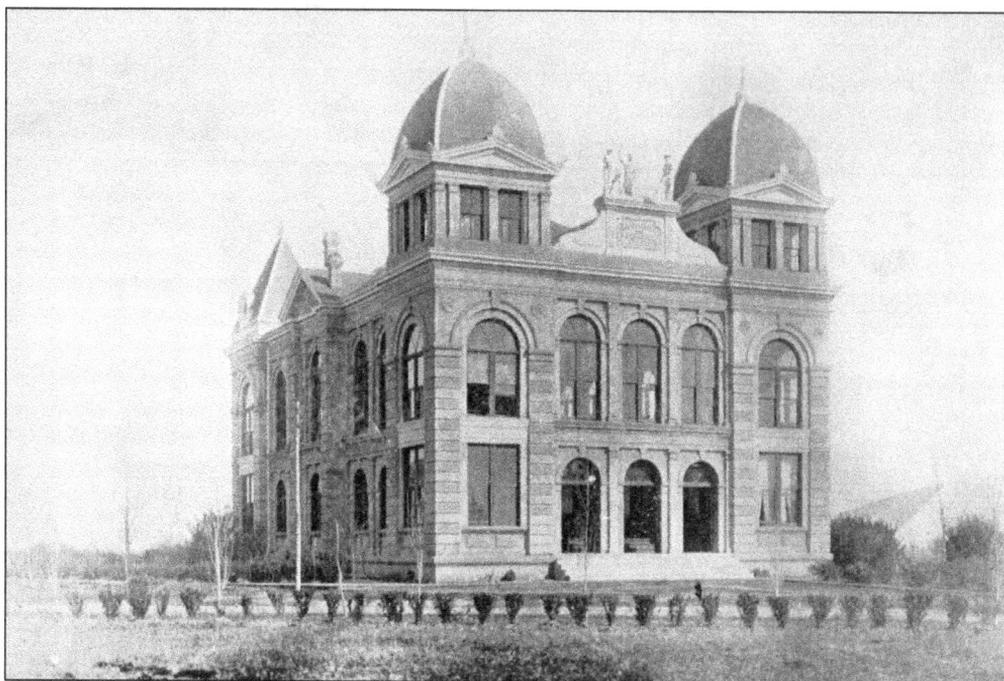

ASSEMBLY HALL, 1889–1929. The early chapel, meeting hall, and student center for those first cadets was the Assembly Hall. It was located on the east side of what would become Military Walk, at the south end next to the future Guion Hall. The YMCA in 1914 and Guion Hall in 1918 supplanted the Old Assembly Hall in its function. It was demolished in 1929 to make way for Hart Hall, built in 1930. A second Assembly Hall was built in 1923 to accommodate the residents of "Hollywood," the collection of 165 temporary two-man cottages built in the open ground north of the drill field. (The cottages replaced two-man tents that had been in use there for some years prior.) The cottages were replaced by the construction of Law and Puryear Halls in 1928. The second Assembly Hall remained in sporadic service until it was demolished in 1953.

BOYETT'S STORE. Around 1900, Boyett's was the store at Northgate where Aggies did much of their shopping. After the number of students began increasing at Aggieland and economic development started for real, the A&M dairy was located at this site. In the general area were a butcher shop, a tailor, a shoe repair shop, a barbershop, and a photography gallery. In 1912, Boyett was given a five-year lease to run his grocery store on the campus grounds. (PH.)

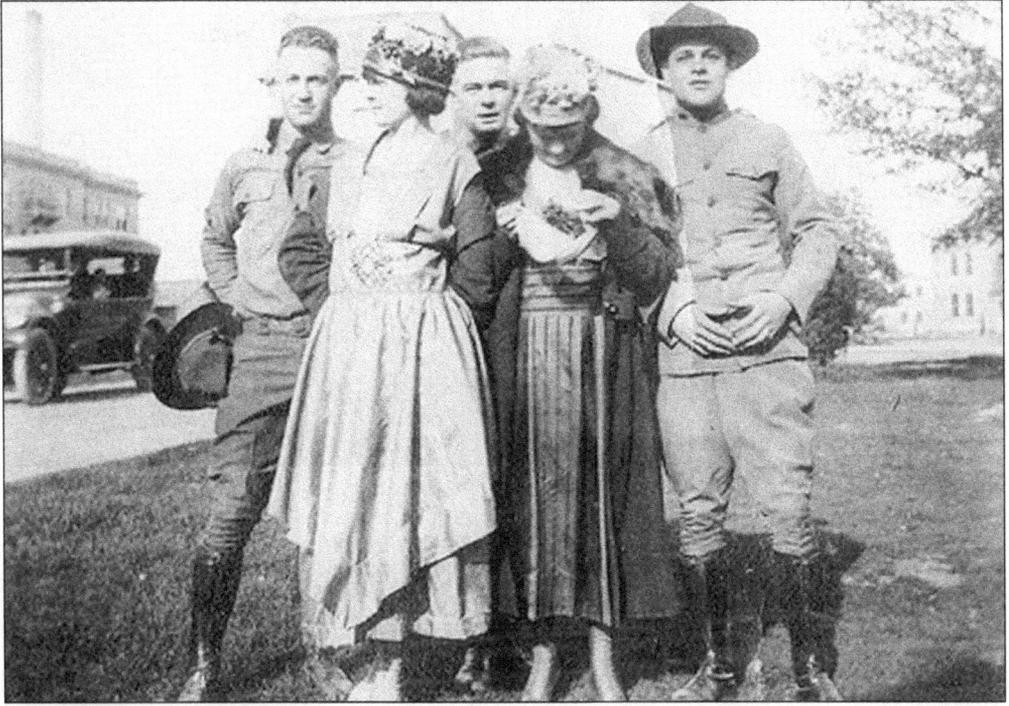

FUN DAYS. Student life in 1910 was not all study. Aggies made time for dates despite the all-male school's strict rules. Here a group of early Aggies meet their dates before a football game, still one of the biggest attractions in the area. The Aggies' military outfits stand in stark contrast to the fashions being sported by their dates. A Ford Model T sits in the background.

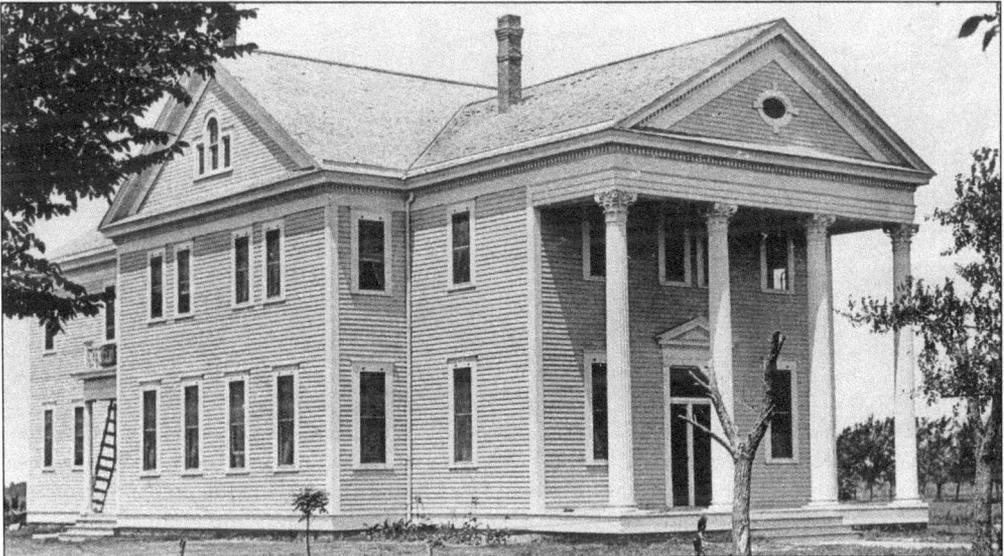

SHIRLEY HOTEL. A large problem for the A&M campus in the early days was the lack of facilities for unmarried faculty members. The Shirley Hotel was constructed on campus in 1906 to alleviate this problem as well as to accommodate visiting professors. The hotel was torn down shortly before 1930, as enrollment started to drop immediately after the stock market crash of 1929, which heralded the Great Depression of the 1930s.

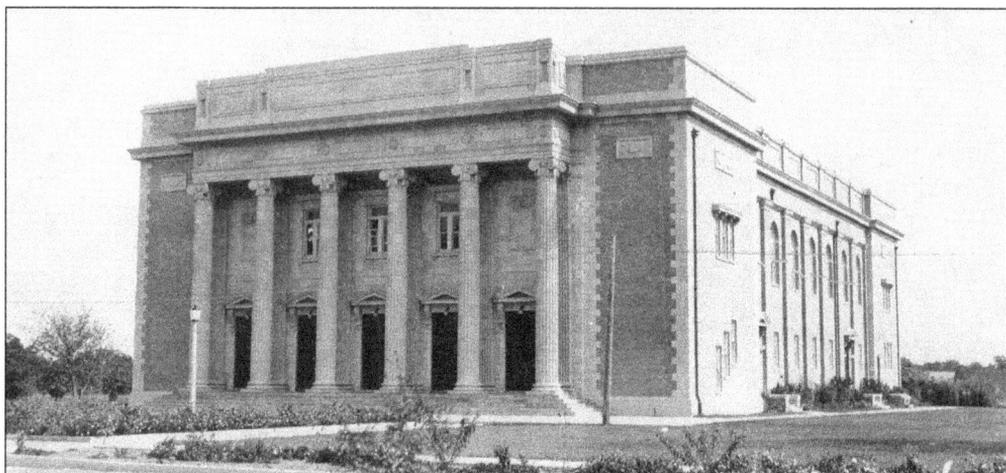

GUION HALL, 1927. The majestic edifice named for the Honorable John I. Guion, county judge, featured 2,500 seats and was the home to theatrical productions, commencements, concerts, church services, and many other cultural events from 1918 until it was torn down in 1971. The advent of the YMCA in 1914 and Guion Hall in 1918 had already supplanted the Old Assembly Hall in its function, so it fell into random use. Even the great Guion Hall had to step aside for bigger development. Though condemned, the sturdy structure stood its ground through several of the first swipes of the wrecking ball. The Rudder Tower now stands in its place.

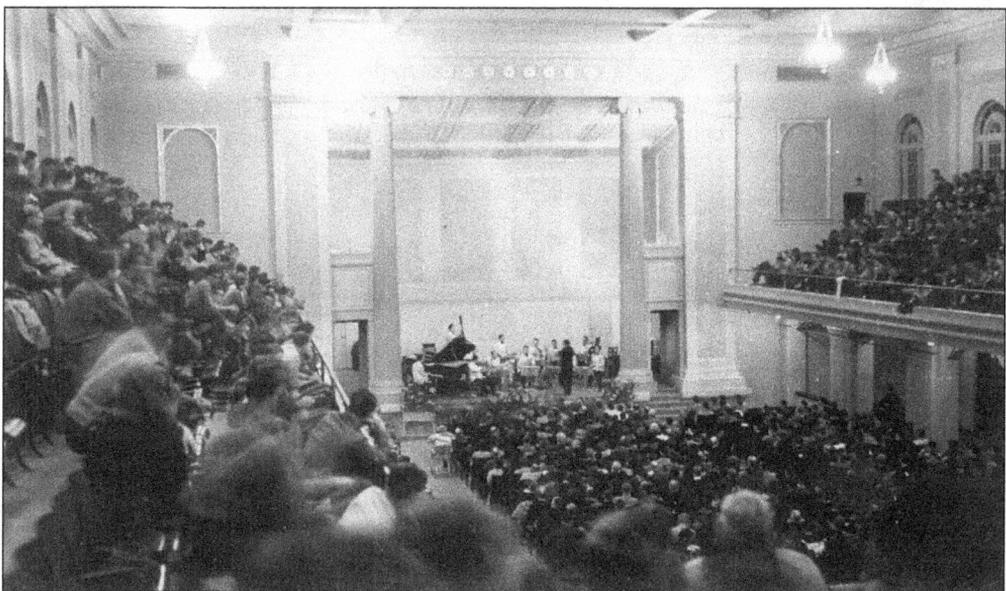

SATURDAY MATINEES. On Saturdays in the 1950s, Guion Hall showed cartoons and movies all day for a nominal fee. The A&M Consolidated High School baccalaureate and sometimes its graduation ceremonies were held here; it was also a venue for stage plays and musical revues. An inscription is found on the top of the building's exterior facade: Ignorance is the Curse of God, Knowledge the Wing Wherewith We Fly to Heaven —William Shakespeare. This picture shows a classical concert in Guion Hall. Although it was thought to be a marvel of European architecture in the 1920s and 1930s, the ideas of Frank Lloyd Wright and other American architects were starting to favor a unique new domestic Prairie School that was soon to sweep away classical European styles. Guion Hall became one of this revolution's early victims.

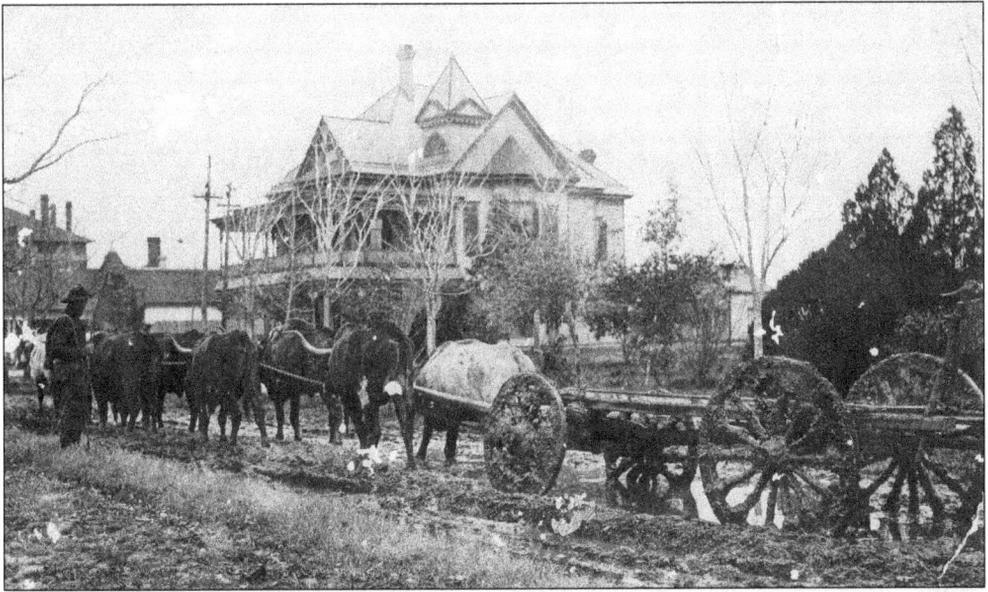

PRESIDENT'S HOME. Gathright Hall served as the residence for A&M's presidents until a private home was constructed for Sul Ross in 1891. Oxen were often used to haul heavy loads to the campus in those days. Pictured here is an oxen train in 1893 pulling cargo past the newly opened president's house. Texas longhorns are being used in the convoy.

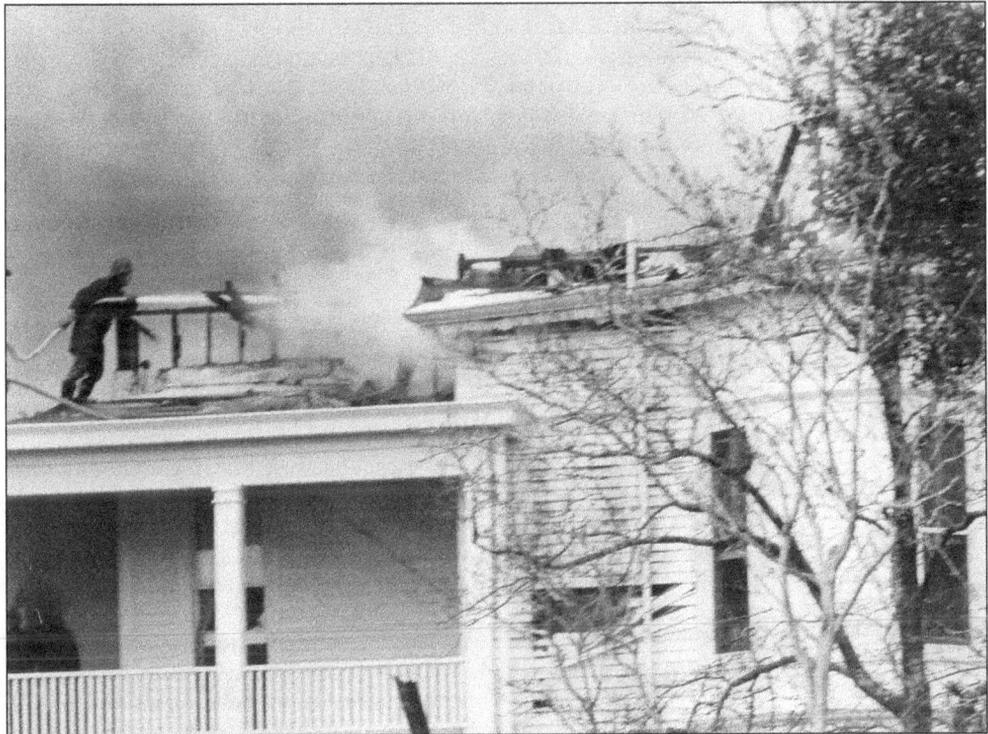

PRESIDENTIAL FIRE. The president's house burned on January 26, 1963. University president Earl Rudder and his family had to be moved to temporary housing on Lee Avenue until the home was rebuilt.

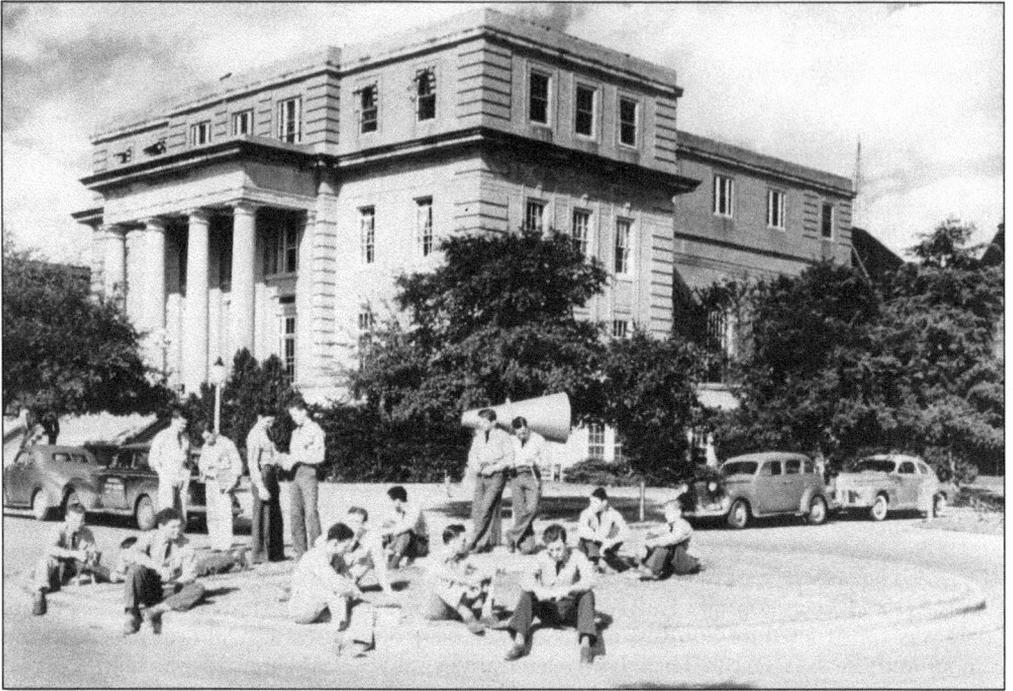

YMCA BUILDING. This haven for students was a prime example of classical architecture on a college campus, and it was very functional as well. The structure had such facilities as a chapel, auditorium, offices, and a swimming pool. In this 1942–1943 photograph, cadet Calvin C. Boykin Jr., class of 1946, can be seen in the foreground, second from right. Shortly after this photograph was taken, Boykin, like many Aggies, enlisted in the army and went off to war. He later returned at the end of World War II on the G.I. Bill and graduated.

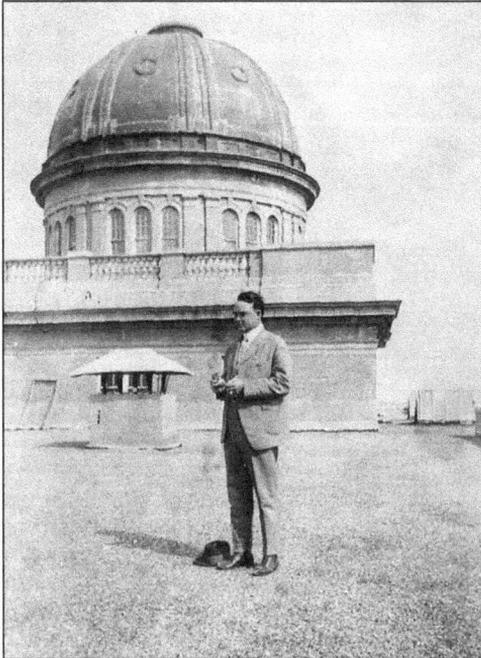

ON TOP OF THE WORLD. In this unusual c. 1915 photograph, a MoorMan Feed Company salesman, Thomas G. Heath, stands on top of the Academic Building next to its famous copper dome. Heath's grandson, the late Calvin C. Boykin Jr., discovered the history of this image within the last few years. Heath did not attend A&M but was known to have a collection of interesting self-portraits. Most likely, he was seeking the expertise of the well-known college's research. The roof of the Academic Building was open to anyone until the sniper incident on the TU campus in the 1960s. Now only buglers access the roof of the Academic Building when they play Silver Taps. (Anne Boykin.)

24

Three

COLLEGE STATION GROWS

CADETS STRUT. This photograph, from the 1930s scrapbook of then cadet Mortimer H. "Morty" Stewart (father of the late city councilman Larry Stewart), shows the Corps of Cadets carrying out a practice review on the Simpson Drill Field. The DeWare Field House is clearly visible in the background. (PH.)

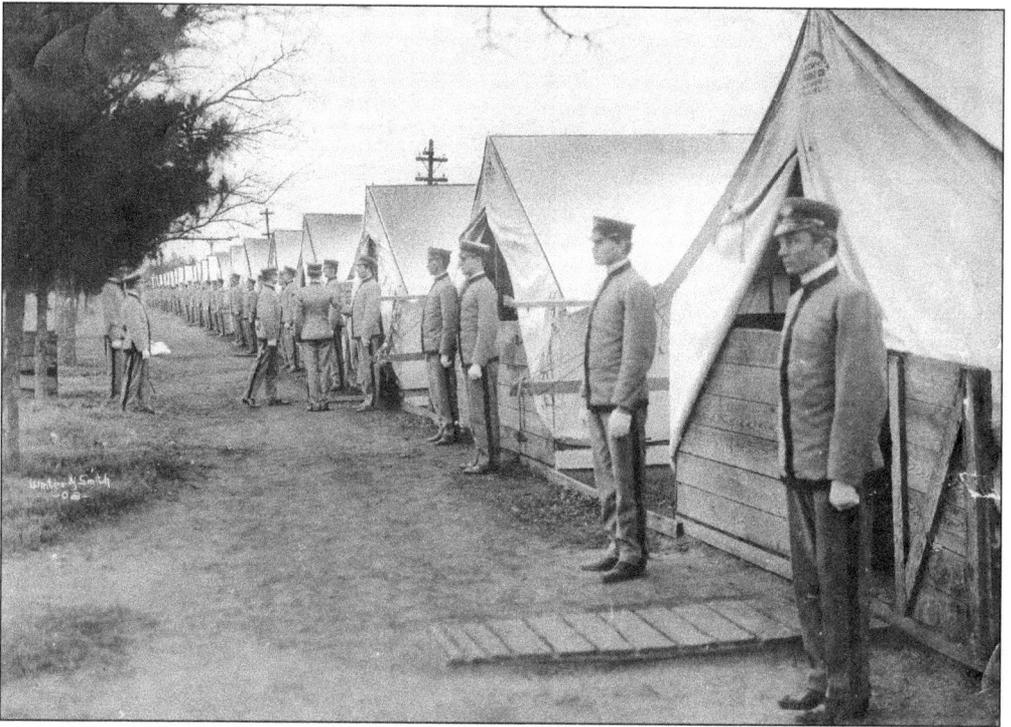

TENT CITY. In the early days on campus, there were not enough living quarters for all students, so some cadets were housed in tents. Inspection was weekly, normally on Saturdays. In this pre-1916 photograph, cadets line up for inspection. Tents did not offer the luxuries of a dormitory, especially when the cold north wind started to blow in winter.

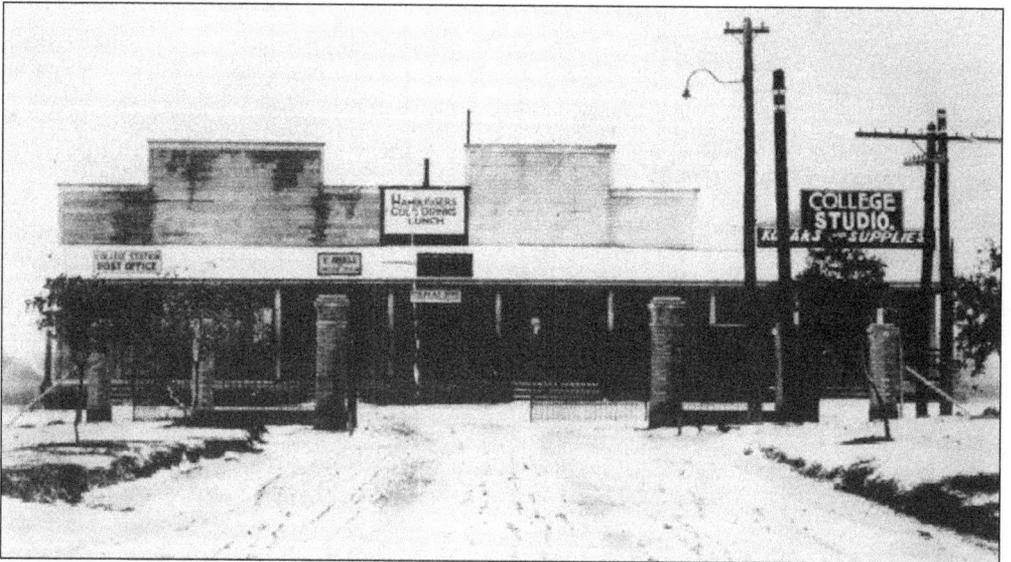

NORTHGATE STRIP. In 1910, area merchants opened the community's first strip center, a U.S. Post Office, a burger joint advertising tamales, and College Studio, which sold school supplies as well as Kodak photographic supplies to eager students. (PH.)

PARSONS MOUNTED CAVALRY. Formed in 1973, this cavalry unit is the successor to the mounted cavalry units that play a central role in A&M traditions. This is a "parade and show" unit composed of sophomore, junior, and senior cadets who represent Texas A&M University at events across the state. It is the only mounted ROTC (Reserve Officer Training Corps) unit in the United States.

SURVEYORS AND SEXTANTS. This is a group of cadet surveyors in 1908 learning their craft. The "rough out" uniform worn by these cadets was inspired by Teddy Roosevelt's Rough Riders from the Spanish-American War. The hats are very different from the cadet norm.

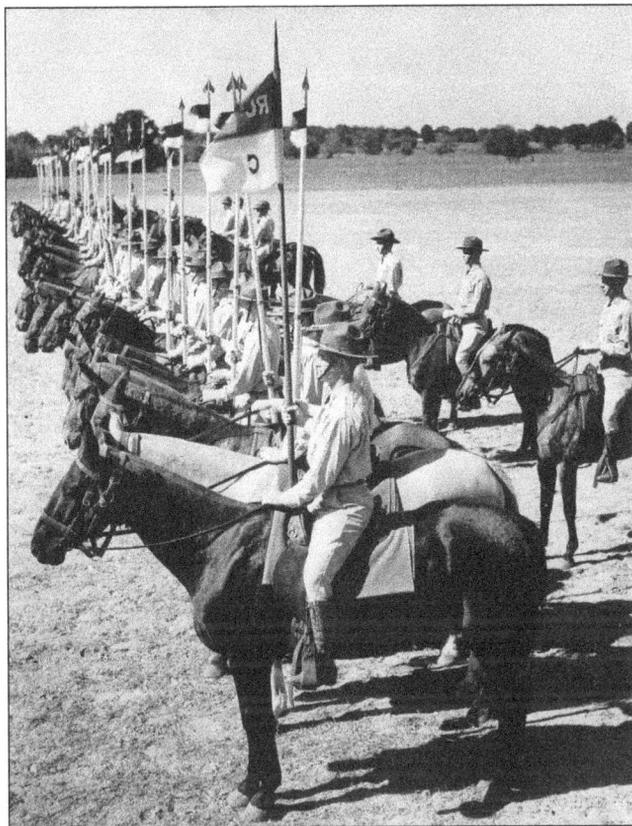

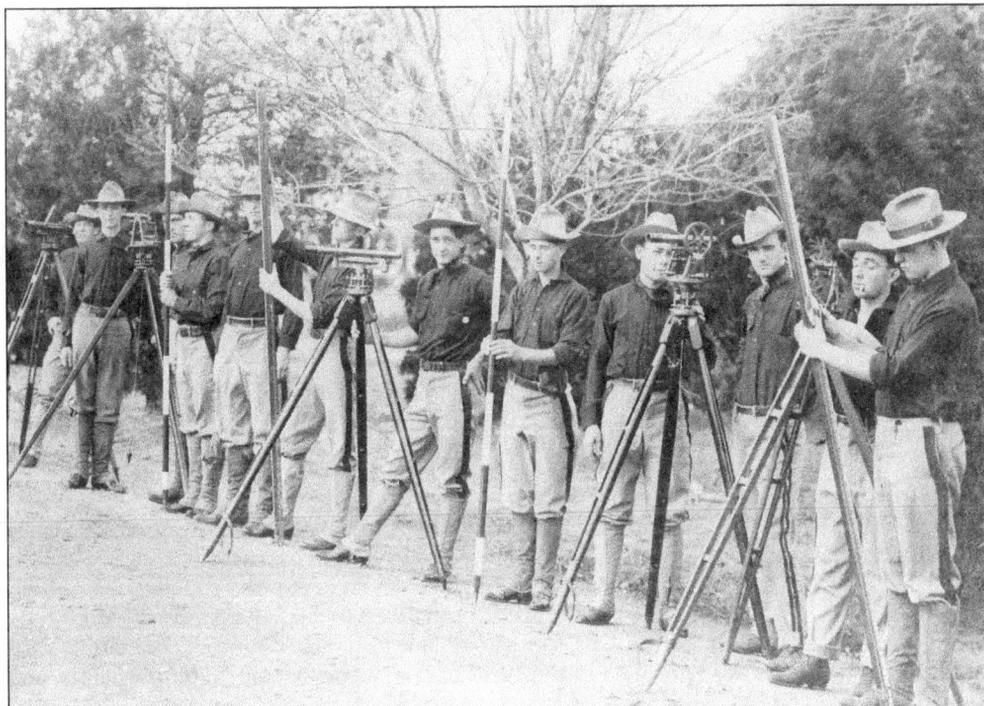

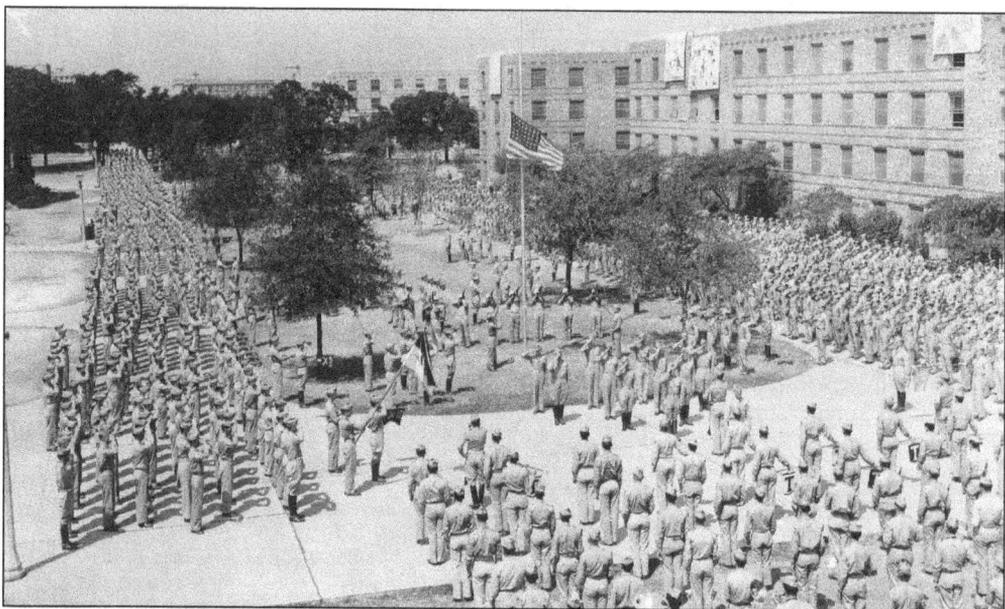

Corps Retreat. There seems to be a formal drill for everything in the corps, even retiring for bed in the evening. Here is a retreat on campus in 1948. Handmade banners (messages written on sheets) hang from the dormitory windows. According to some former students, the messages were sometimes quite bawdy. The influx of coeds in later years threw a wet blanket on this activity, so to speak.

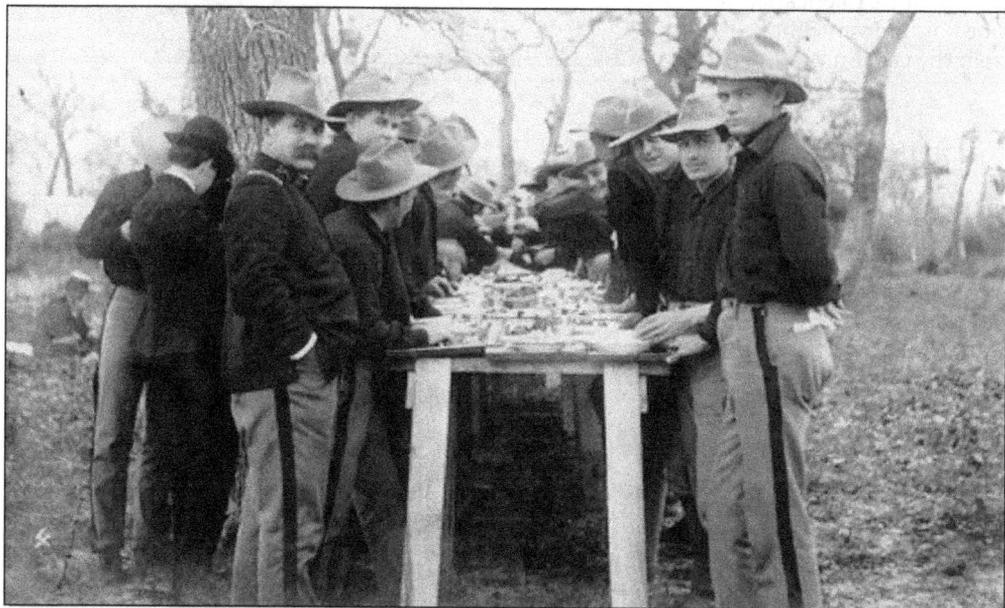

March to the Brazos. April Fool's jokes, mainly played by fish (freshman) changing places with sophomores on that day, got so out of hand at one point that cadet leadership decided to have an off-campus march all the way to the Brazos River (8 miles) to quell the practical jokers. "The Hike," as it was called in the early 1900s, turned into another Aggie tradition. Discontinued for many years, the march was reinstated in the 1970s to raise money for the March of Dimes, and more than $1 million has been raised so far.

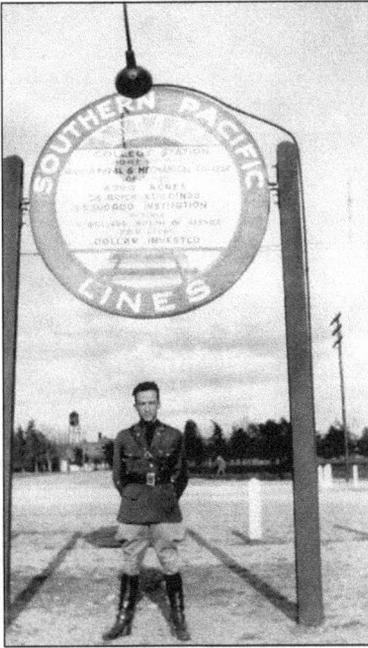

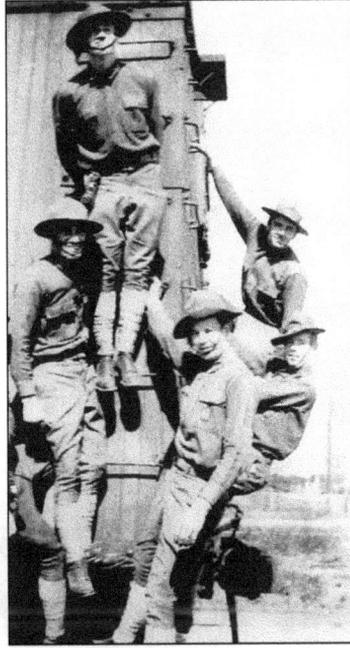

CADET AT THE STATION. Cadet M. H. "Morty" Stewart stands at ease under the Southern Pacific Lines sign at the depot in the early 1930s. The sign boasts, "College Station, Home of the Agricultural and Mechanical College of Texas, 4,000 acres, 54 brick buildings, $5,500,000 institution, serving a dollar's worth of service for every dollar invested." At right is the Broom Brigade, a group of fish selected to sweep up designated areas, not all of them on campus. Passenger trains, for instance, were swept when they stopped in College Station. (Left, PH; right, CL.)

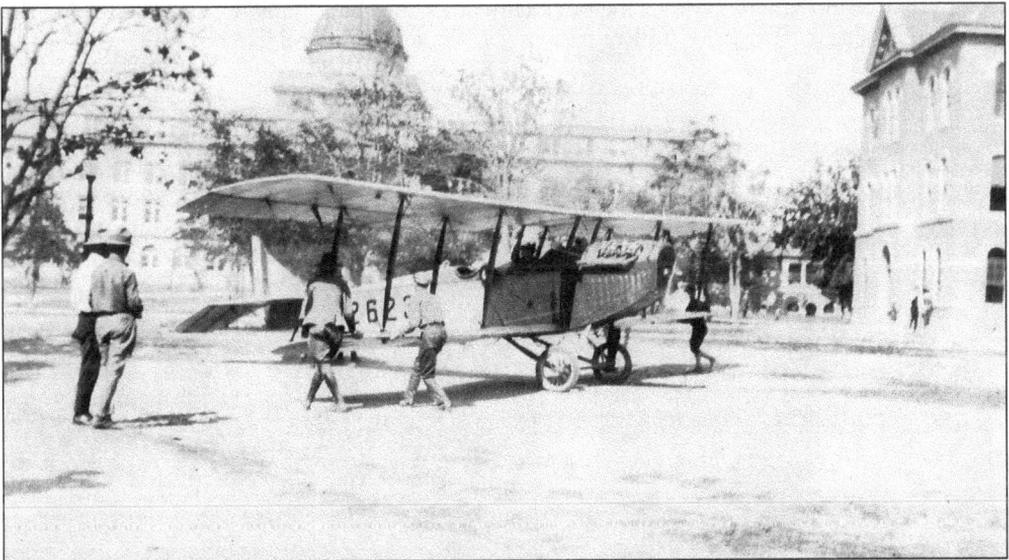

BIPLANE TRAINING. Unidentified cadets receive training for biplanes shortly before World War I. Many of the Aggies killed in that war died in such planes. A little booklet called *The Gold Book* contains a biography and photograph of each Aggie who paid the ultimate price in the First World War. Jesse Easterwood, for whom Easterwood Airport is named, was one such casualty. Easterwood was posthumously awarded the Navy Cross.

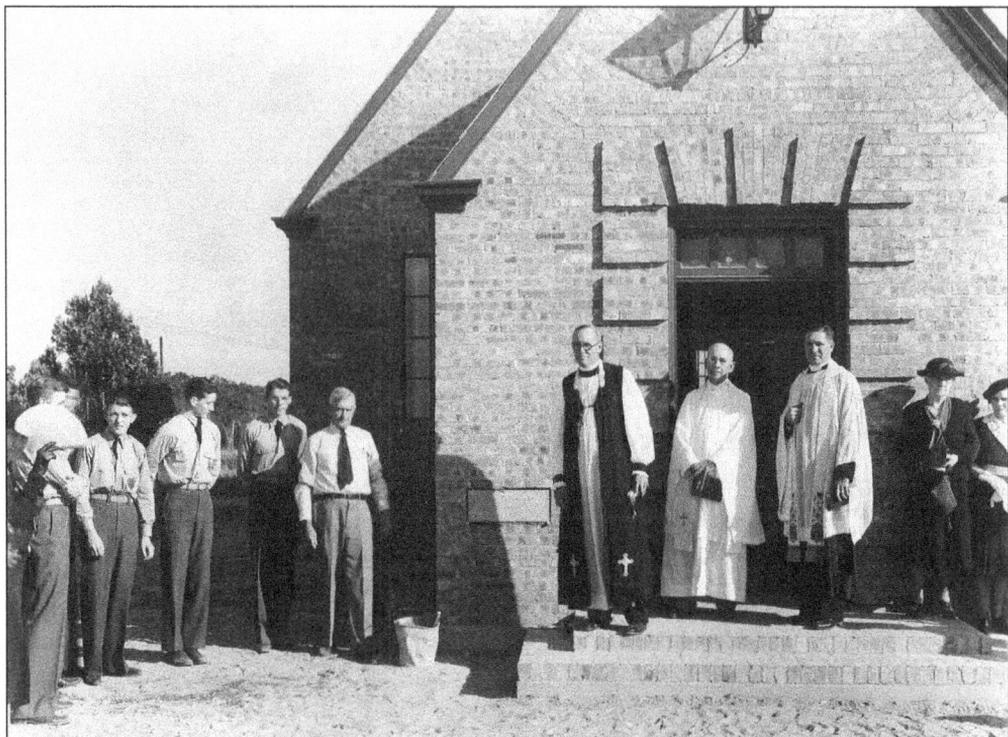

ST. THOMAS EPISCOPAL CHURCH. The chapel opened September 23, 1938, and is still in the same location on George Bush Drive. Pictured here, from left to right, are four unidentified A&M cadets; Rt. Rev. Clinton S. Quin, bishop of the Episcopal Diocese of Texas; the Reverend J. Parker Love, rector of All Saints Church; Mr. Cameron, chairman of the chapel building committee; and the Reverend Roscoe C. Hauser Jr. (student pastor). (St. Thomas Episcopal Church.)

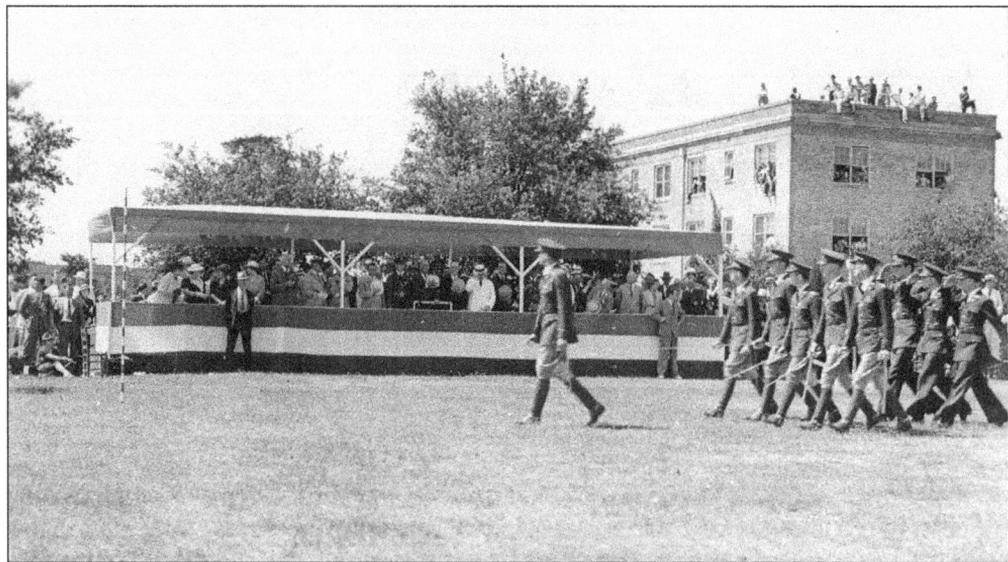

FDR's REVIEW. Pres. Franklin D. Roosevelt visited the A&M campus in 1937 and reviewed the Corps of Cadets. Although the Secret Service removed all cars from the area for security reasons, it did not prevent students and others from standing on nearby rooftops.

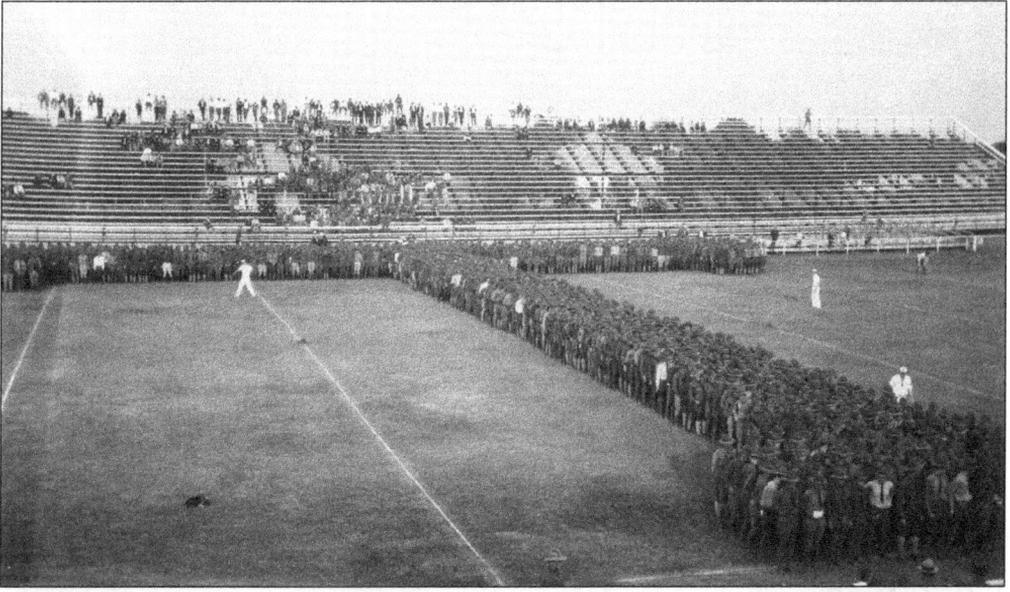

Aggie T. The Corps of Cadets makes this formation once every four years, although the Aggie Band does it at every football game and on other special occasions. Here the corps makes the Aggie T at a football game in the late 1920s. (CC.)

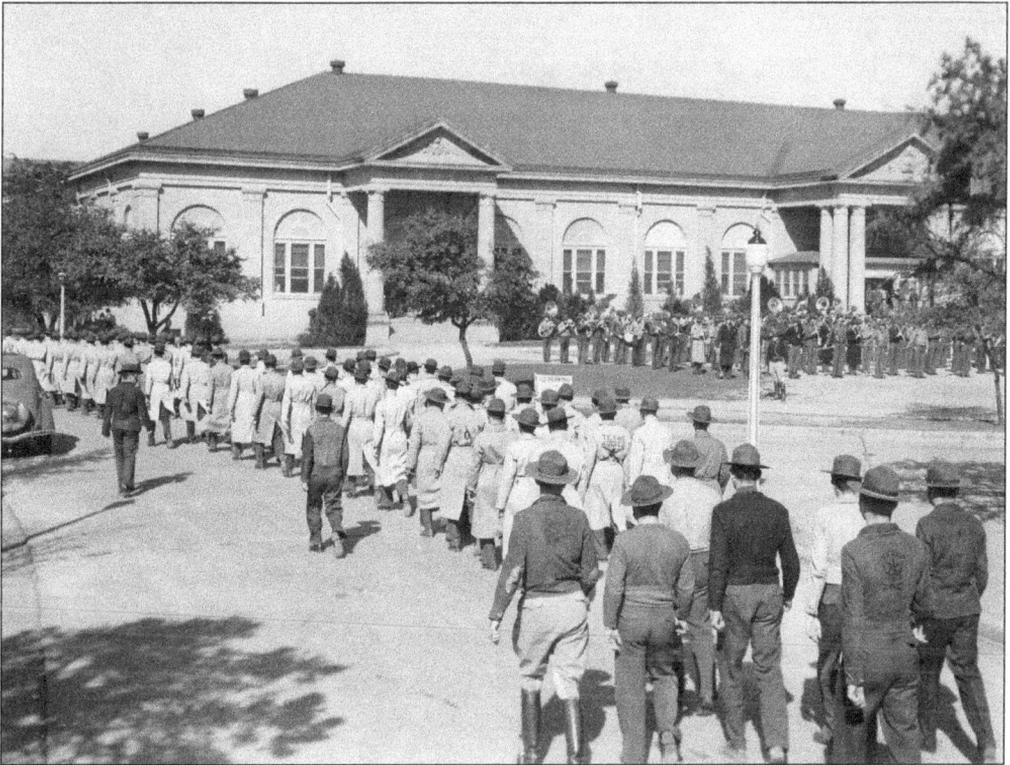

March to Sbisa Hall. Formations march to Sbisa Hall for all meals, as shown here in 1939. Drummers are on hand to beat the cadence as the cadets march into the hall. For decades, Sbisa's claim to fame has been its size—the biggest student dining hall in the world. (CC.)

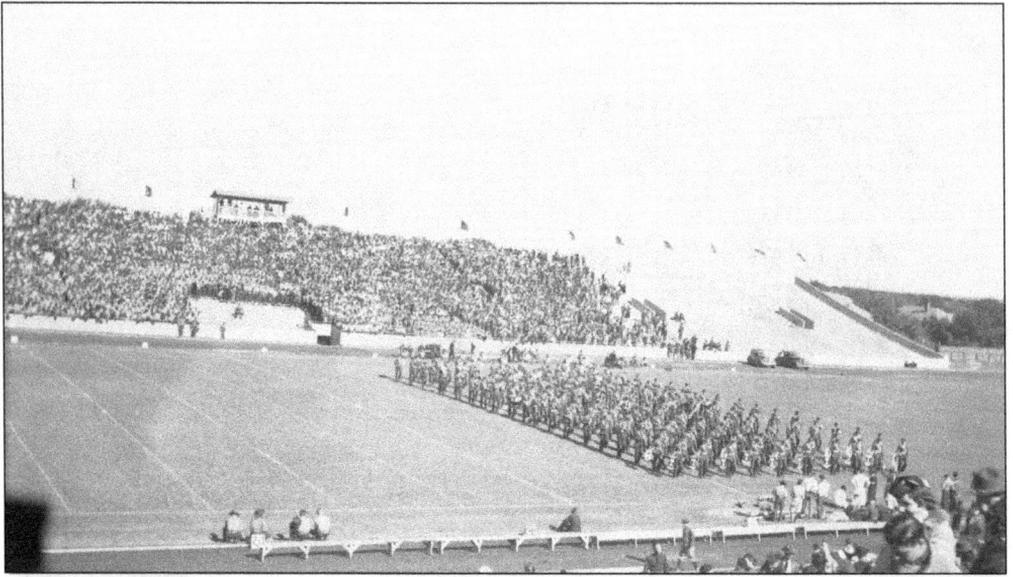

MILITARY MARCHING BAND. The world-famous Fightin' Texas Aggie Band marches at halftime during a game in the 1930s. By this time, Kyle Field had added a press box, even though the stadium was still a single-deck horseshoe. (CC.)

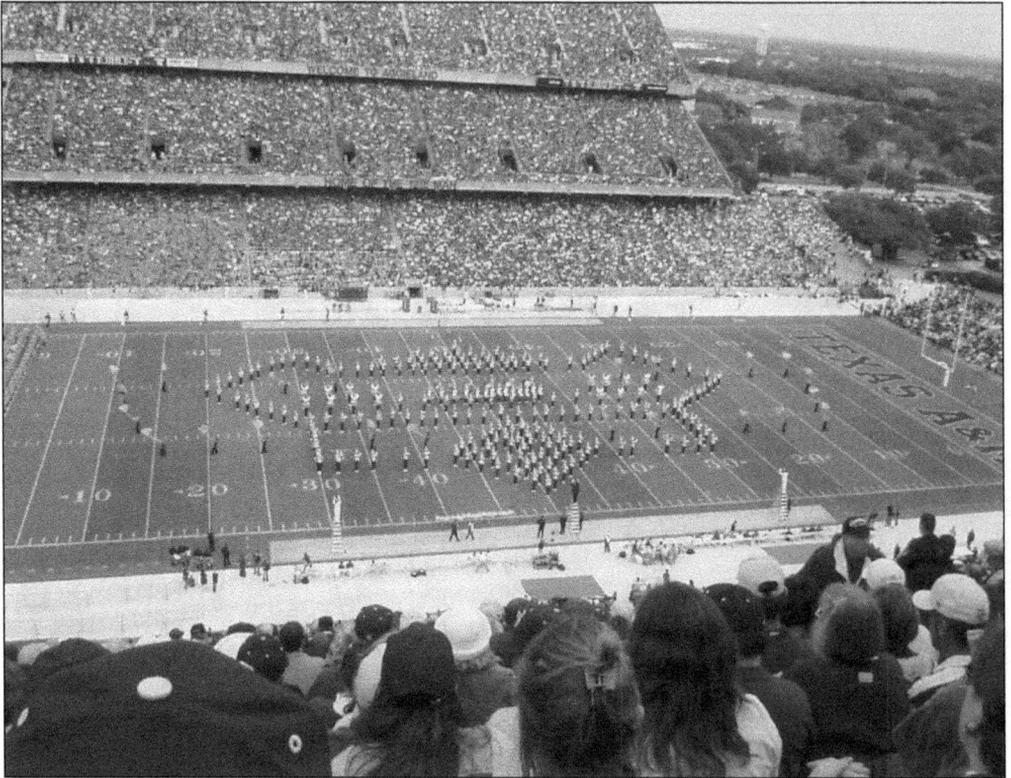

MODERN BAND. Texas A&M is one of six U.S. senior military colleges, and the corps is the largest uniformed student body outside the service academies, such as West Point. The 400-member band is among the largest uniformed college marching bands in the United States.

WOMEN IN BAND.
The band was the
last essential part
of the corps to
integrate. In 1985,
Andrea Abat, class
of 1989, was the first
woman allowed into
the band; however,
this recent close-up
shows there are many
women in today's
band. The cadet in
the foreground is
the band major, a
coveted position. The
first female drum
major debuted in
2009. Those wearing
boots are seniors.
(Photograph by
Glenn D. Davis.)

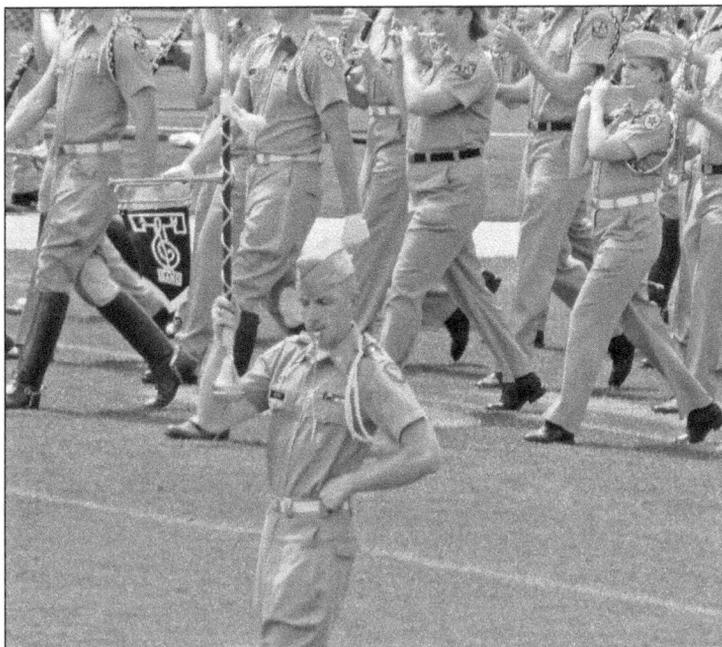

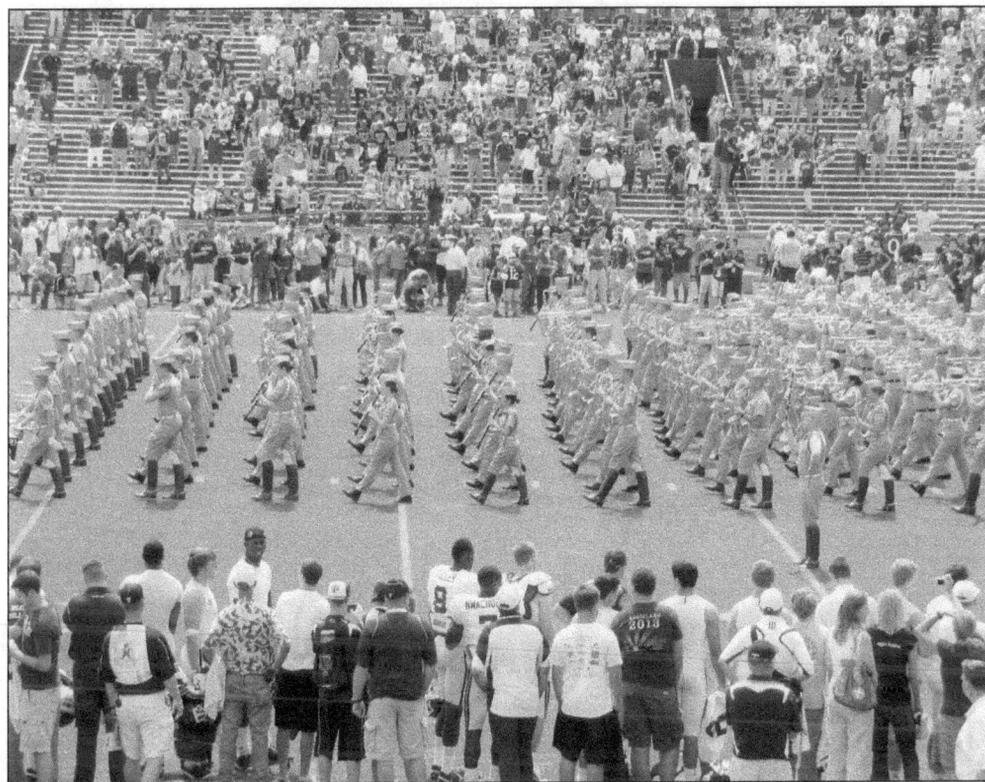

MILITARY PRECISION. The Texas Aggie Band has gained national and international fame for
formations and maneuvers so precise and complex that they require members to step between
each others' legs while marching. (Photograph by Glenn D. Davis.)

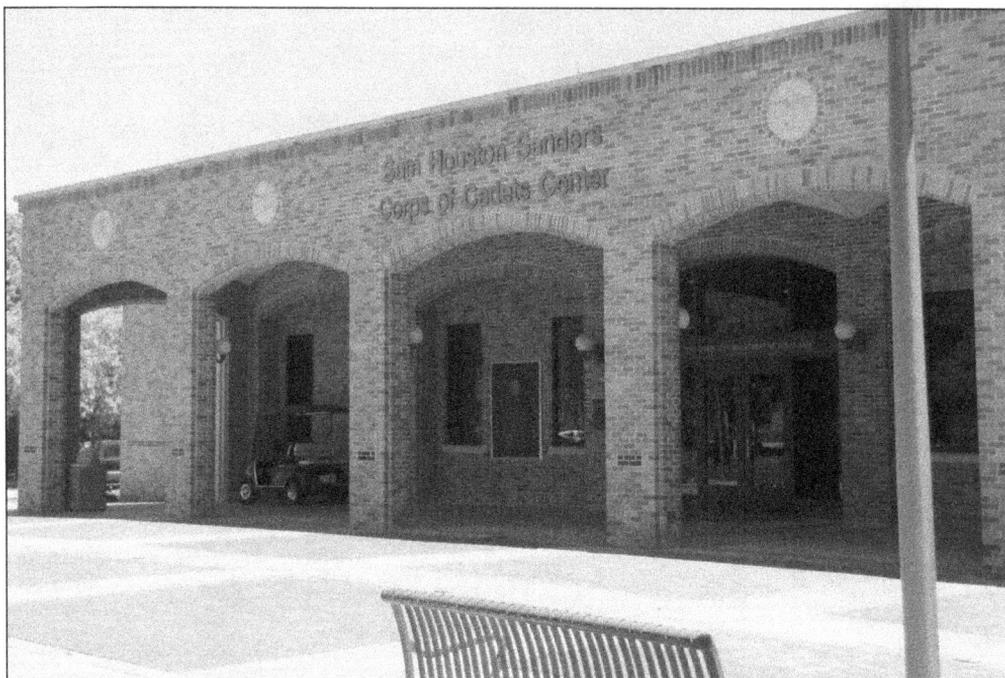

CORPS EPICENTER. The Sam Houston Sanders Corps of Cadets Center contains exhibits, paraphernalia, pictures, and other objects on the Corps of Cadets and its history. On display there, for instance, is the wallet (containing $13) that Earl Rudder carried throughout World War II. The sign over the south entrance to the Cadet Center reads "Keepers of the Spirit, Guardians of Tradition." Cadets argue that this is not a creed or motto, but just a phrase that is sometimes used to describe the corps. (Photograph by Glenn D. Davis.)

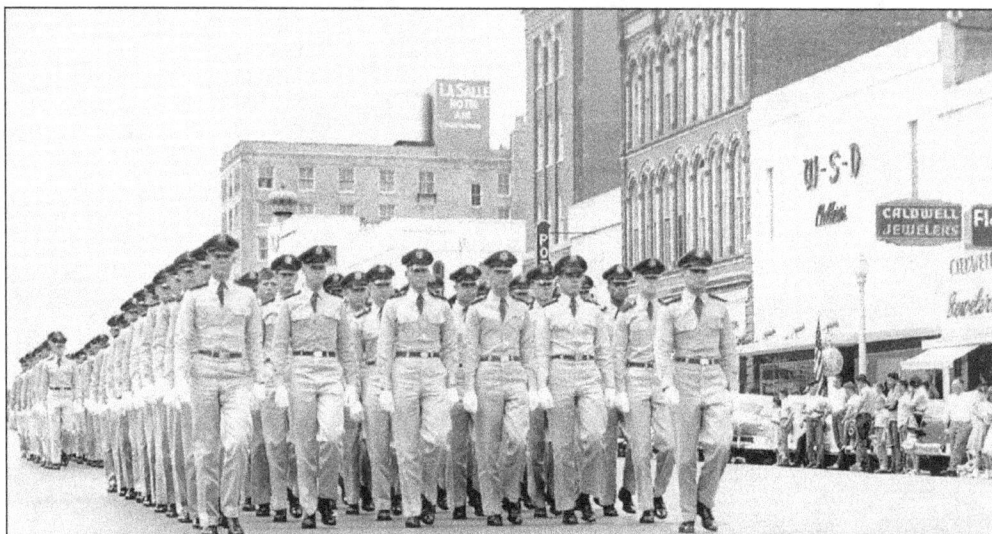

MARCH-IN. The corps marches in down Main Street in Bryan past the LaSalle Hotel, the Queen Theater, and Caldwell Jewelers. A march-in was always a good excuse for the community to show up in support of the college that was its primary source of income. Although today there are fewer members of the Corps of Cadets, they still have a major impact on campus and in the community.

34

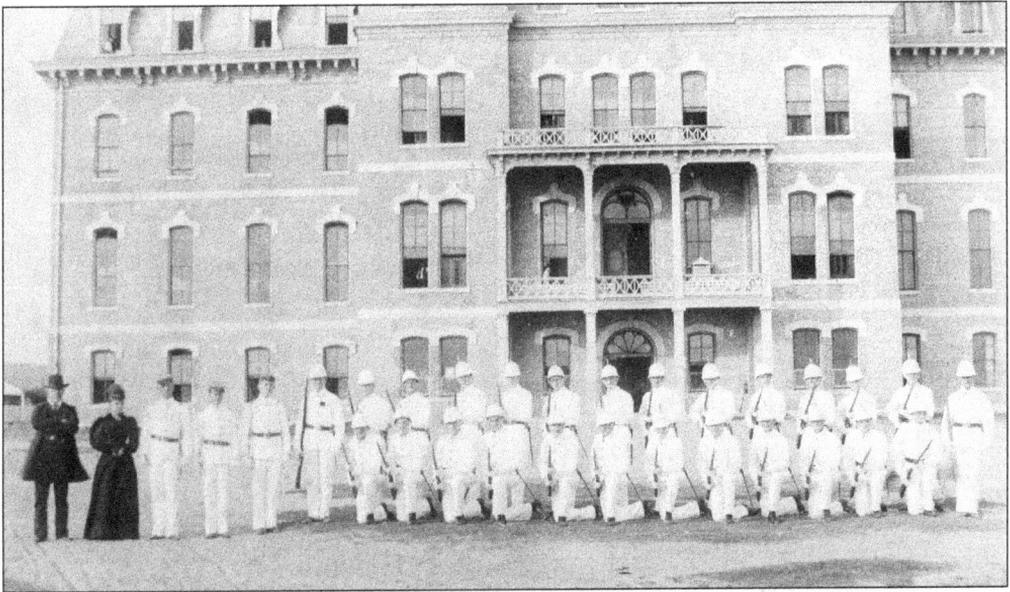

SPECIAL GUARDS. This 1895 photograph shows A&M's crack cadet team in full dress whites. Started in 1887, the team was first called the Scott Volunteers, then the Ross Volunteers, the Foster Guard, the Houston Rifles, and finally, reverted back to the Ross Volunteers under A&M president Tom Harrington. The Ross Volunteer Company is the official honor guard of the Texas governor. Its creed is "Soldier, Statesman, Knightly Gentleman."

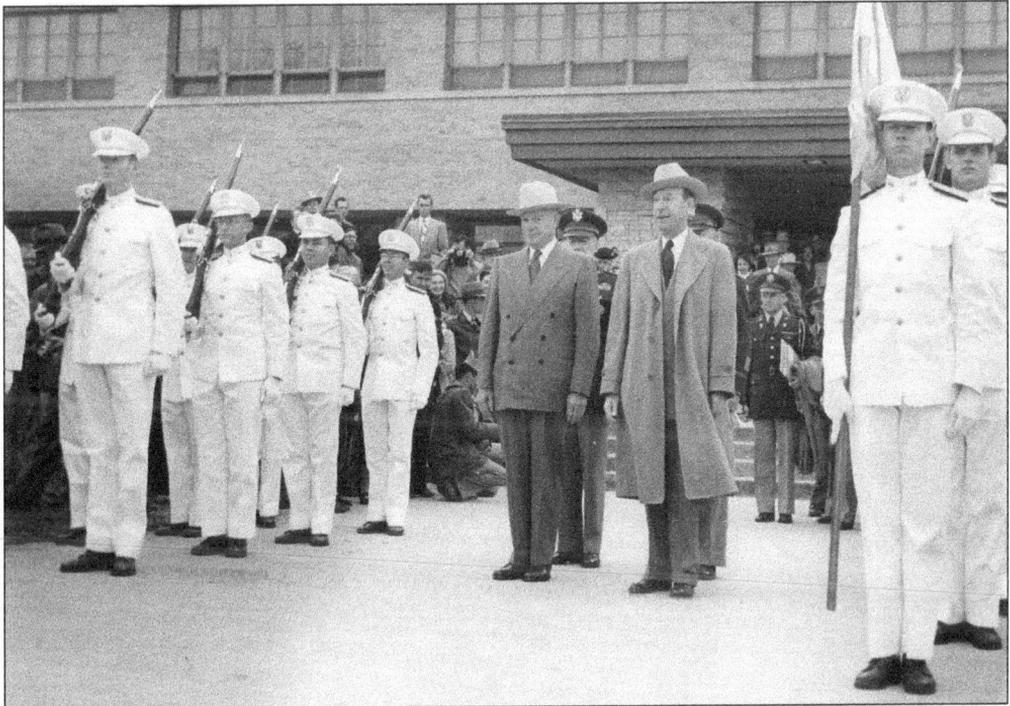

MSC DEDICATION. Pres. Dwight D. Eisenhower (center left) was on hand April 21, 1951, when the Memorial Student Center was dedicated. Standing next to him is A&M president Tom Harrington. Ross Volunteers stand to the left and right.

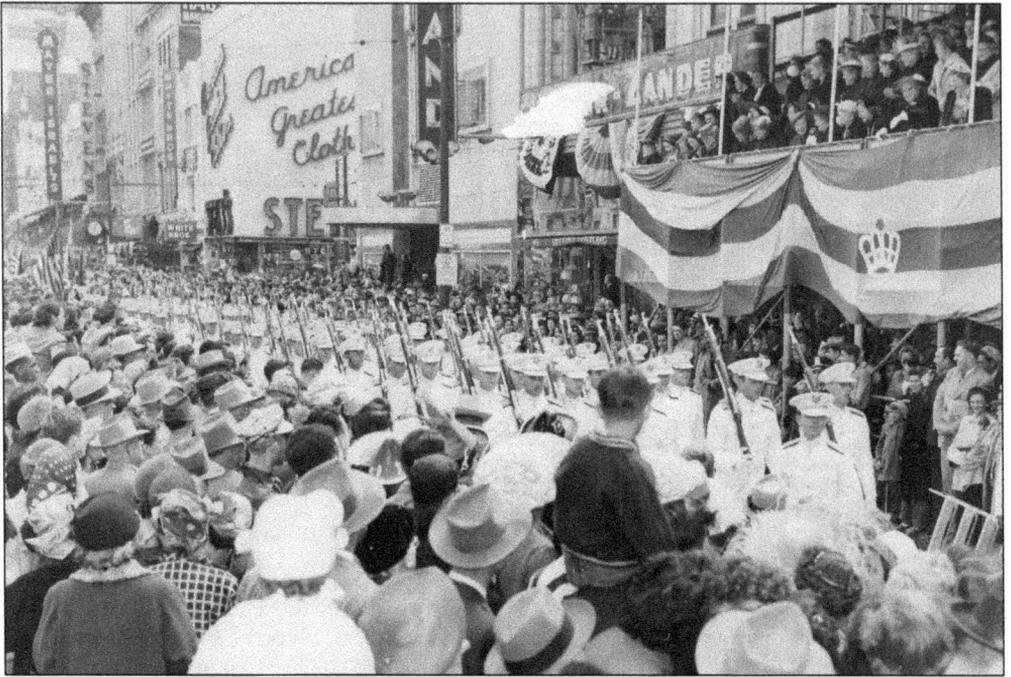

NEW ORLEANS. The Ross Volunteers march at Mardi Gras, specifically in the King Rex Parade. They have been marching in that particular parade in New Orleans since 1952. There is a crown insignia on the bunting in the background.

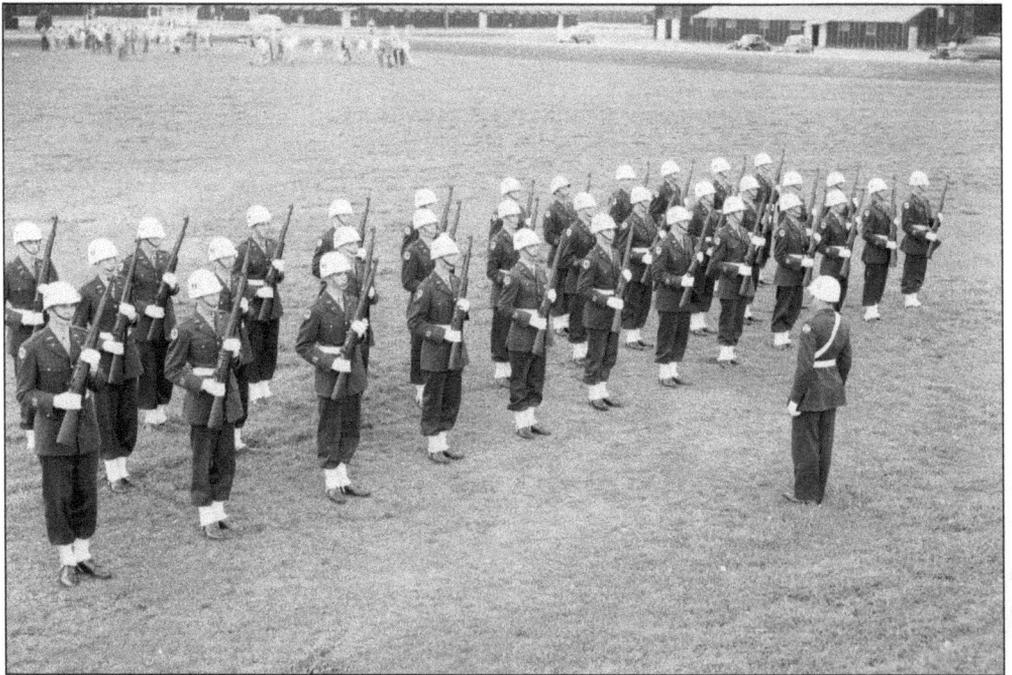

FISH DRILL TEAM. A precision marching and rifle drill team that repeatedly wins championships is the Fish Drill Team. Its skills at marching and at handling rifles have been displayed in such Hollywood movies as A *Few Good Men* and *Courage Under Fire*.

MESS CALL. Cadets answer mess call in this early 1911 photograph. Old Main stands proudly in the background. It burned the following year, and the Mess Hall, where the cadets are headed, was consumed by fire in November 1911.

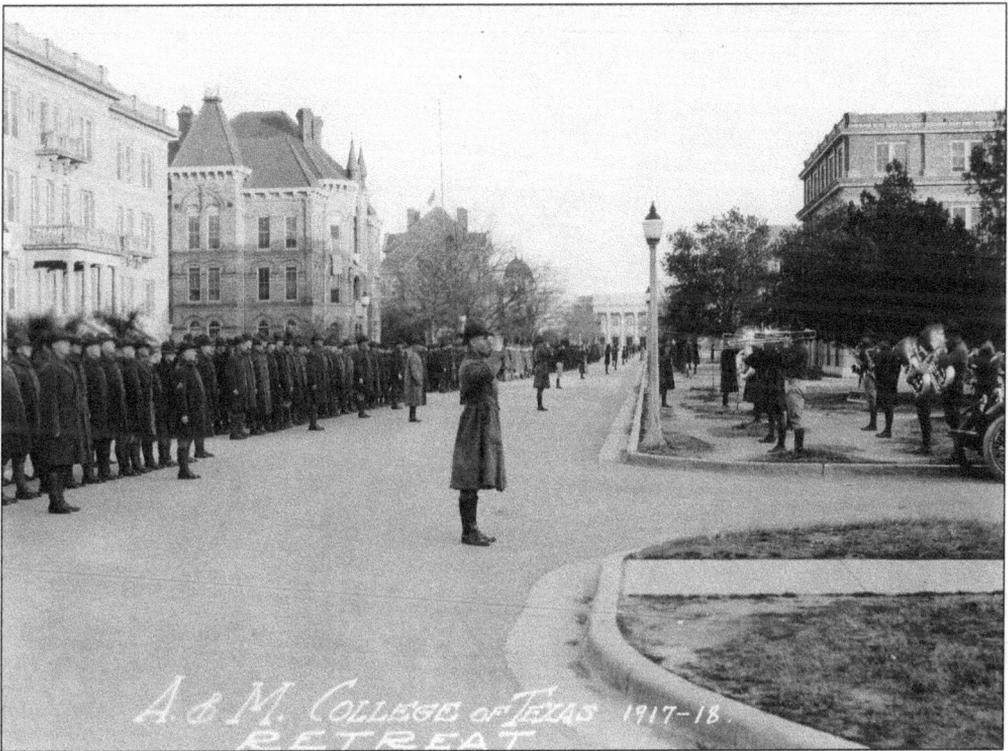

MILITARY WALK, 1917–1918. This panoramic shot of Military Walk was taken during a cadet retreat. This walk created a direct line between Guion Hall (for assemblies) at one end and Sbisa Hall (for meals) at the other end. The camera is pointed southward toward Guion Hall.

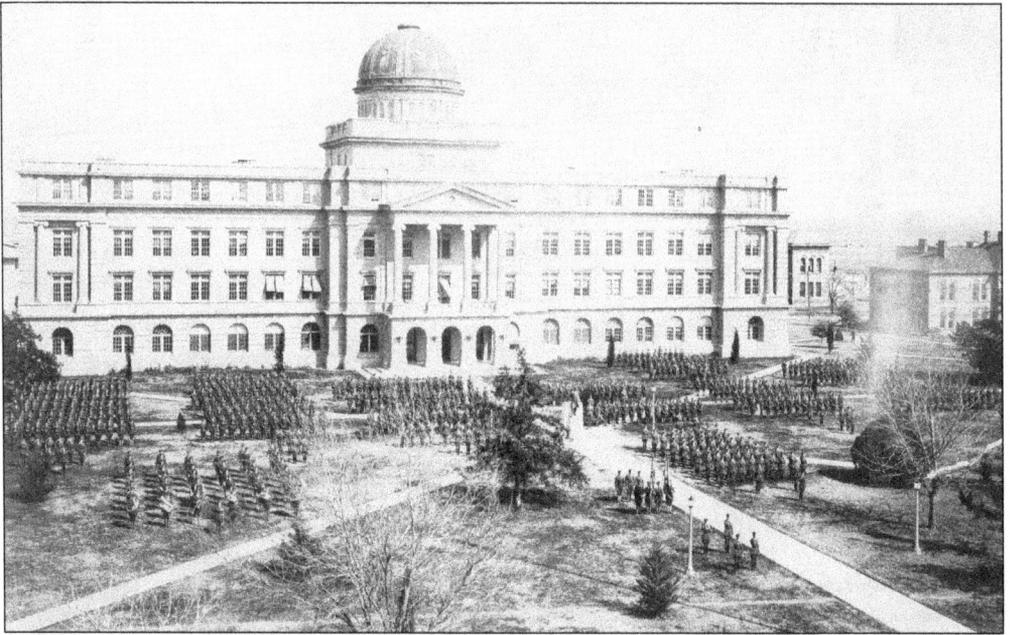

MUSTER. Cadets muster in front of the Academic Building in this photograph from the early 1900s. This is where cadets would also gather before their annual March to the Brazos, but not in this image, as cadets are not sporting the backpacks required for that march.

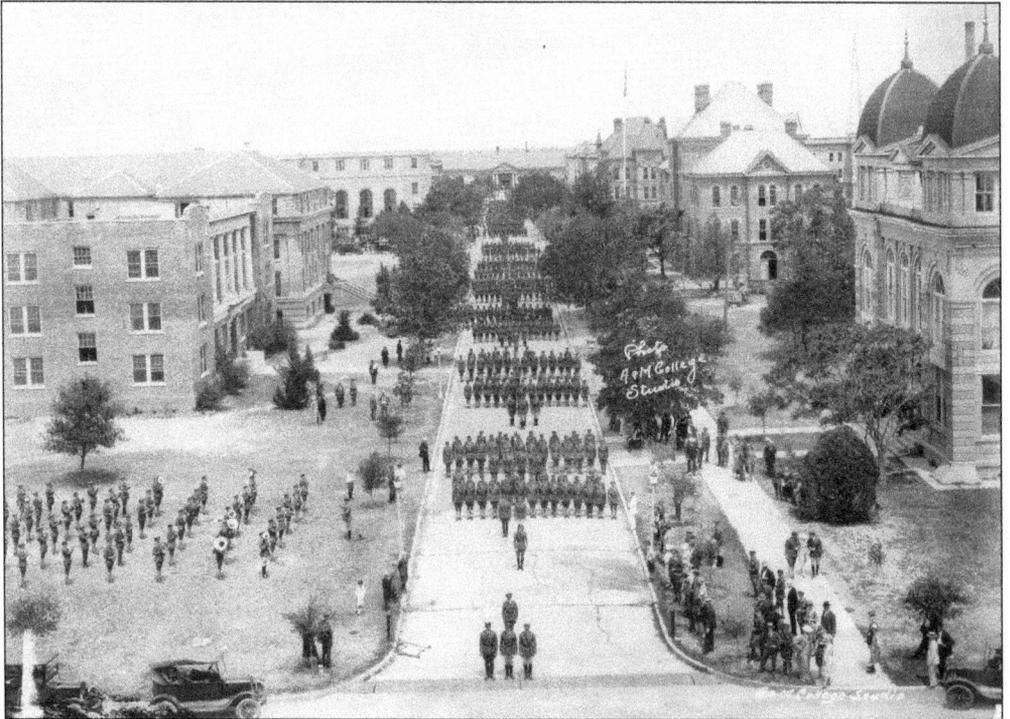

MILITARY WALK, 1928. This is an opposite view of Military Walk looking northward toward Sbisa Hall, with the marchers facing Guion Hall. The architecture of the old classical buildings in this photograph clearly reflects a strong European influence.

OLD-STYLE MEGAPHONE. This megaphone, for the bugler to blow taps and reveille through, used to be located in front of the YMCA but was moved to the Quad area. The senior in front is Jake Betty, class of 1973, now Col. Betty and current commandant of the Corps of Cadets. Betty was also a mascot corporal (guarded Reveille) as well as a yell leader.

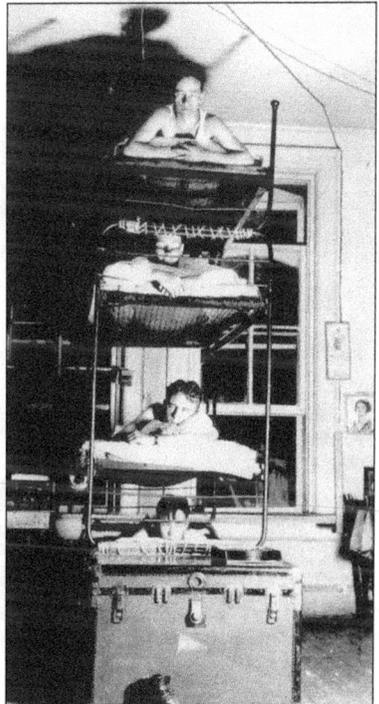

AGGIE INGENUITY. With dorm space at a premium in the early days, Aggies could always be counted on for their ingenious ways of making the best of a bad situation. Here, four army beds have been made into a four-deck bunk bed. From the top bunk down are M. H. "Morty" Stewart, R. C. Daniels, E. F. Booty, and T. M. Sowell—all class of 1939. (PH.)

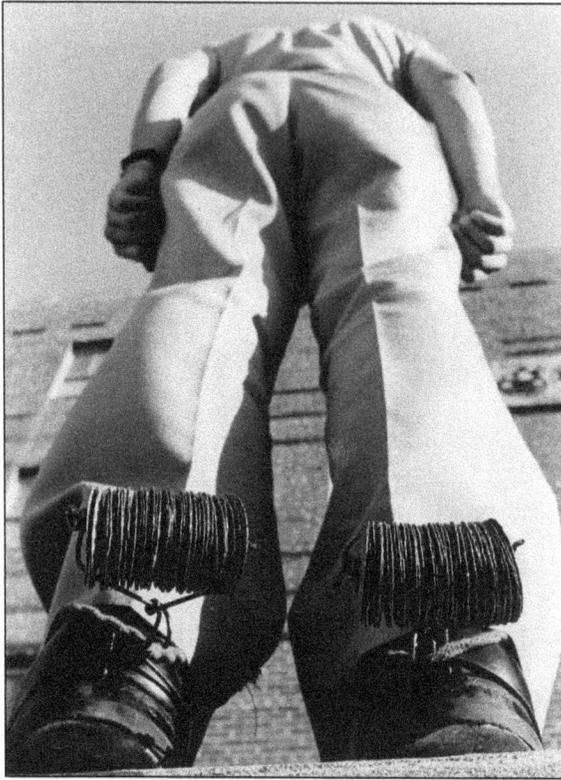

FISH SPURS. A tradition dating back to the football days of the old Southwest Conference is sporting "fish spurs" for the game against Southern Methodist University, since SMU's mascot was a pony. Freshman cadets still fashion these spurs from bottle caps and wear them the week before the Texas Tech (Red Raider) game, as the Raider rides a horse. The spurs make an unmistakable jingling sound throughout the campus. At one time, the number of bottle caps had to equal the last two digits of the cadet's class year.

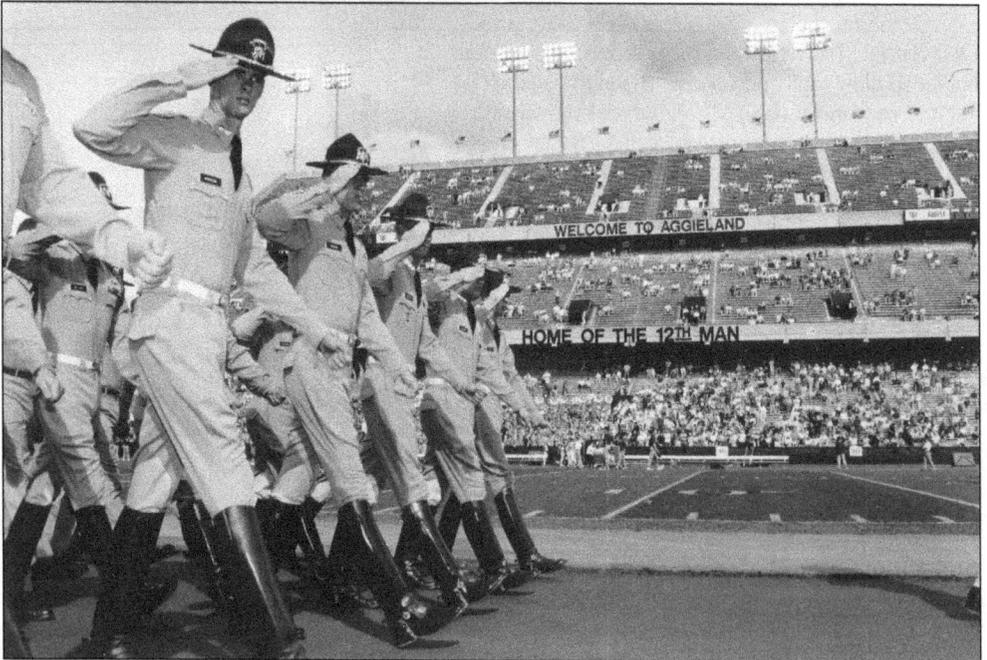

HOME OF THE 12TH MAN. With eyes right and hands in salute, the Corps of Cadets stages a march-in at Kyle Field before a home football game. A Parsons Mounted Cavalry member also fires off a cannon called The Spirit of '02 in the south end zone every time the Aggies score.

Humpin' It for Girls. This shot from the late 1970s shows a freshman female member of the corps "humpin' it," which is a kind of standardized yell made by bending over with hands on knees. One such corps hump is "Corps Center Guard . . . first ones there . . . last ones out . . . no one even knows we're there!" In the early years, a student determined that the best, and loudest, yells could be produced in this unlikely position.

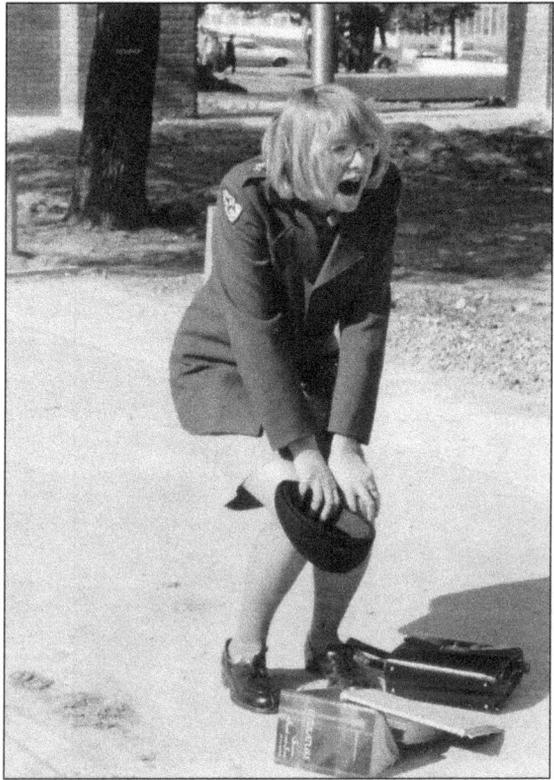

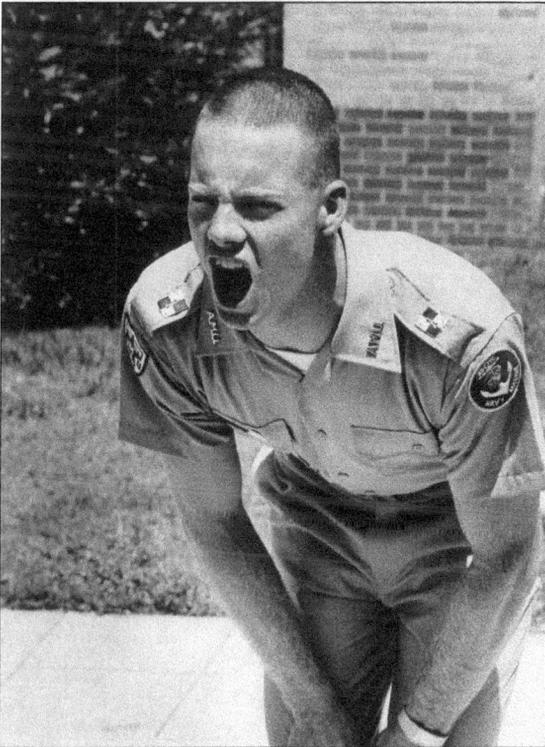

Humpin' It for Guys. Of course, male freshmen have to do the drill, too—maybe even more. A "whip out" is a different drill in which a fish has to yell out his or her name and other information to an upperclassman when told to do so. The fish is expected to memorize the names, hometowns, and fields of study of the upperclassmen in his outfit.

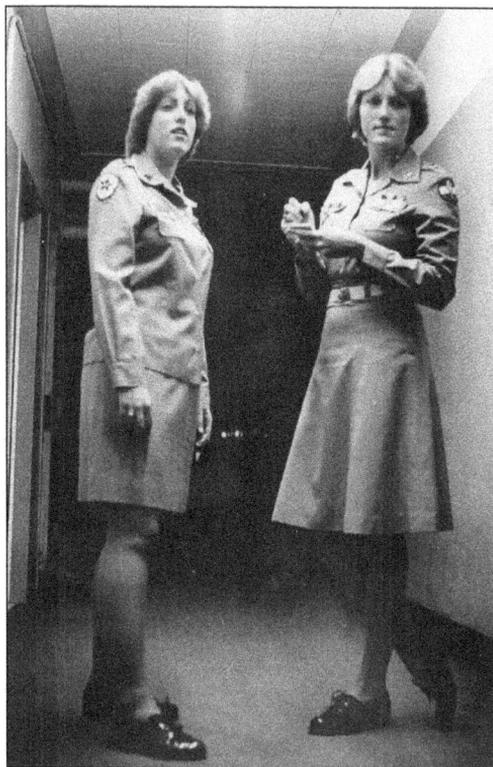

WOMEN IN THE CORPS. More and more women started joining the corps in the 1970s and 1980s, and the uniforms began to change. Pictured here are the ladies in the early 1980s wearing full skirts, as opposed to the straight skirts of the 1970s. (SC.)

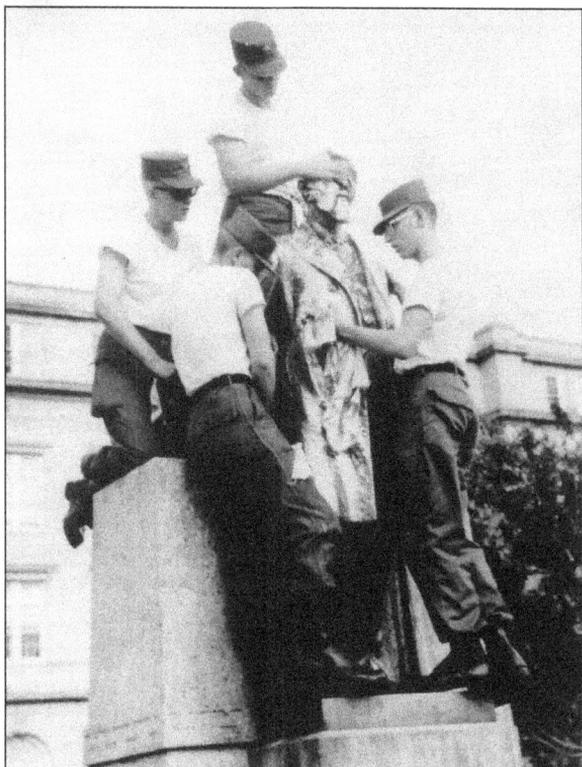

SULLY'S BATH. The statue of Sul Ross used to get a scrubbing every Saturday from members of the corps. This practice was discontinued when it was discovered the metal of the structure was actually being worn down. "Did you know that Sully used to have a full head of hair?" was a standard joke in those days.

AGGIE WANNABE. Many children in Texas grow up wanting to attend Texas A&M, and children of Aggies get indoctrinated in the lore of the university at an early age. Here a Marine ROTC member is already showing his young son the ropes.

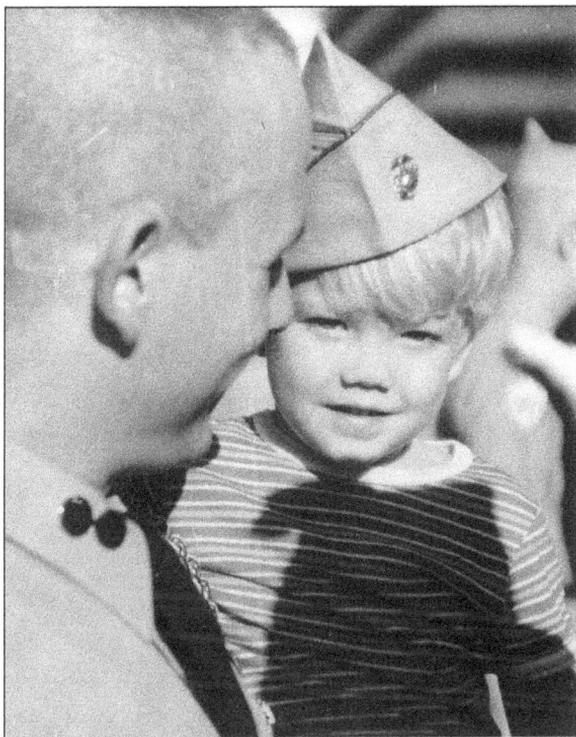

VICTORY EAGLE, 1993. This bronze statue stands in front of Cain Hall, where the student athletes lived until the late 1990s, when the NCAA changed the rules concerning athletes living in separate dorms. The eagle was a gift from the class of 1991 as a perpetual symbol of the Aggie spirit. It stands 9 feet tall and has a 14-foot wingspan.

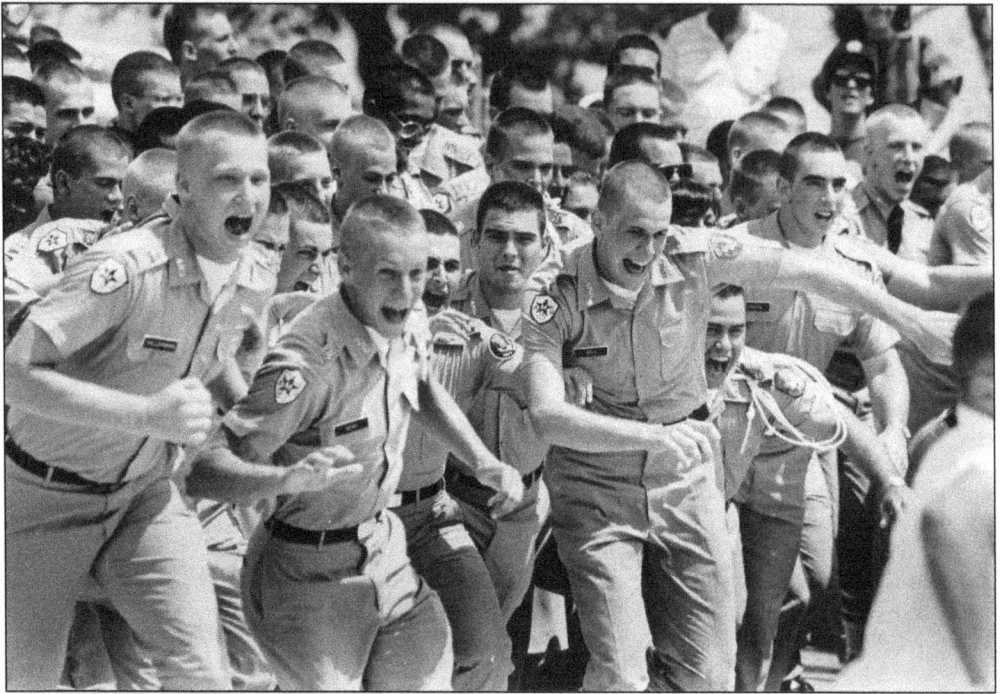

LET THE FISH GO! When the Aggies win a home football game, fish are "released" (given the go sign) to chase a yell leader, catch him, carry him to the "fish pond," and throw him in the water. Afterward, a yell practice is held. It is another Aggie tradition that dates way back.

BROOM MAN. An unidentified cadet sweeps out a passenger train that has stopped at College Station. A&M has a long tradition of students helping keep the community clean. Aggies founded the nation's biggest one-day community cleaning event known as The Big Event. The idea is for students to give something back to the surrounding community. (PH.)

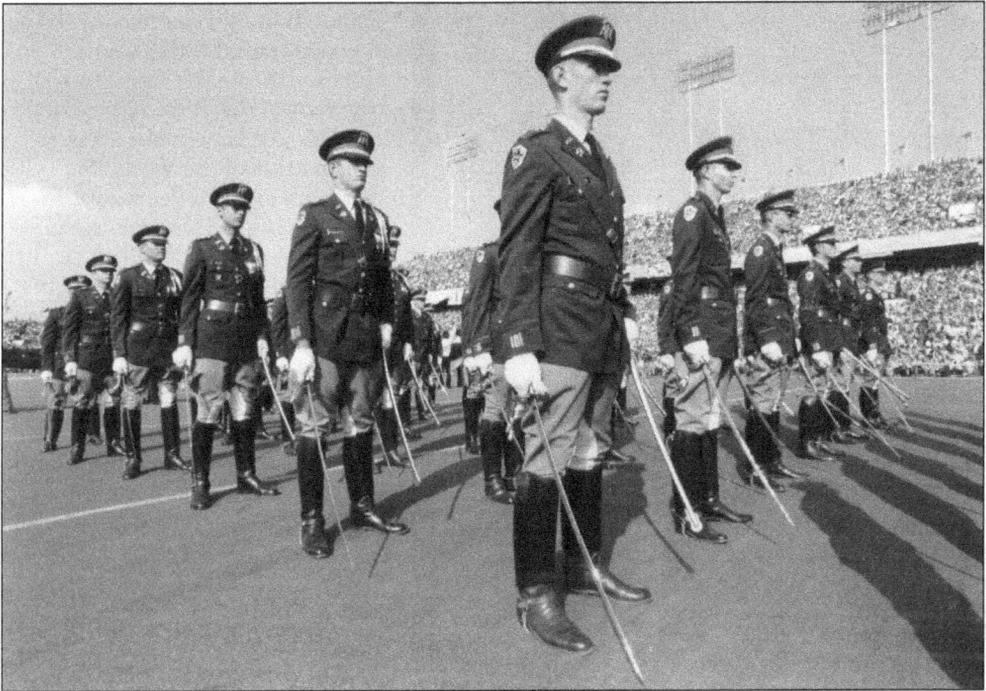

MARCH-IN, AGAIN. Here is another shot of the traditional march-in at Kyle Field before the game. Shown here are corps staff wearing the winter uniforms, which have been discontinued. Since they are wearing formal uniforms, this is probably the Thanksgiving Day game against archrival TU.

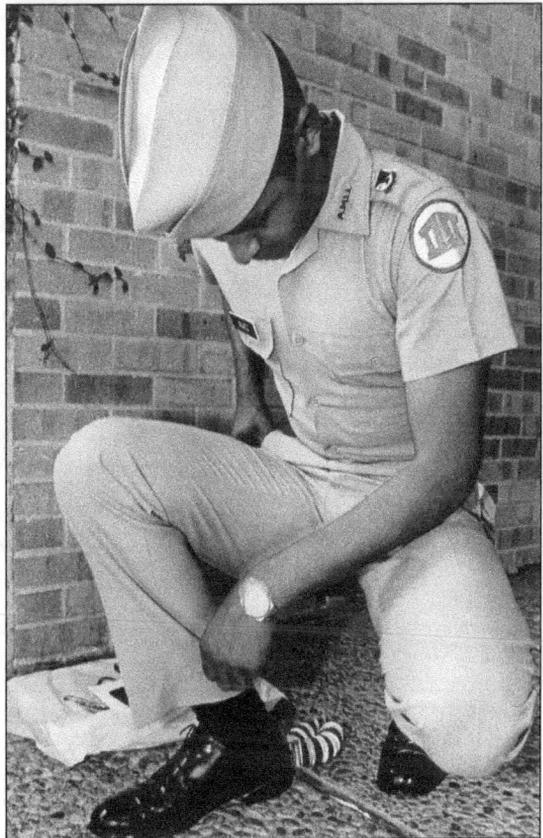

MINORITIES. Although Hispanics and other minorities have attended A&M since the 1870s, African American students joined in the 1960s, when the Rudder reforms opened the doors to all.

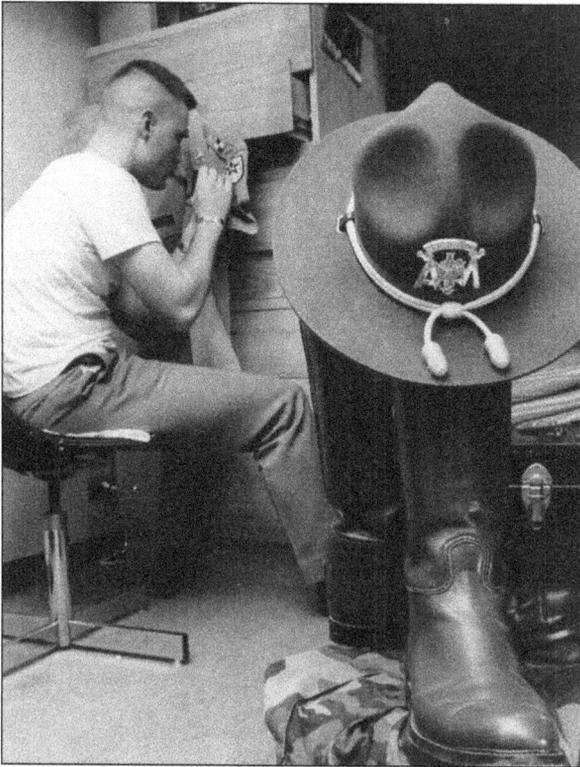

SENIOR BOOTS. The senior boots tradition started with Joseph Holick, a shoemaker from Austria who formed the Texas Aggie Band in 1894. The boots came about as an extension of the World War I doughboy uniform (leg wraps), as cadet seniors had the privilege of wearing cavalry boots. By the early 1900s, seniors wearing knee-high leather boots had become another tradition. The boots, custom-made for each senior cadet, are quite pricey. They were once handcrafted at Holick's Boot Shop at Northgate. Some seniors hand their boots down to juniors after Final Review in May.

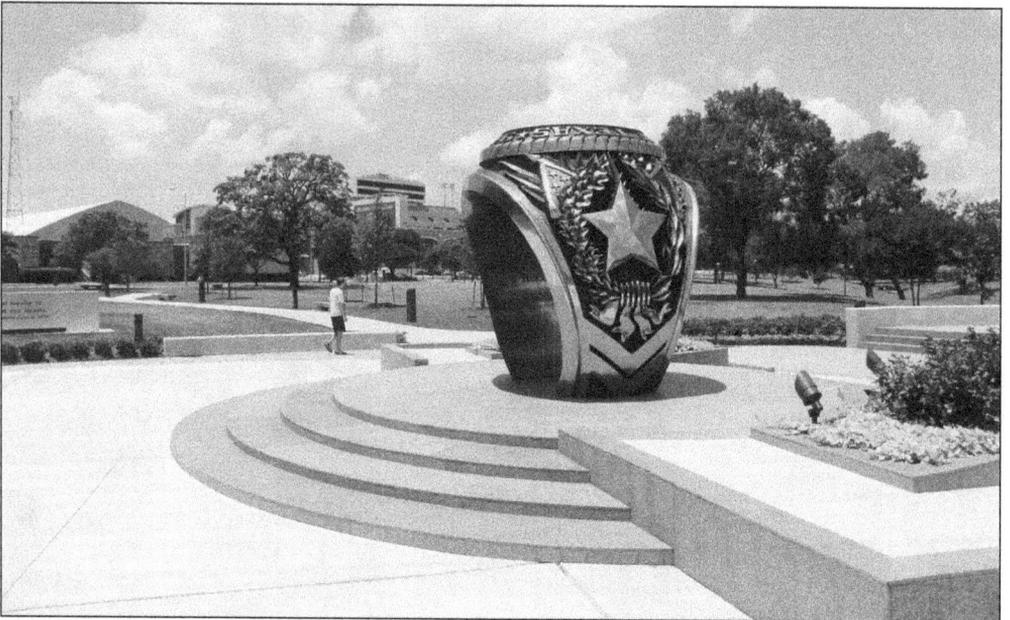

SENIOR RING. The ultimate aim of all Aggie students is to put on the famous ring at the beginning of their senior year. The tradition started in 1894 under Sul Ross. An Aggie ring must be turned around upon graduation so that the date faces outward and must be christened by dunking it—dropping it in a pitcher of beer at Northgate and chugging it (the beer, not the ring). (Photograph by Glenn D. Davis.)

46

Four

COLLEGE STATION INCORPORATES

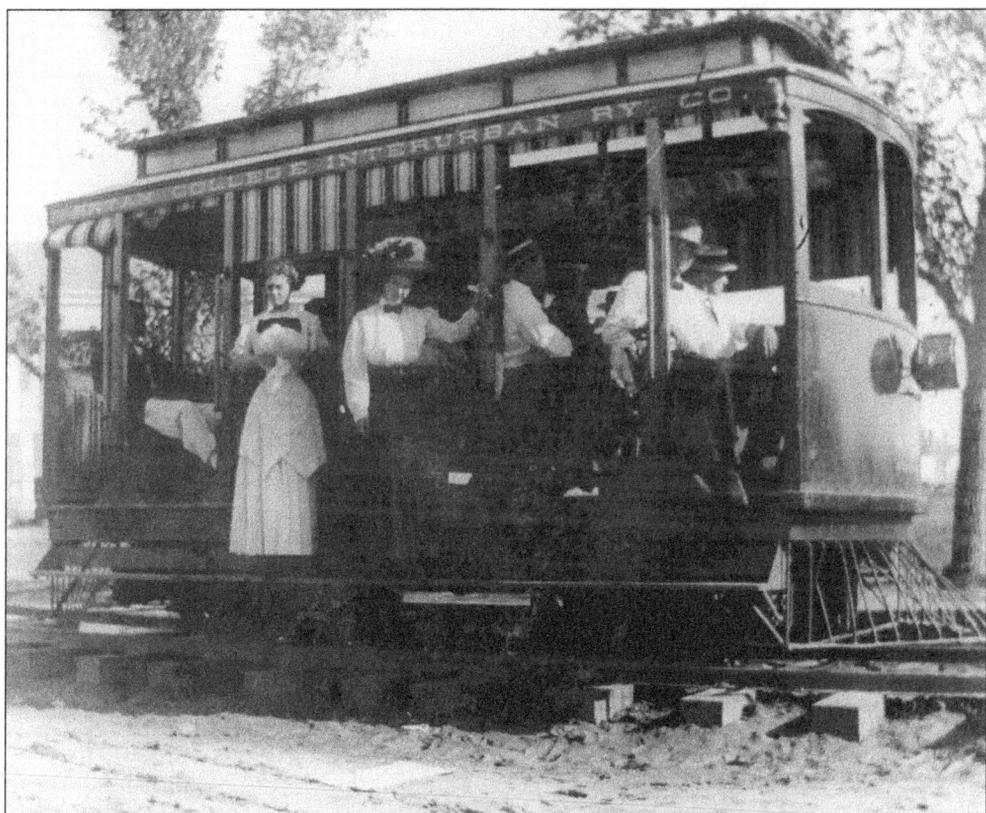

TROLLEY DAYS. Since many employees and students attending A&M College in the early 1900s actually lived miles away in Bryan and few had cars, a more modern transportation system was needed to replace bicycles. The Bryan College Interurban Railway Company was established in 1910 to connect the two cities. Daily service consisted of ten 30-minute trips with gasoline-powered trolleys, upgraded to electric models in 1915. Although the railway went out of business in 1922, it influenced economic development in both Bryan and College Station. It was often referred to as the "Toonerville Trolley," as riders had to sometimes get out and push. (PH.)

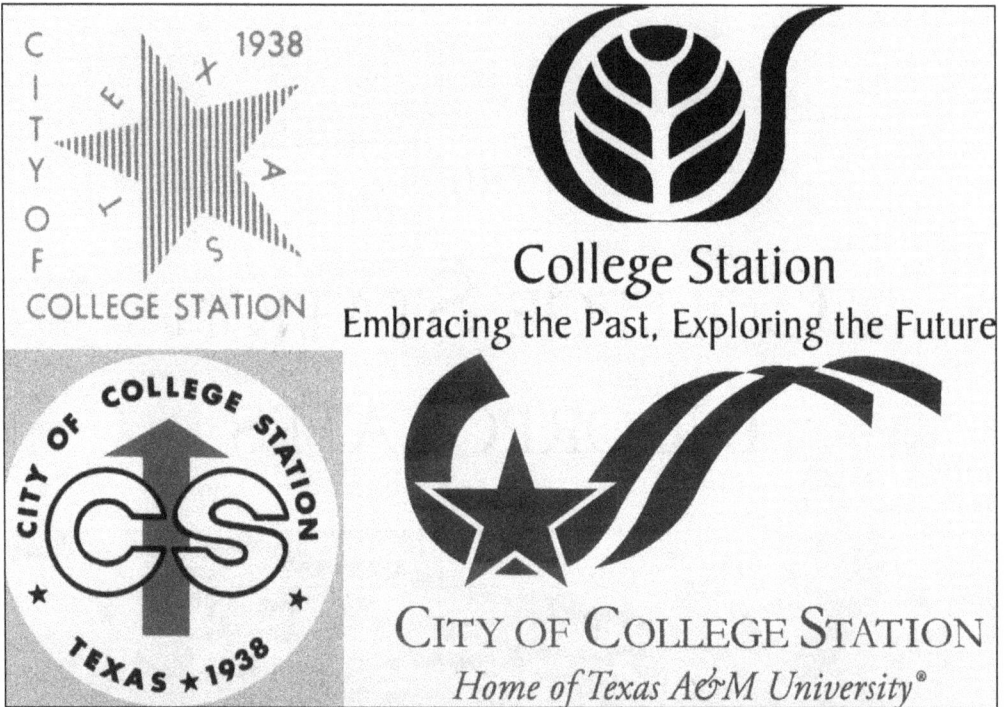

SEARCHING FOR IDENTITY. College Station finally incorporated in 1938, and its first official mark became known as the star logo (upper left). Over the years, the city has had four official logos. The arrow logo (lower left) was designed in 1970. The oak tree logo (upper right) followed some years later. The current logo (lower right), with a more modern look, was designed in 2004. The city paid Texas A&M dearly for the right to use the phrase "Home of Texas A&M University." Connections between the two have always run deep and, at times, have been inseparable. (PH.)

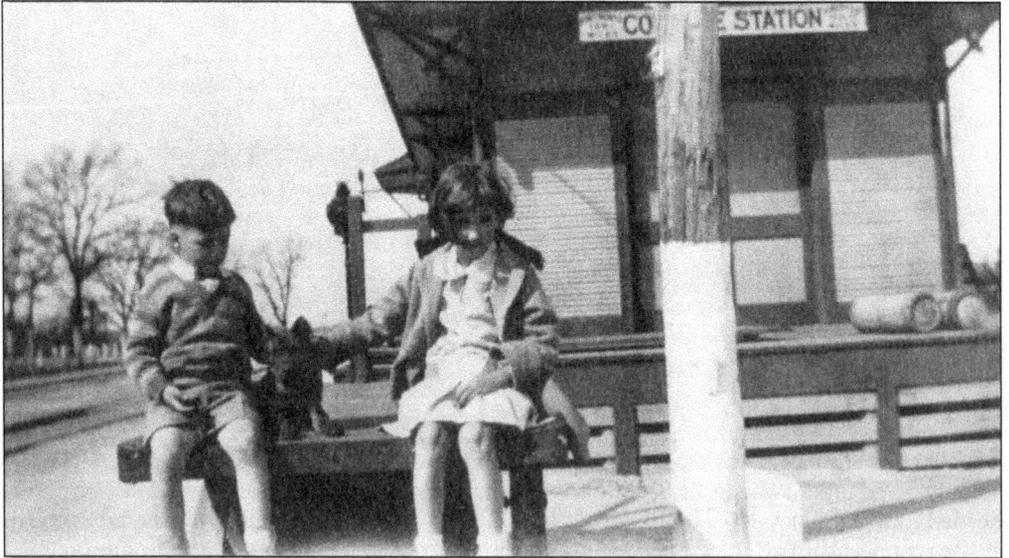

HANGING OUT. Charles "Sunny" Campbell, his sister Peggy, and their dog Lucky are seen at the College Station depot in the late 1920s. Both were "campus kids," born and schooled on the A&M campus. (PH.)

INCORPORATION. On October 19, 1938, residents voted 217 to 39 to incorporate College Station, a community that had existed for more than 60 years. Deborah Lynn Parks, in her thesis on this history, points out that "the designated polling place, the Southern Pacific depot, added a symbolic touch to the election since the city derived its name from that of a railroad station." John H. Binney was duly elected as College Station's first mayor, but only served in his post for a short time (1939–1940). He was injured in a car accident and died shortly thereafter. Rail service continued off and on, ending when the Amtrak service, the *Texas Eagle*, was discontinued on September 10, 1995. (PH.)

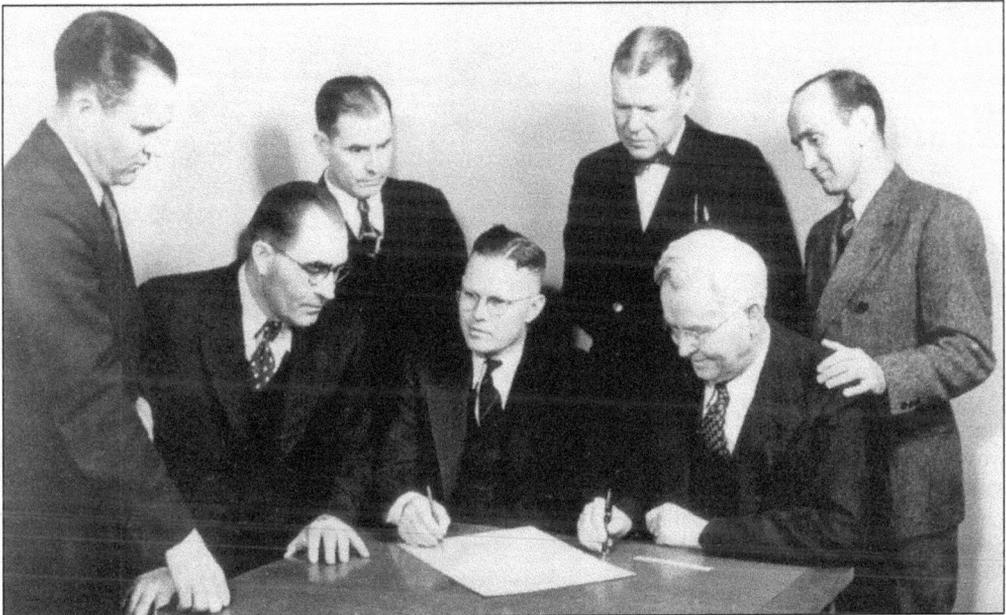

MEETING ON CAMPUS. The first College Station City Council held its inaugural meeting in the Chemistry Building on the A&M campus. Members, from left to right, are (first row) John S. Hopper, Dr. Letcher P. Gabbard, Dr. John H. Binney, and Alva Mitchell; (second row) George W. Wilcox, Ernest Langford, and Luther G. Jones. All were members of the Texas A&M College faculty and staff. (PH.)

STRONG LEADER. College Station was starting to expand, and concerned residents called for a strong leader. The mayor elected to succeed Binney was Frank Anderson, A&M's track coach, who had studied under legendary football coach Dana X. Bible. Anderson was a fiscal conservative and promised "ham sandwich trees and lemonade springs." Anderson retired to go fight in World War II, despite being 52 years old at the time (1942). (PH.)

SOLID FOUNDATION. Anderson had laid a solid foundation for Ernest Langford, his replacement, who was an architect, archivist, and scholar. During Langford's long tenure of 24 years as mayor, College Station enjoyed unprecedented economic growth as returning soldiers, sailors, and airmen from the Second World War used the G.I. Bill to get an education at Texas A&M College. College Station was rapidly making the transition from town to full-fledged city. (PH.)

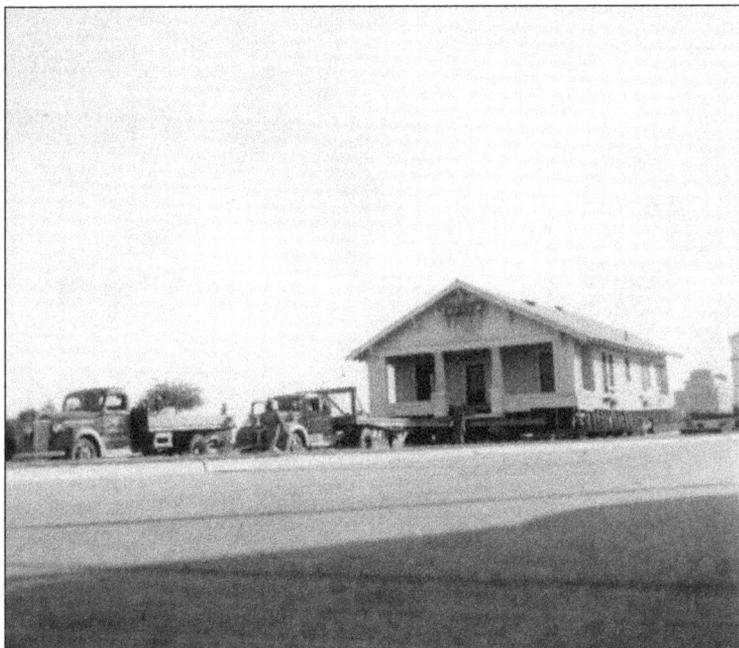

CAMPUS HOUSES. In the early 1930s, as the campus began to grow, campus houses being built for faculty and staff were ordered off campus. This was the beginning of the neighborhoods that still surround the campus. Many of these homes have been awarded local historical markers.

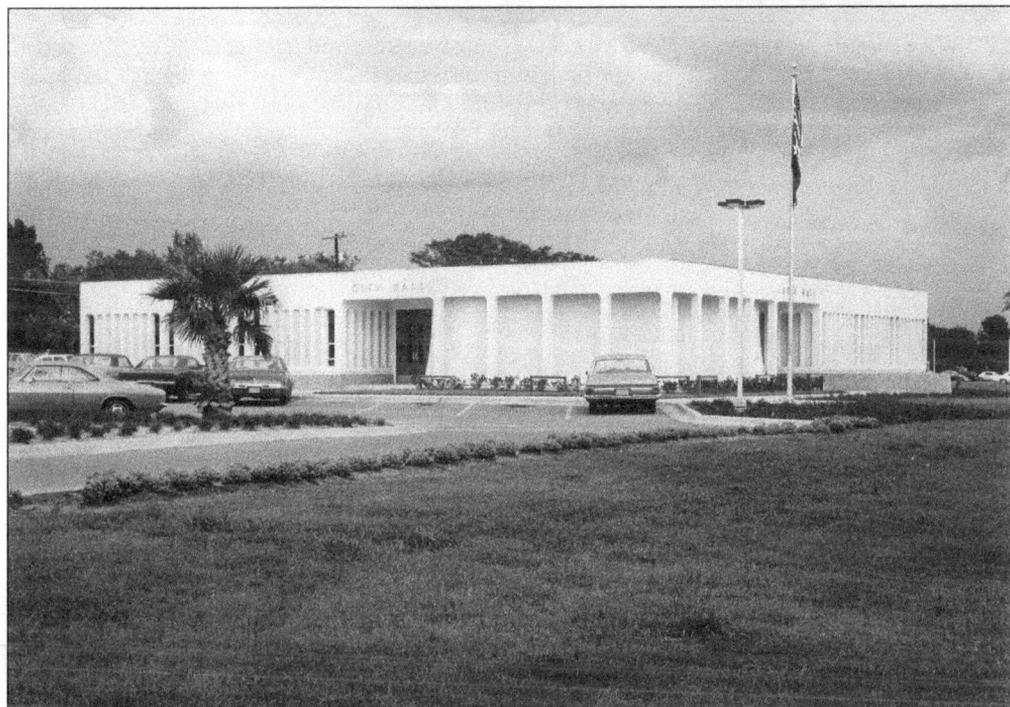

MOVING OFF CAMPUS. City council meetings moved off campus to an office above the camera shop in Northgate, from there to Southside buildings, and then to the first building dedicated as a city hall. Now this structure is Café Eccell in Northgate and still bears the city's historical designation (although it is repeatedly stolen). Finally, the city got its second building on Texas Avenue, shown here in its first incarnation, opening in April 1969. College Station's first fire department building was constructed next door in the following year. (PH.)

51

PRIVACY AT LAST. To block the view of gawkers from the street and to offer some other forms of privacy, College Station constructed the pink wall that bears the city's name in large letters easily visible from Texas Avenue. The wall runs north and south in front of the building. (PH.)

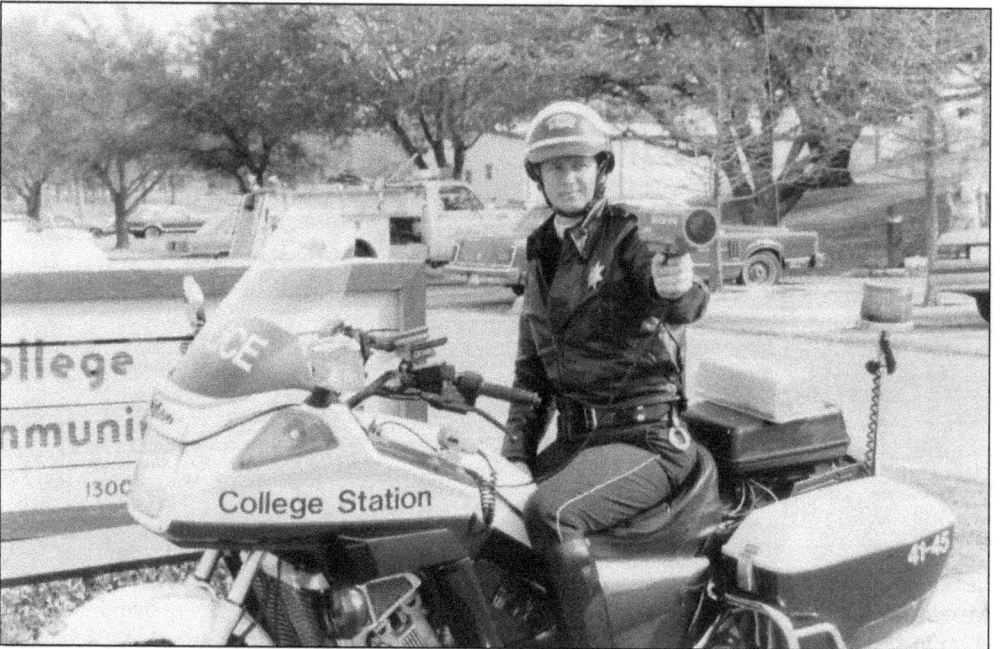

RADAR GUNS. Since so much of College Station's population consists of college students, who like to drive fast, the city's police force spends a large amount of time with its radar guns tracking those breaking speed limits. The city also had stoplight cameras at intersections until a referendum in 2010 removed them. (PH.)

Five

AGGIES GO TO WAR

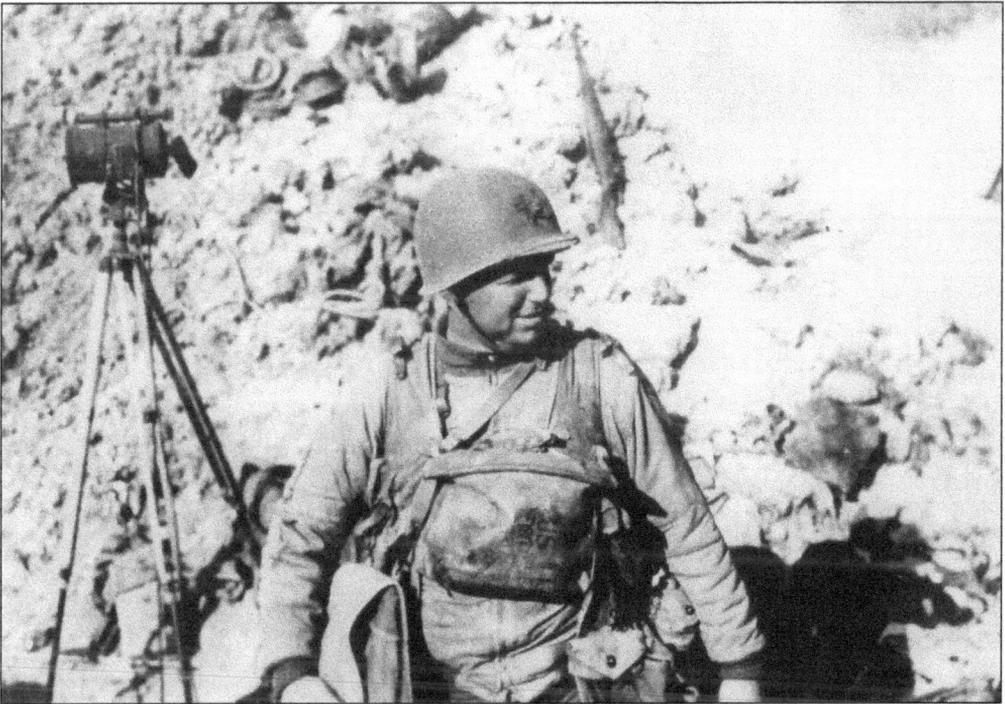

RUDDER AT NORMANDY. Lt. Col. James Earl Rudder was in charge of the 2nd Ranger Battalion scaling the cliffs at Normandy on D-day in World War II to eliminate the German 155-millimeter battery shelling U.S. troops landing on Omaha and Utah beaches. Rudder was wounded as he and his men managed to knock out the big guns and save many American lives. A&M produced 20,229 combat troops for World War II; 14,123 Aggies served as officers, more than any other school, including West Point, and 29 reached the rank of general. A signaling instrument stands to Rudder's left.

AGGIE WAR HYMN. James V. "Pinky" Wilson, an Aggie who served in World War I on the Rhine River in Germany, penned the words to a song he called "Goodbye to Texas University" that would eventually become known as the "Aggie War Hymn." An early version was the following: "Hullabaloo, Caneck! Caneck! / Hullabaloo, Caneck! Caneck! / Good-bye to Texas University, / So long to the Orange and White. / Good luck to the dear old Texas Aggies, / They are the boys that show the real old fight, / The eyes of Texas are upon you, / That is the song they sing so well. / So good-bye to Texas University, / We are going to beat you all to . . . / Chig-ga-roo-gar-rem! / Chig-ga-roo-gar-rem! / Rough! Rough! / Real Stuff! / Texas A&M!"

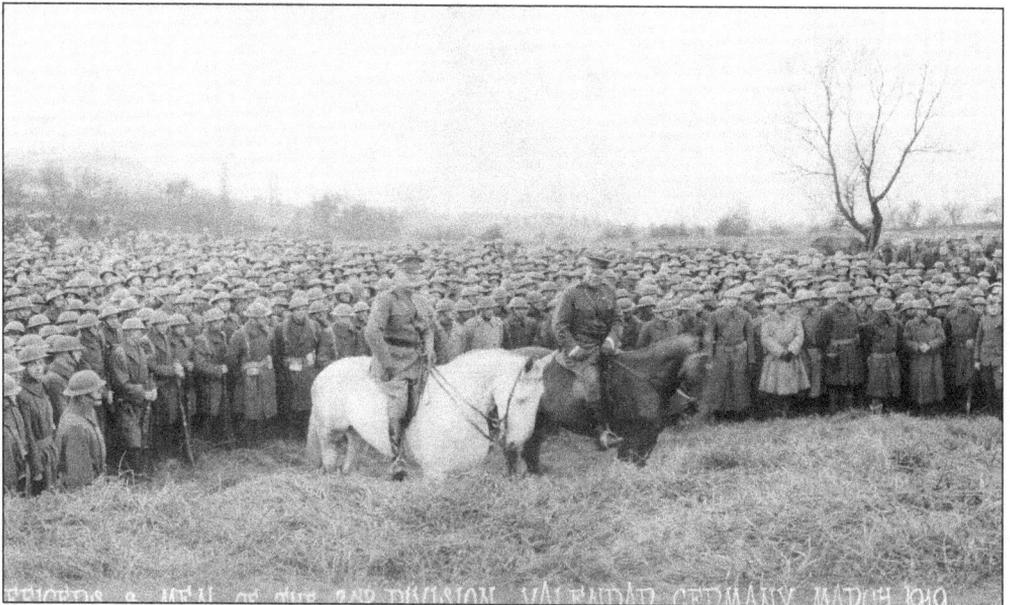

PERSHING IN FRANCE. Other Aggies served in the First World War in France with Gen. John "Black Jack" Pershing. Texas Aggies fighting in Pershing's armies in Europe included names such as Ball, Ashton, Perrine, Easterwood (the airport namesake), and Jouine.

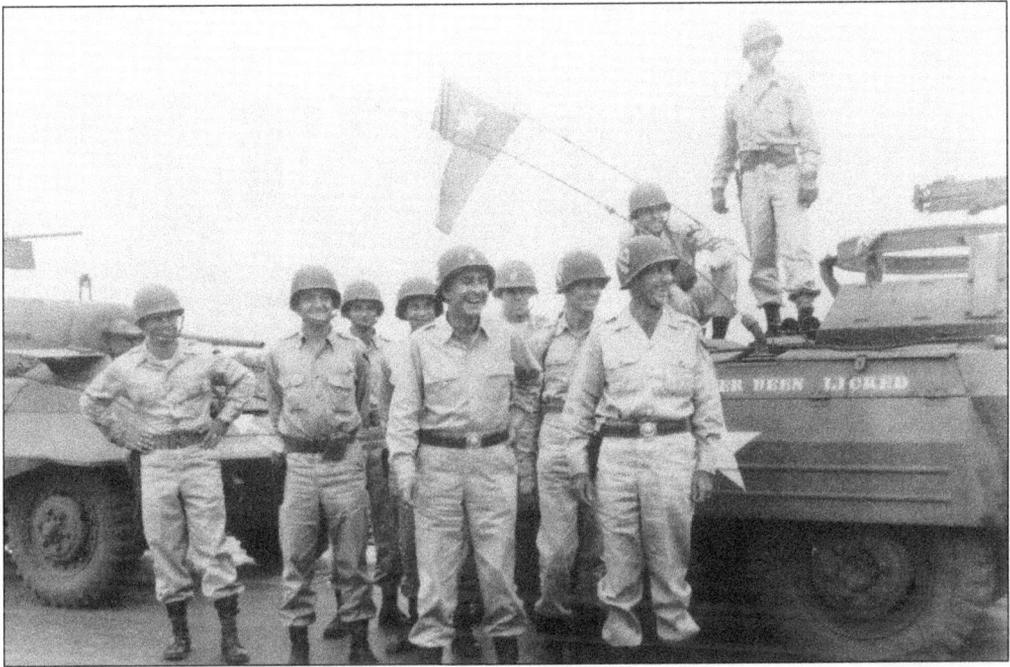

IN TOKYO. At the end of World War II, the Japanese surrendered on August 15, 1945. Allies entered the capital, and Aggies were among them. Shown here is a group of Ags flying the flags of Texas and Texas A&M. "We've Never Been Licked" is written on the side of the tank as a reference to the wartime movie about the college.

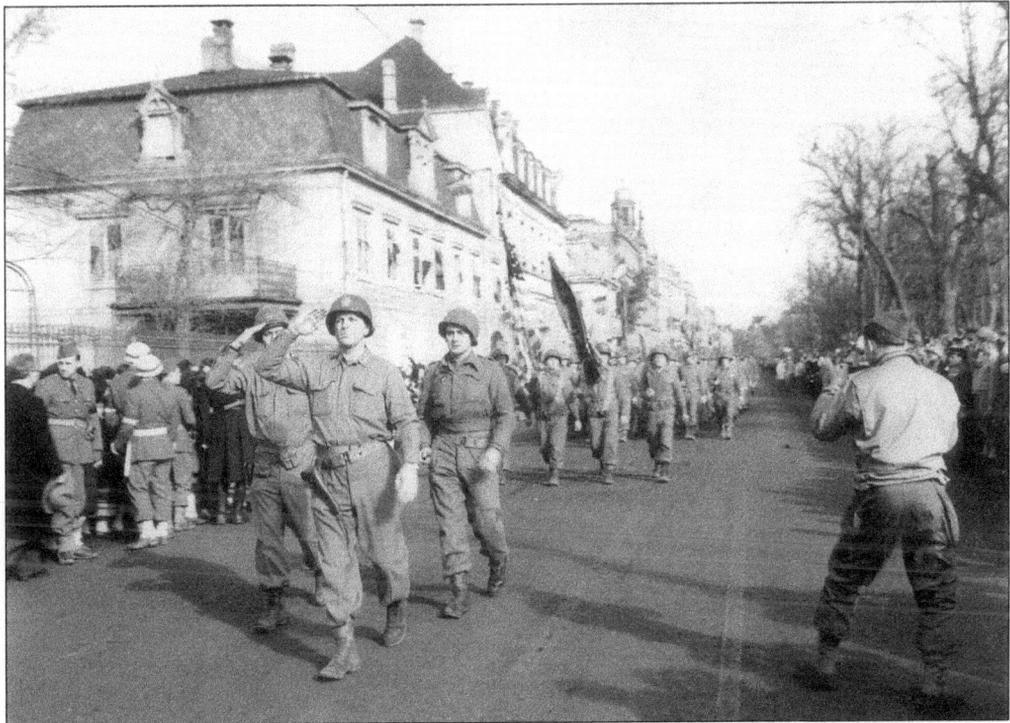

A SOLDIER TRIUMPHANT. Lt. Col. Earl Rudder victoriously leads his men into France in 1945.

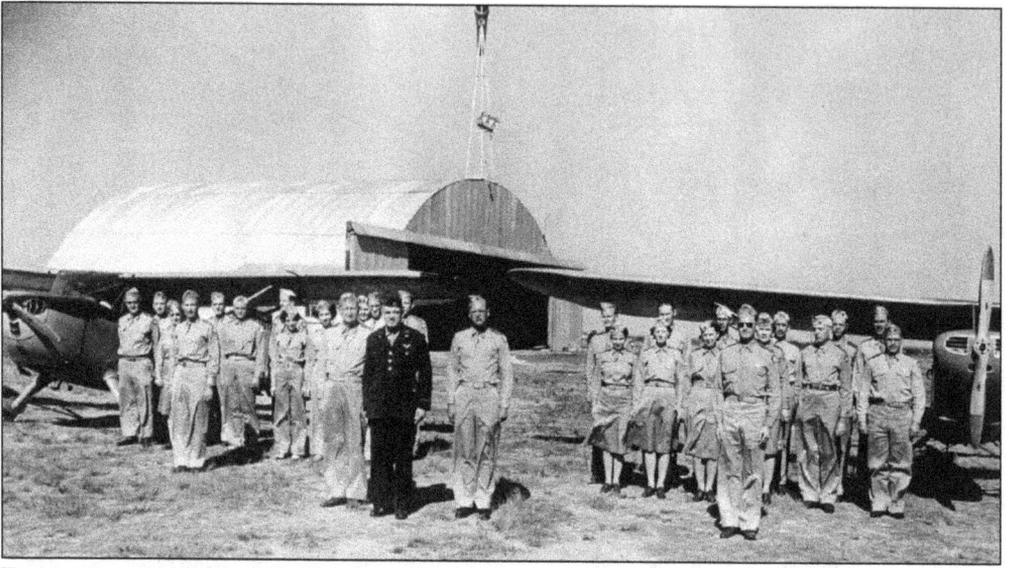

EASTERWOOD AIRPORT. The Civil Air Patrol operated at the local airport named after World War I pilot Jesse Easterwood. Shown here are members of the CAP based at Easterwood during the Second World War. (PH.)

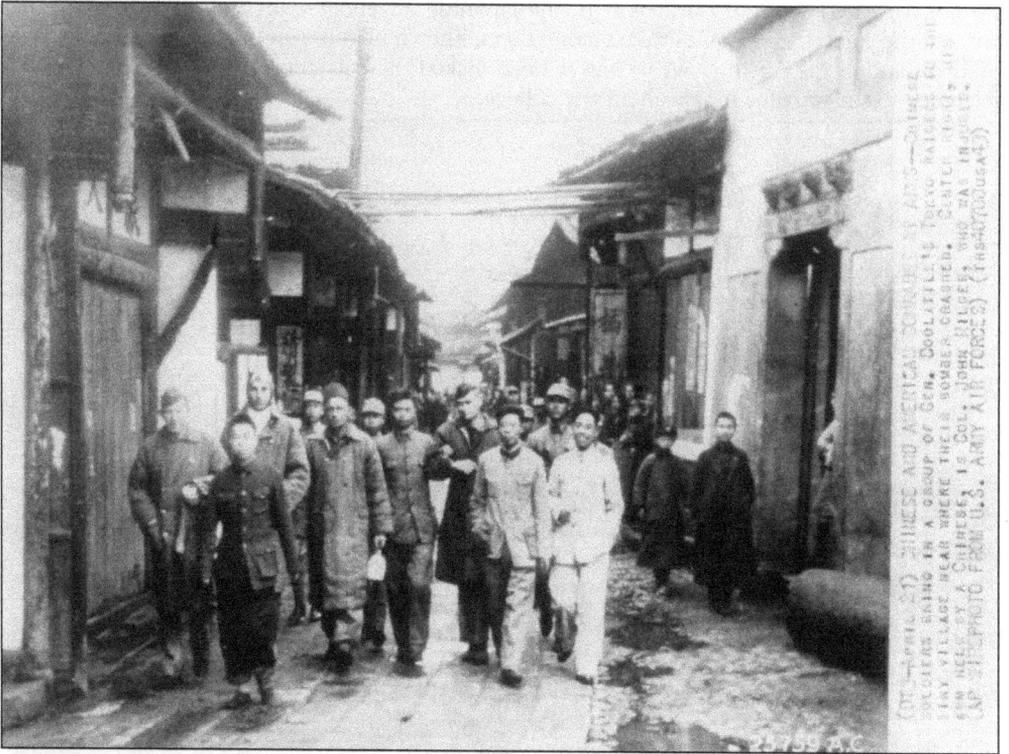

DOOLITTLE. In April 1942, U.S. planes flew over Tokyo in a daring raid on Japan's capital city. Lt. Col. Jimmy Doolittle led the attack, later crash-landing in China. Picked up by sympathetic Nationalist Chinese, his crew was paraded down the streets as heroes. Doolittle's second in command was Maj. John Hilger (arms locked with unidentified Chinese), an Aggie.

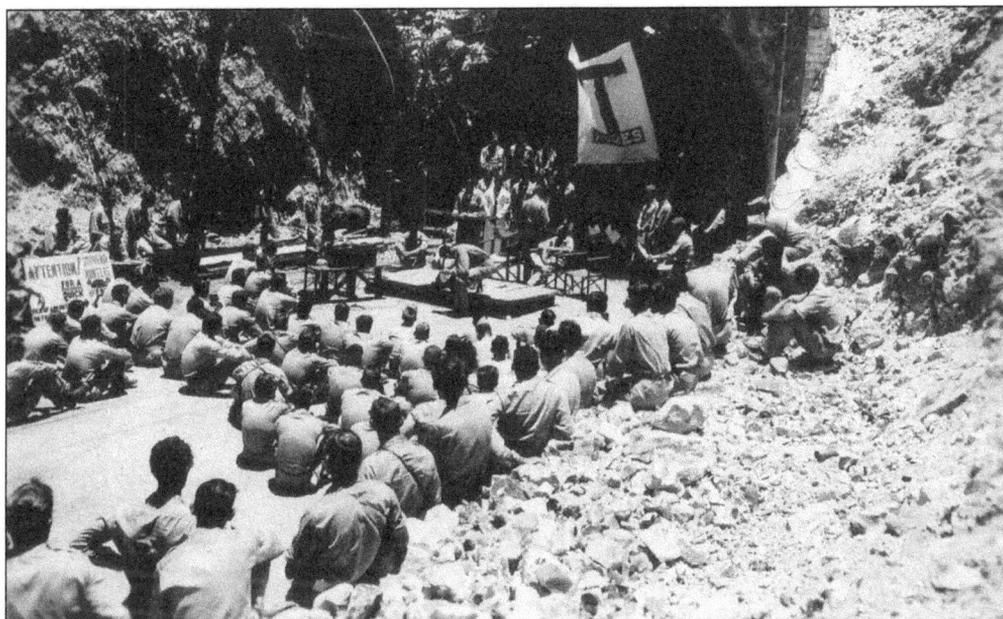

CORREGIDOR. Aggies muster every April 21 in remembrance of the Battle of San Jacinto, when Texas won its independence from Mexico. On that day in 1942, Aggies assembled on Corregidor just weeks before the Japanese took "the rock" on May 6. Most of the Aggies at the battle site died defending the island. The homemade flag seen here is on display in the The Association of Former Students Building.

HAWAII. Since many U.S. servicemen returning from World War II battlegrounds could not go straight home due to lack of space aboard ships, they got "stuck" in places like Hawaii for several months. Here Aggies muster at Fort Shafter, in Honolulu, in April 1946.

57

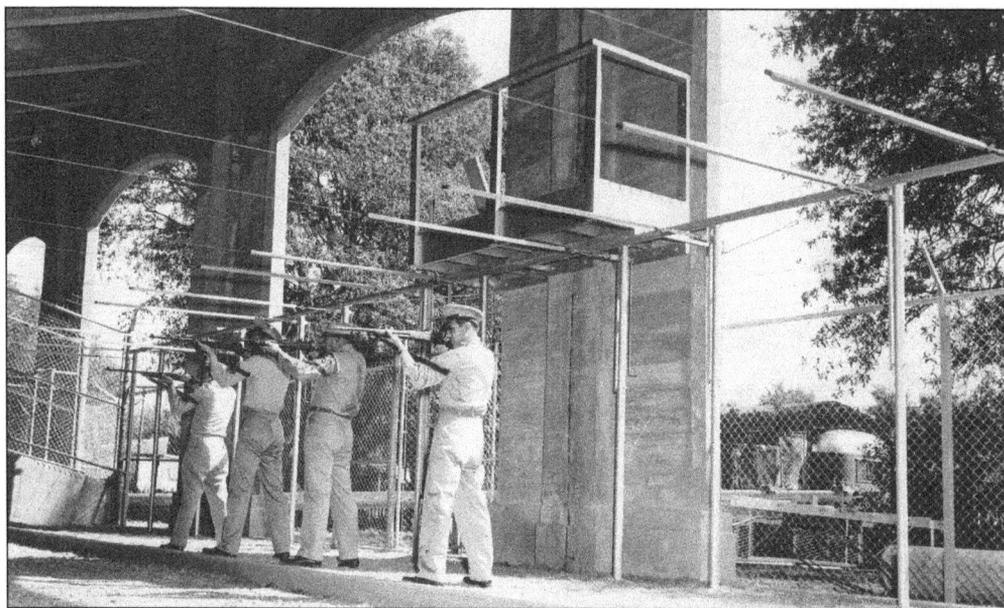

Firing Range. Cadets practice their marksmanship at the firing range under the east stands of Kyle Field next to G. Rollie White Coliseum. Archery was also practiced here. Local children used to cling to the fence and watch in the afternoons after school. Safety was not always a concern. Much to the parents' relief, the range was closed with the additions to the stadium. (PH.)

War Rations. Unlike in today's wars, the entire home front was asked to sacrifice for the World War II effort. Staples such as gasoline, coffee, sugar, flour, beef, and clothing were rationed. Stamps from ration books were redeemed for these items. This book belonged to Fred Brison, an interim mayor for College Station in 1971. (PH.)

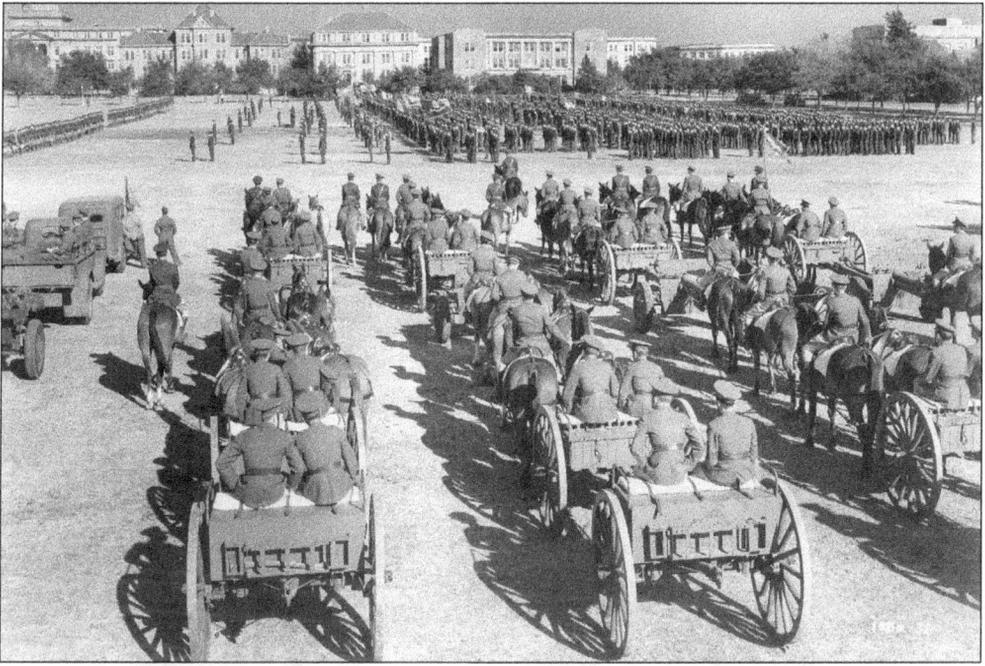

AGGIE FILM. Even Hollywood went to war making films to promote patriotism for the war effort. Richard Quine, Anne Gwynne, and Noah Beery Jr. starred in this camp classic *We've Never Been Licked*, filmed on campus in 1943. Robert Mitchum refers to this movie as the first and the worst movie he ever made. Considered corny by today's standards, the film is almost required viewing by incoming freshmen at A&M. (SC.)

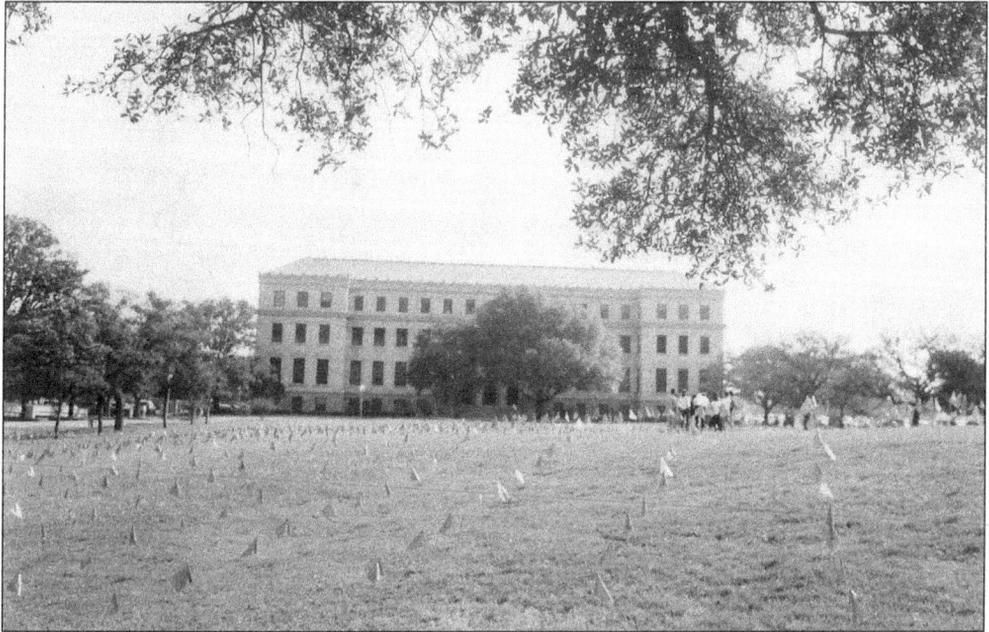

SEPTEMBER 11 FLAGS. The dedication of the Freedom from Terrorism Memorial on September 11, 2009, included a display of American flags—one for each casualty of the attacks on New York City, the Pentagon, and the downed United Airlines Flight 93.

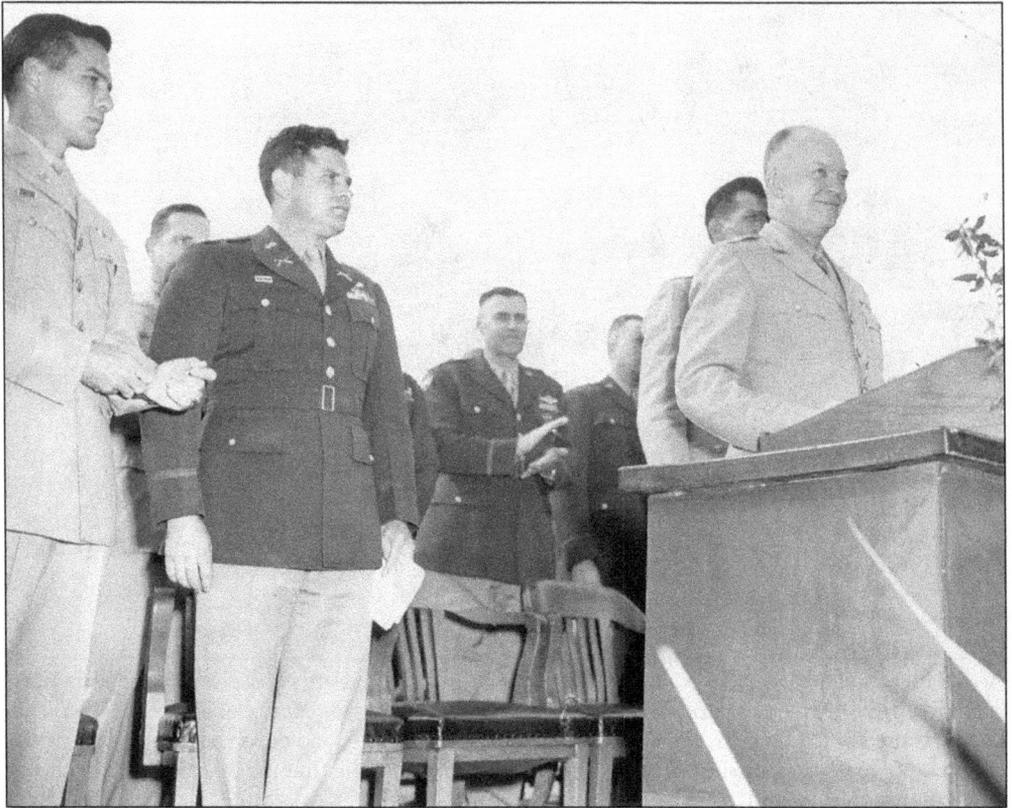

A GENERAL SPEAKS. Gen. Dwight D. Eisenhower (right), commander of Allied troops in the D-day invasion of World War II, speaks to a muster of the corps at Kyle Field on Easter morning in 1946. Army Lt. Col. Thomas Dooley, the Aggie who told the world about the Corregidor Muster, stands to the left of Eisenhower.

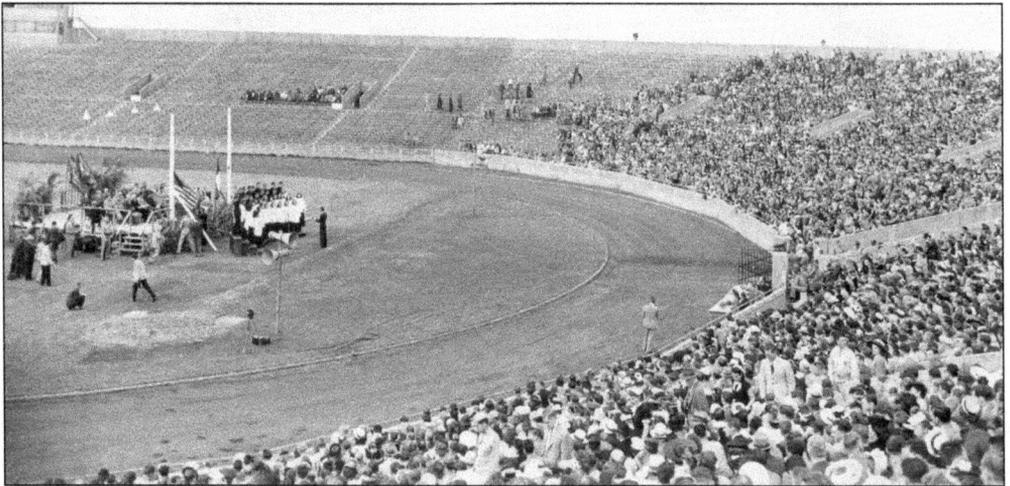

GOOD TURNOUT. Over 15,000 Aggies gathered at Kyle Field to hear Eisenhower's speech. Dooley also presented the Muster Tradition and conducted a World War II Roll Call. To represent the 900 Aggies who died in the war, the names of the four deceased Aggie World War II Medal of Honor recipients were called.

JAPANESE HORSE. George P. Munson Jr., class of 1928, sits astride a captured Japanese pony beside his World War II plane, aptly named *The Texas Aggie*. Munson commanded the 843rd Engineer Aviation Battalion, which he led in the Normandy invasion on D-day +10. He also participated in the liberation of Paris and the occupation of Berlin. (SC.)

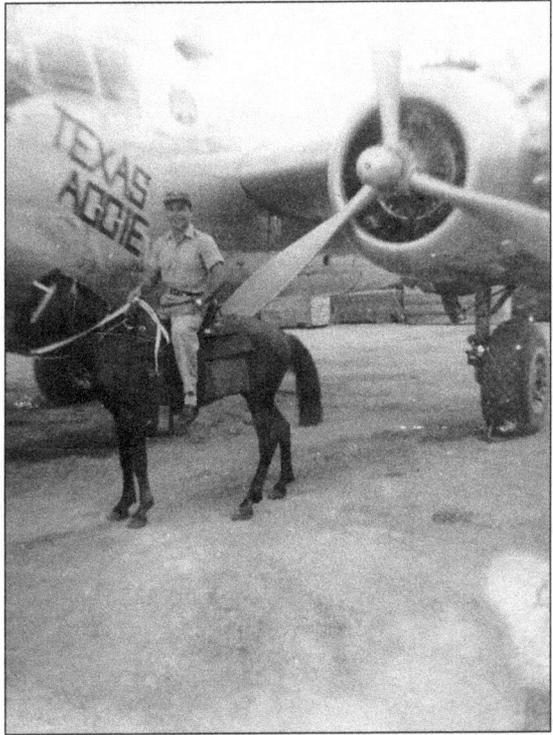

JEEP JUMPER. Graham Purcell, class of 1941, jumps a jeep at the Pittsburgh, Pennsylvania, fairgrounds during an Army War Show. A *Collier's* magazine reporter dared the Aggie to jump the jeep on August 15, 1942. Purcell went on to serve as a district judge and as a Texas state representative. (SC.)

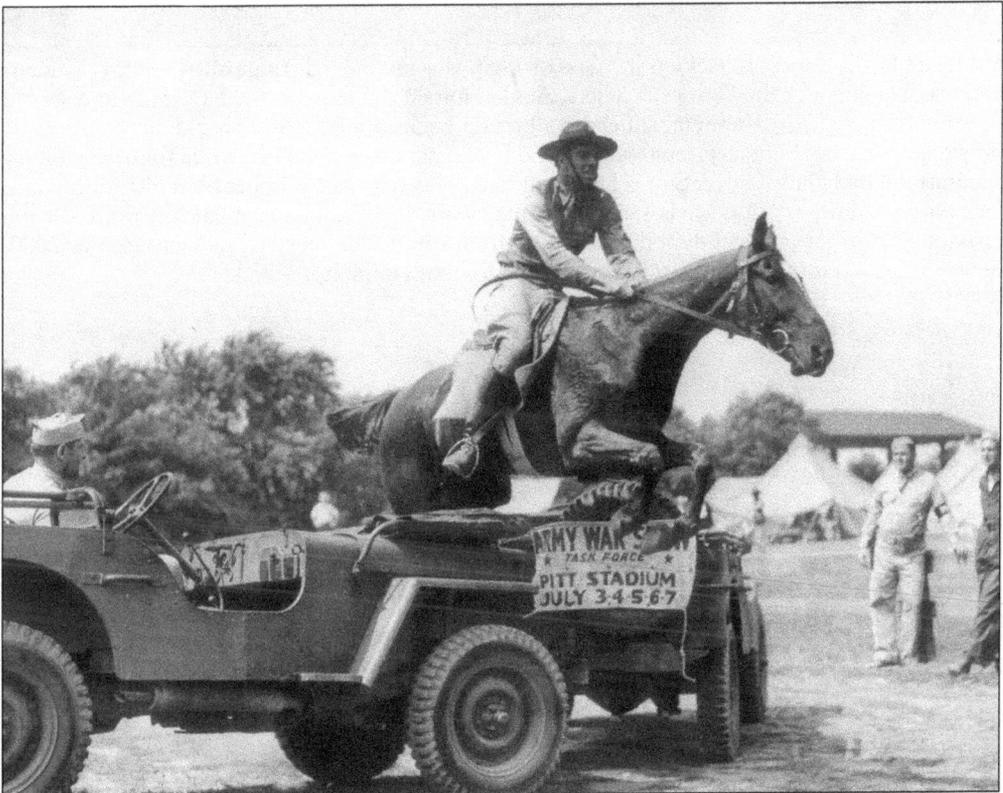

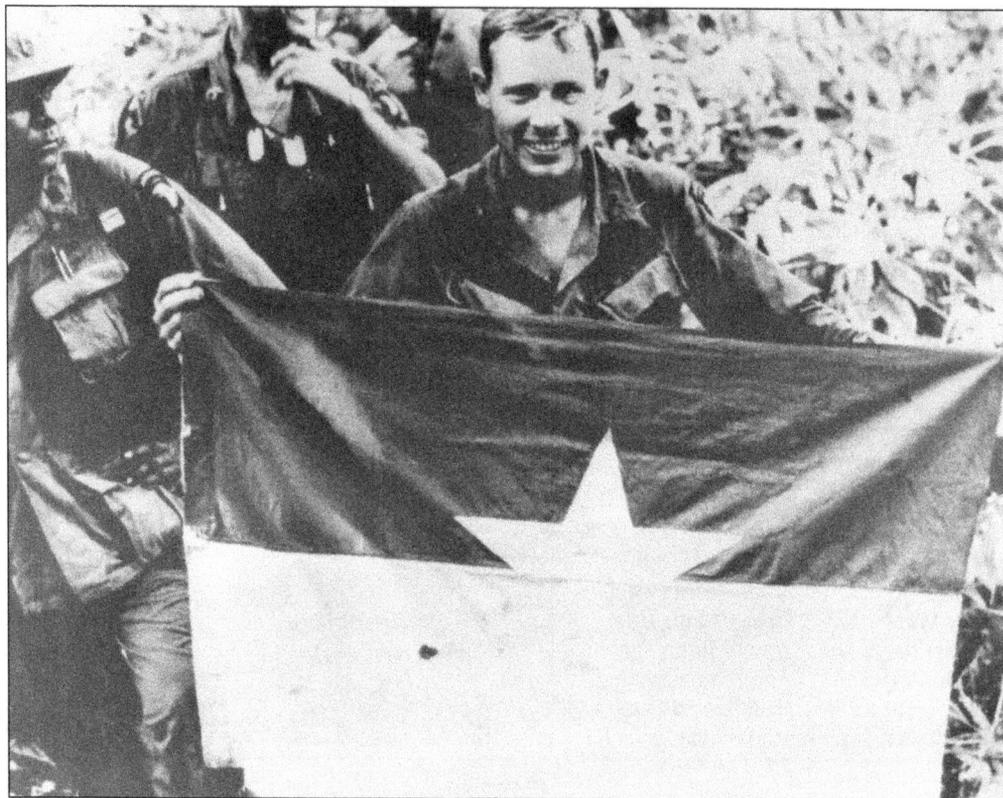

VIETNAM WAR. Robert L. Acklen Jr., class of 1963, was named a distinguished military student and was a member of the Corps of Cadets. Acklen joined the army in the late 1960s and served 32 straight months in Vietnam, suffering a broken back in a helicopter accident. Acklen not only recovered, but his exceptional service and heroic actions earned him more than 60 military decorations, including a Silver Star, a Distinguished Flying Cross, six Bronze Stars, 40 Air Medals, four Army Commendation Medals, and a Purple Heart. In 1978, he was medically retired at the rank of captain for physical disability resulting from injuries he received in Vietnam. In 2000, he was inducted into Texas A&M's Corps of Cadets Hall of Honor. (SC.)

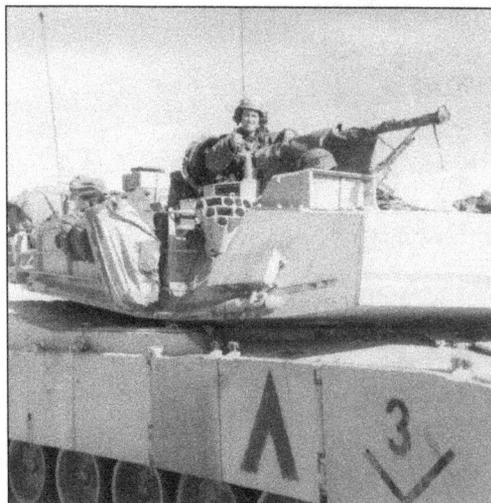

GULF WAR. Michael Kelley is a U.S. Army veteran officer who served on active duty from 1990 to 1992 during Operation Desert Storm. He later served in the Texas Army National Guard as a battalion staff officer, tank company commander, and senior instructor of the Officer Candidate School. Kelley, class of 1989, holds a bachelor's degree from Texas A&M University and a master's of public affairs from the University of Texas at Austin's LBJ School of Public Affairs. (SC.)

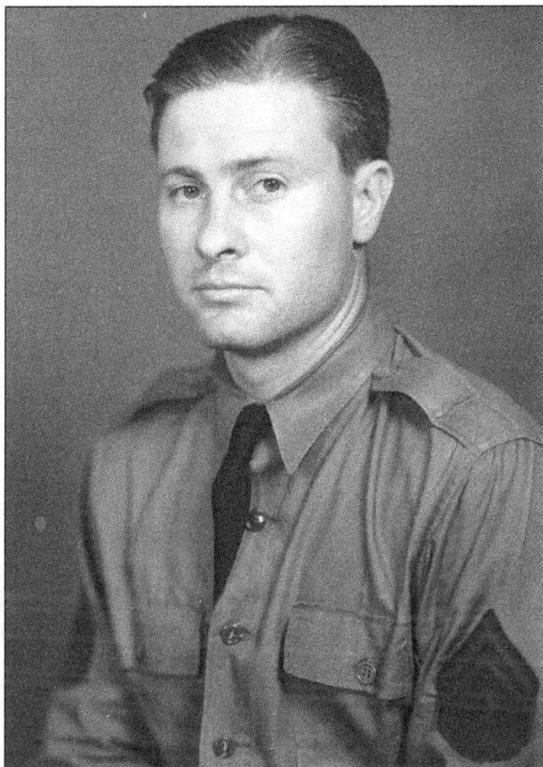

CARSWELL, WORLD WAR II MEDAL OF HONOR RECIPIENT. During World War II, seven Aggies were awarded the Congressional Medal of Honor. Maj. Horace S. Carswell piloted a B-24 in a one-lane attack on a Japanese convoy in October 1944. After being shot up, Carswell managed to fly the plane to the China shore, where all but one of the crew jumped to safety. The plane then struck a mountainside and burned. (SC.)

FOWLER, WORLD WAR II MEDAL OF HONOR RECIPIENT. Lt. Thomas W. Fowler was killed in action at Cassino, Italy, in May 1944, while trying to save the lives of those wounded when an American tank was set afire. He ran directly into the fire and was killed. (SC.)

63

HARRELL, WORLD WAR II MEDAL OF HONOR RECIPIENT. In March 1945, Marine Sgt. William G. Harrell was on watch when the Japanese launched a dawn attack on Iwo Jima. Harrell responded with a one-man counterattack, killing a dozen of the enemy. A missile blew off his left hand, but he kept on fighting. (SC.)

HUGHES, WORLD WAR II MEDAL OF HONOR RECIPIENT. The first Aggie in World War II to receive the Medal of Honor was 2nd Lt. Lloyd Hughes. In August 1943, Hughes piloted his B-24 bomber over Romania, took direct hits, and dropped his bombs on target. He then made a crash-landing in which he died. Hughes was awarded the medal posthumously. (SC.)

KEATHLEY, WORLD WAR II MEDAL OF HONOR RECIPIENT. Staff Sgt. George D. Keathley was wounded in September 1944 near Mount Altuzzo, Italy, but went to the aid of two platoons under heavy small arms and mortar fire. He shouted orders and inspired the men to keep fighting, routing the enemy. Keathly died a few minutes later. (SC.)

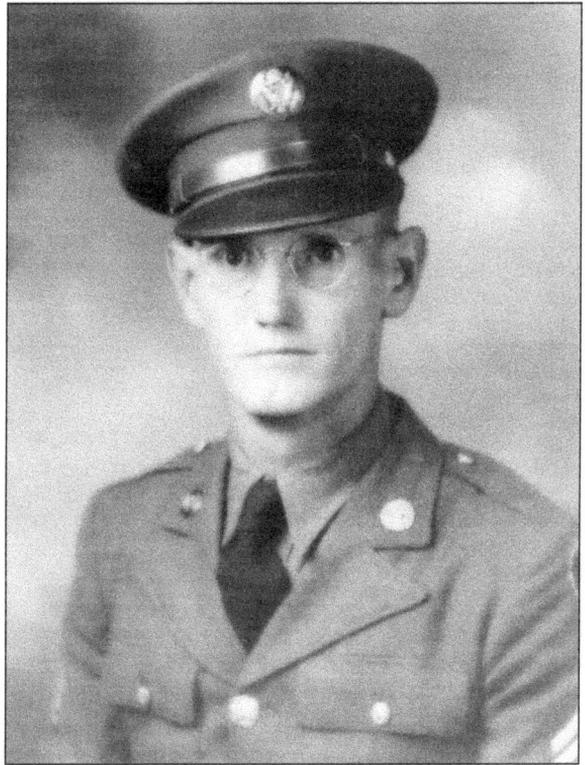

LEONARD, WORLD WAR II MEDAL OF HONOR RECIPIENT. Lt. Turney W. Leonard was wounded in action in Kommerscheidt, Germany, in November 1944. He advanced alone in the battle, eliminating an enemy emplacement with a grenade. His superb courage enabled American forces to hold off the enemy attack, but he was captured after a high-explosive shell shattered his arm. (SC.)

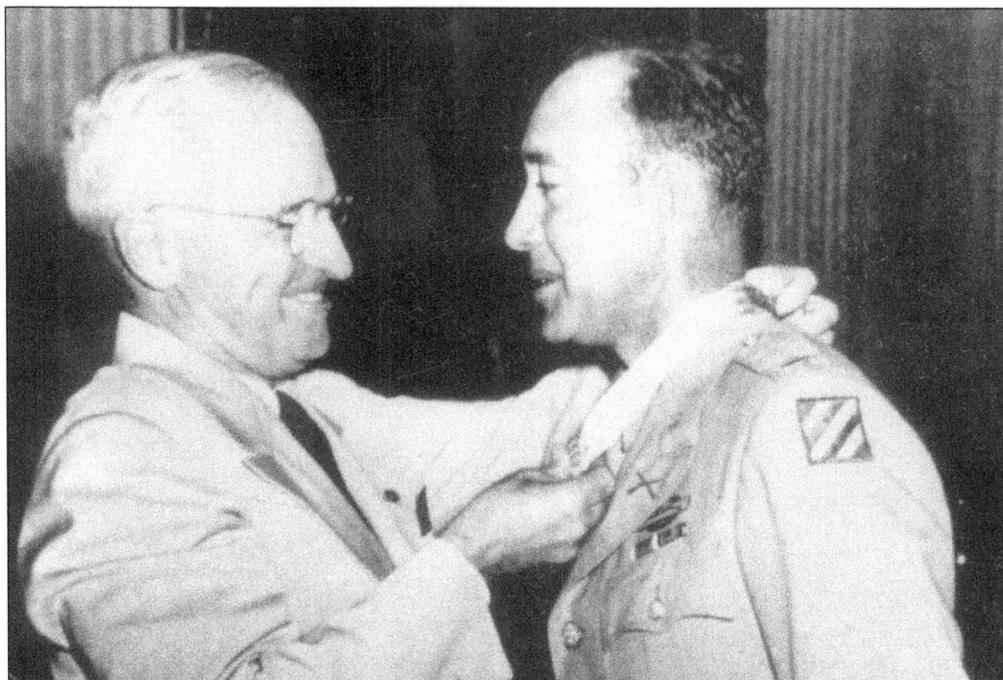

WHITELY, WORLD WAR II MEDAL OF HONOR RECIPIENT. Lt. Eli Whitely assumed command of his unit when the company commander was severely wounded in December 1944 at Sigolsheim, France. Whitely led a dawn attack and managed to kill or capture two dozen Germans. He was awarded the Medal of Honor by Pres. Harry S. Truman. (SC.)

AN AGGIE RING RETURNED. Lt. Turney Leonard lost his Aggie ring in December 1944, but it was returned to College Station 57 years later by German Lt. Volker Lossner (right), the son-in-law of German soldier Alfred Hutmacher, who had found Leonard's ring on the battlefield. Accepting the ring is Douglas Leonard (left), Leonard's only surviving sibling. The ring is now on display in the Sanders Corps of Cadets Center. Lossner's son hopes to enter A&M as a student in the near future. (SC.)

Six

College Station Expands Postwar

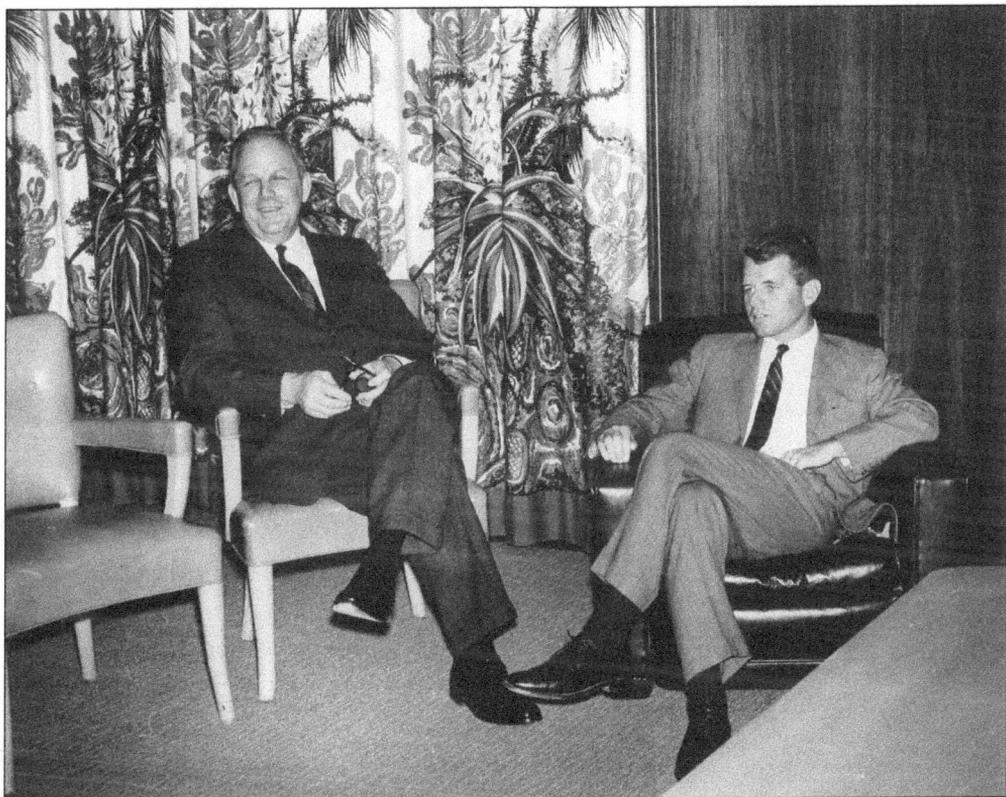

A Hero's Return. James Earl Rudder, the World War II hero who scaled the cliffs at Pointe du Hoc (Normandy), became president of Texas A&M in March 1960. He was the right man for the job. Rudder restructured, revitalized, and revolutionized A&M by making the corps voluntary, allowing coeducation, and integrating the campus. In 1963, the 58th Legislature of Texas approved Rudder's reforms and officially changed the school's name to Texas A&M University, specifying the A&M as purely symbolic. Pictured here, Earl Rudder, then vice president of A&M, met with Robert F. Kennedy in November 1959. Rudder was to meet a number of dignitaries, including Kennedy, especially after opening the former all-male college to women and minorities.

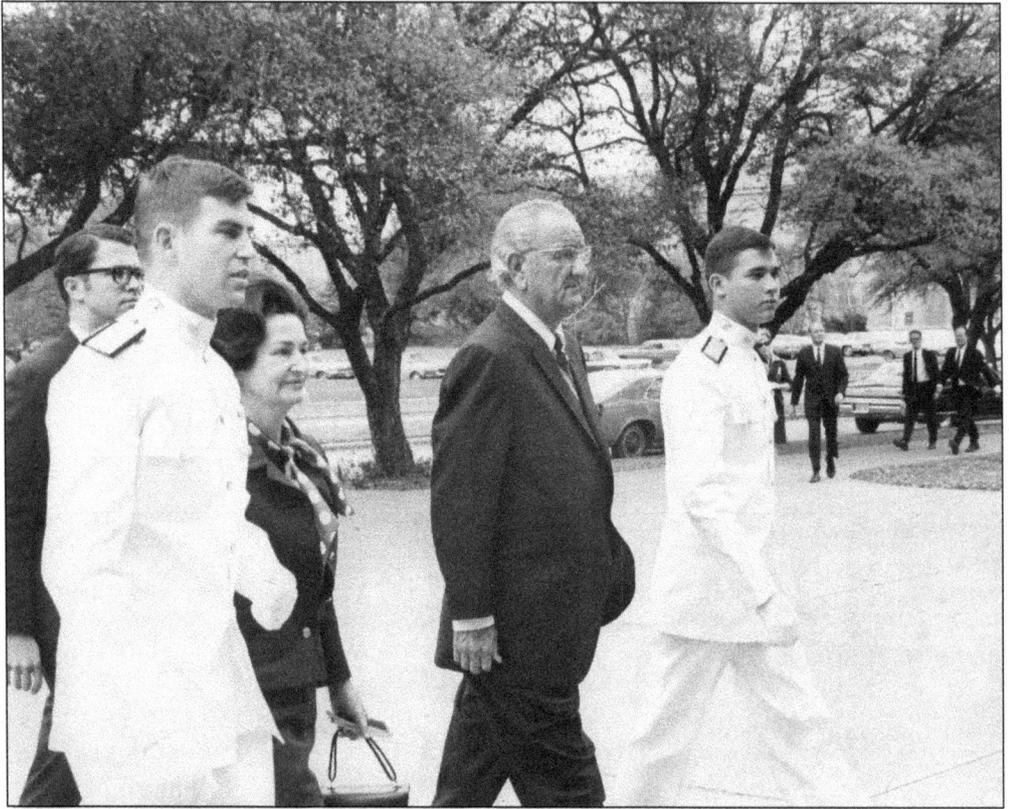

LBJ ATTENDS FUNERAL. When Earl Rudder passed away in 1970, the funeral was held on the A&M campus, with former president Lyndon B. Johnson and Lady Bird attending. Rudder is still respected abroad, especially in France. Since his death in 1970, an annual service has been held in Normandy, France, in his honor.

SWEETHEART RINGS. Contrary to popular belief, Texas A&M has historically been open to women. For example, women (such as wives of faculty) were allowed to attend the School of Veterinary Medicine since it was the only such institute of higher learning in the district. Mothers, wives, and girlfriends received "sweetheart" rings, which were much smaller than those for males and had to be worn on the little finger, from seniors. These were eliminated after 1963, when A&M was opened to all women. The pinkie ring ended up being the design for the ladies' Aggie ring that is seen now.

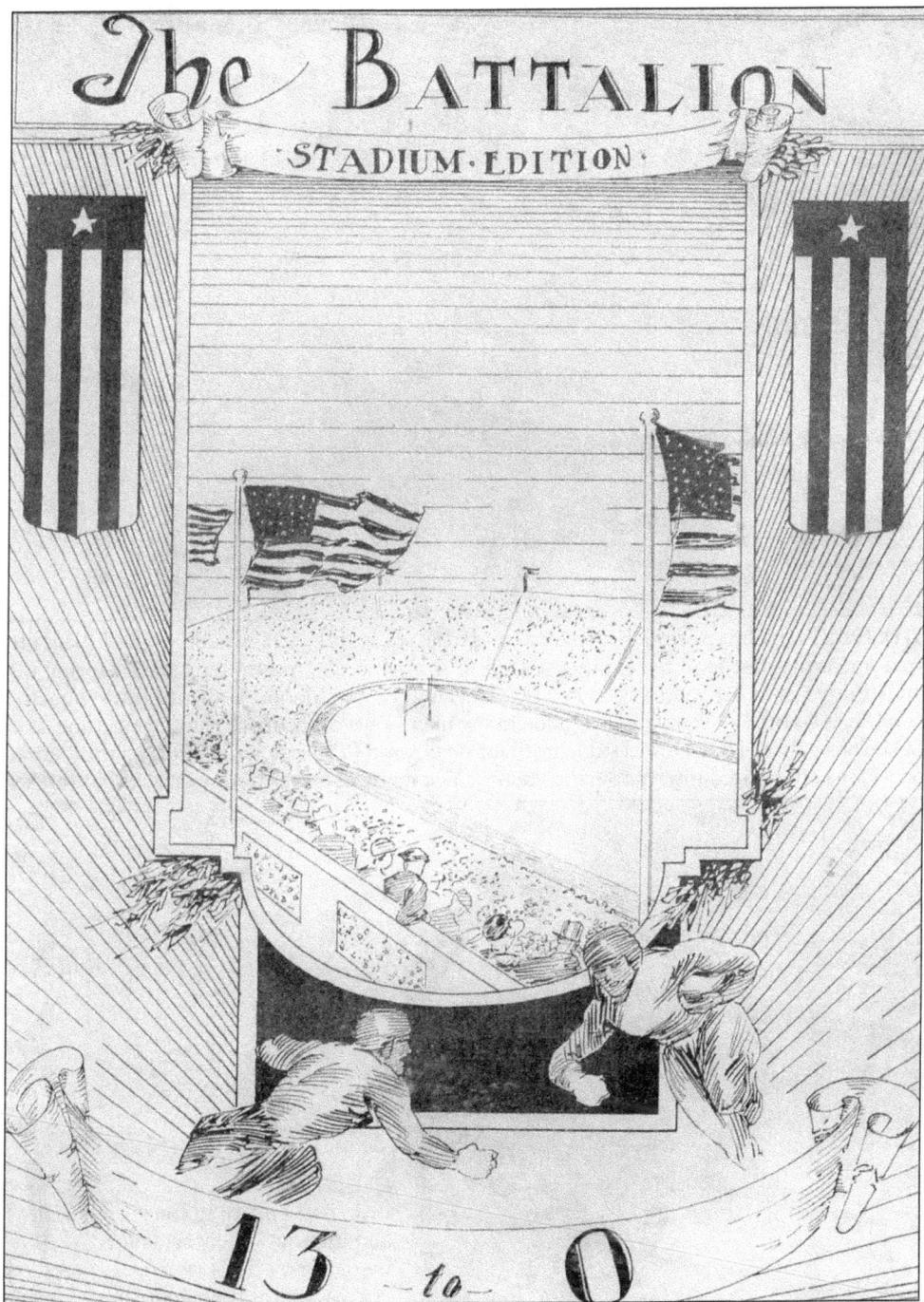

THE BATTALION. Founded in 1893, the award-winning campus newspaper *Battalion* has been ranked by the Princeton Review as the 20th-best college newspaper. Students also publish a secondary school paper called the *Maroon Weekly*. *Aggieland*, formerly known as both the *Olio* and the *Longhorn*, is one of America's largest yearbooks in terms of size and number of copies sold. Pictured here is the 1915 stadium edition after the famous 13-0 defeat of TU in football. For many years the *Battalion* was the official newspaper of the city of College Station.

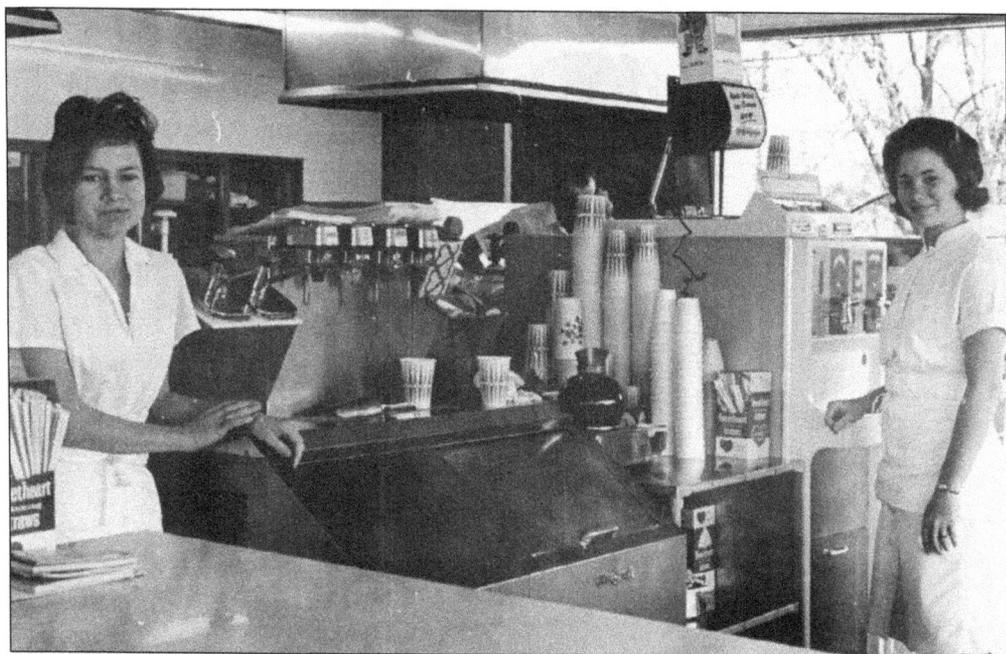

ENTER FAST FOOD. It is no understatement to say that students love fast food. As the college grew into a university, fast food restaurants started to spring up like mushrooms after a spring rain. Handy Burger, at Northgate, was owned by Mabel and Luther Moon. Always in the vanguard in the 1960s, it boasted a jukebox, a groundbreaking microwave oven, and a Slurpee machine. Local A&M Consolidated High School students Maurine Dawson (left) and Pat Boriski run the fountain. The Moons often hired international students since many of them lived nearby. (PH.)

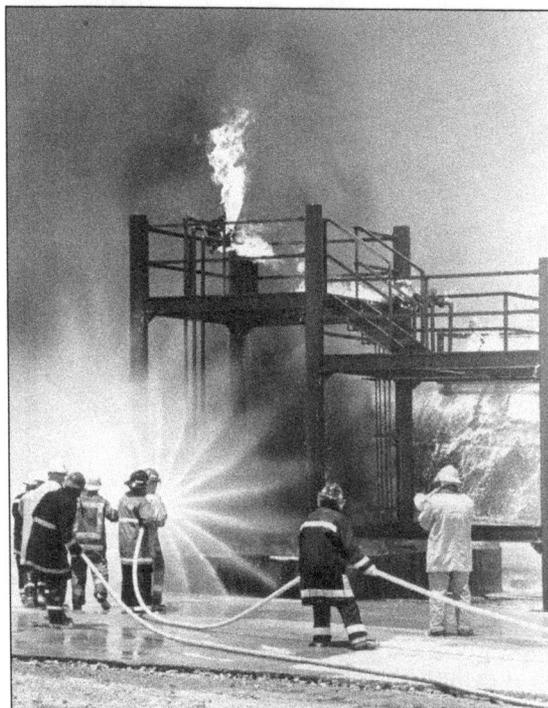

BRAYTON FIRE SCHOOL. A nationally and internationally acclaimed firefighting school near Easterwood Airport trains firefighters in the most up-to-date methods. Pictured here is one of the many burns students must learn to handle before graduating. The burn demonstrations were popular summer evening entertainment in the early days of the school.

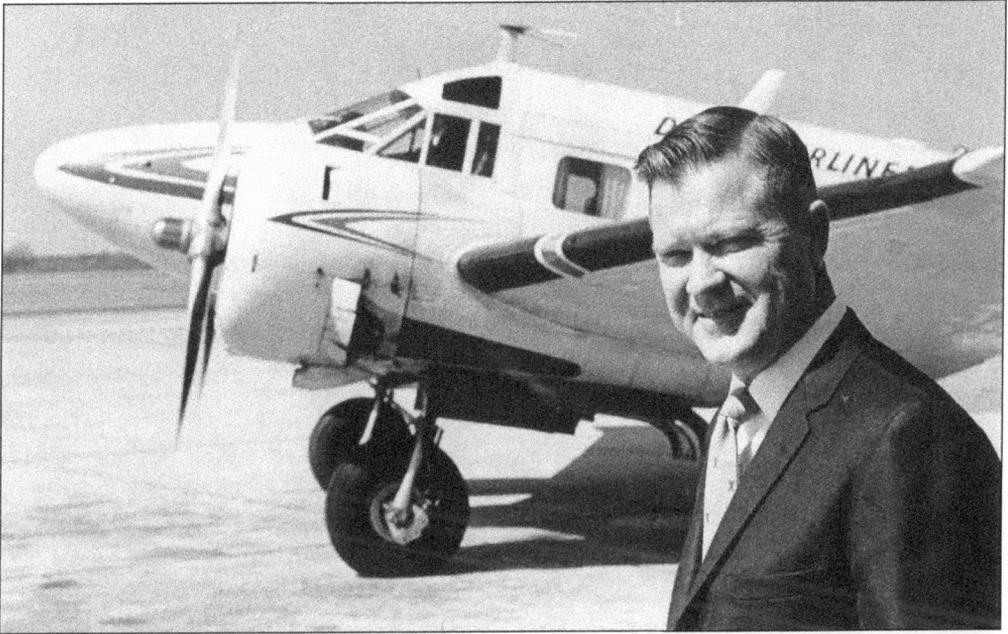

DAVIS AIRLINES. The first commercial airline to set up shop in the 1960s at Easterwood Airport was Davis Airlines, which used only small propeller aircraft such as the one shown here with owner Guy Davis. (PH.)

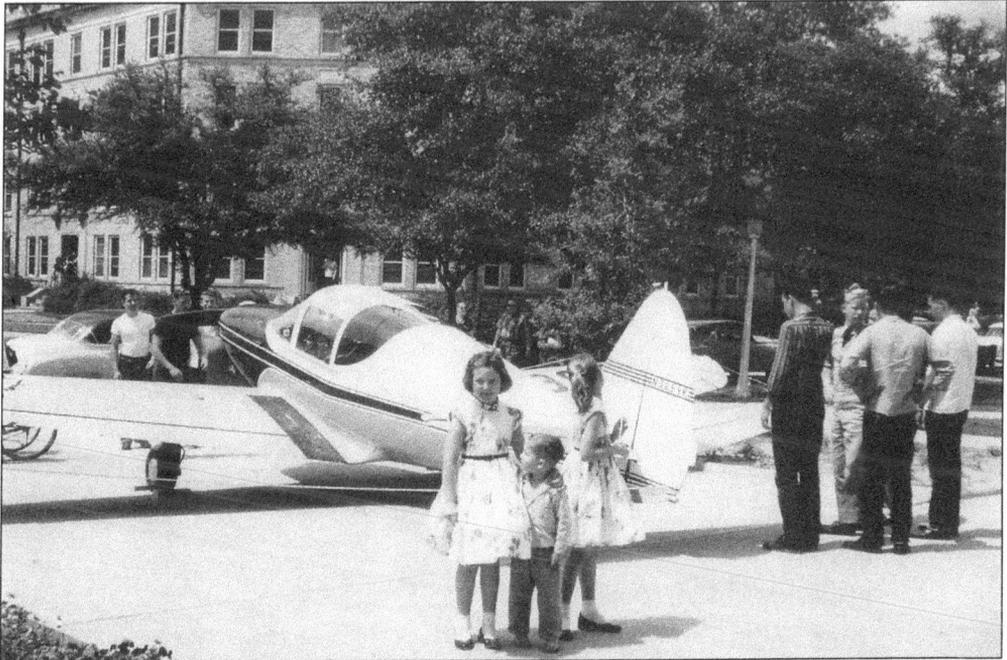

AIRPLANE NOVELTY. Airplanes of all sorts were still a novelty in the late 1950s, especially in College Station. Here a 1948 Temco GC-1B is shown off in front of Guion Hall on the A&M campus on Mother's Day 1959. Each Mother's Day, all of the campus departments hosted exhibits and demonstrations. In the foreground, from left to right, are Anne, Clay, and Karen Boykin. Anne now manages the Project HOLD archives for the City of College Station. (Anne Boykin.)

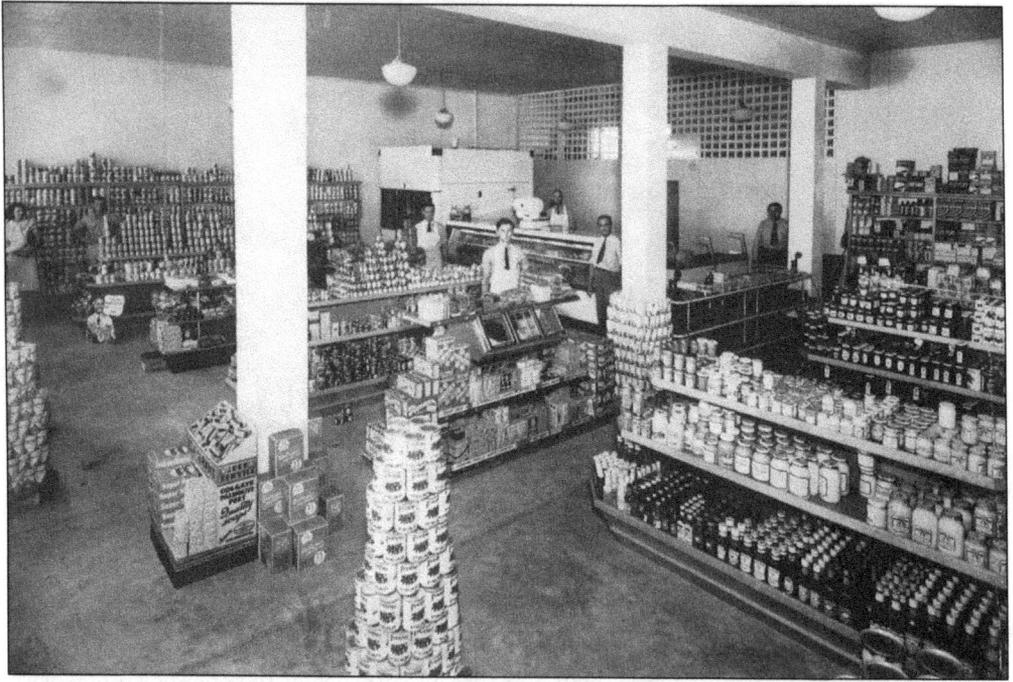

GROCERY STORES. An influx of students also meant new supplies of food for growing families. Grocery stores began expanding to help fill empty stomachs. In the 1960s, the Northgate area was home to Luke and Charlie's Grocery, which many students of the day remember fondly as "Luke's." Sue Brock Matthews (now Davis) recalls shopping there for faux chicken legs on a stick, which were actually made from hamburger meat. (PH.)

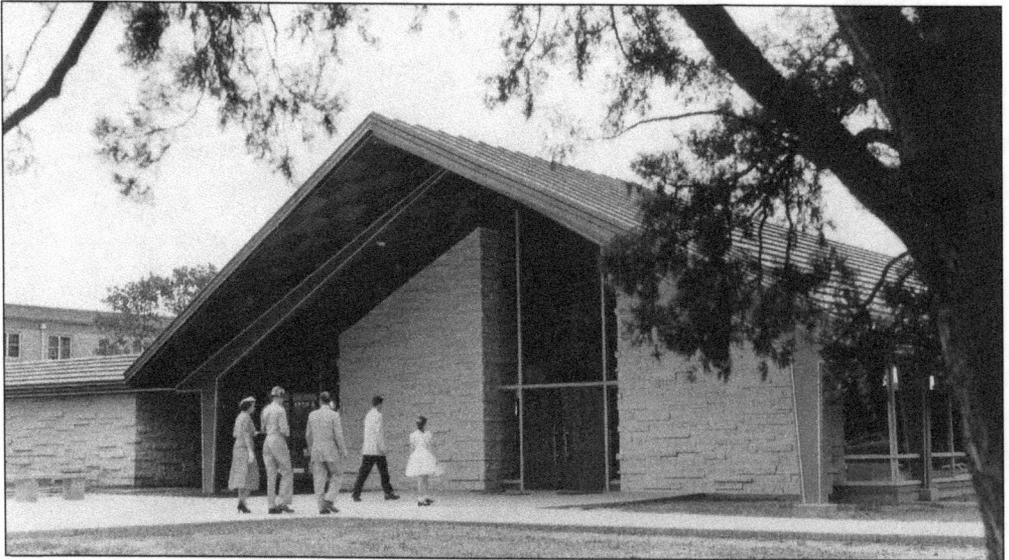

CHAPELS. To accommodate students and others of all beliefs, the All Faiths Chapel was constructed near the campus. Architect Richard E. "Dick" Vrooman was a member of the architecture faculty when he won the competition for the design of this building. The A&M Methodist Church still stands near the campus, but churches of every denomination now dot the College Station landscape. (PH.)

SOCIAL EVENTS PROLIFERATE. As A&M grew, cultural events such as dances began to take center stage. Here original "campus kid" Nancy Reynolds dances with the most decorated World War II hero, Audie Murphy, a Texan who wanted to become an Aggie but joined the army instead. Nancy (Reynolds) Tiner passed away in May 2010. (PH.)

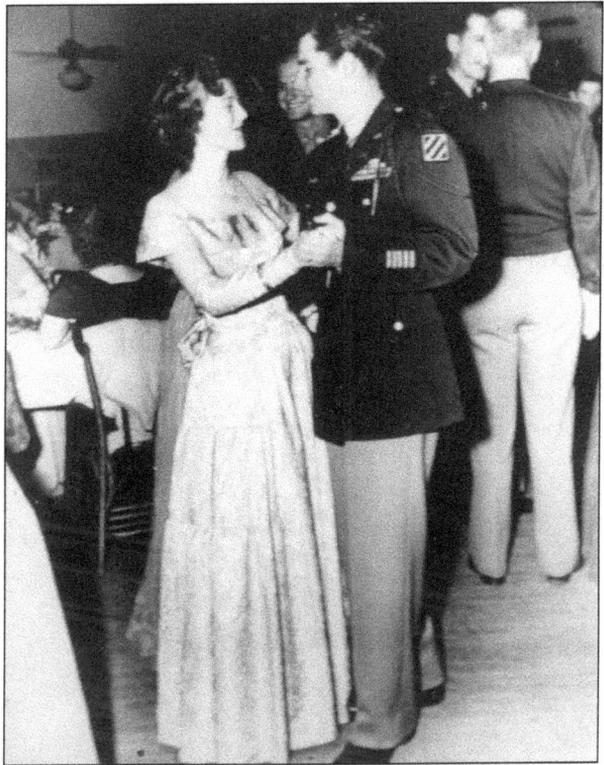

MISS USA. In 1977, a Texas Aggie coed named Kimberly Tomes won the Miss USA title, strongly suggesting that coeducation, introduced only a few years before, had indelibly changed the image of the formerly all-male military college. When crowned, Tomes almost fainted and exclaimed, "I'm the first Aggie to be Miss USA!"

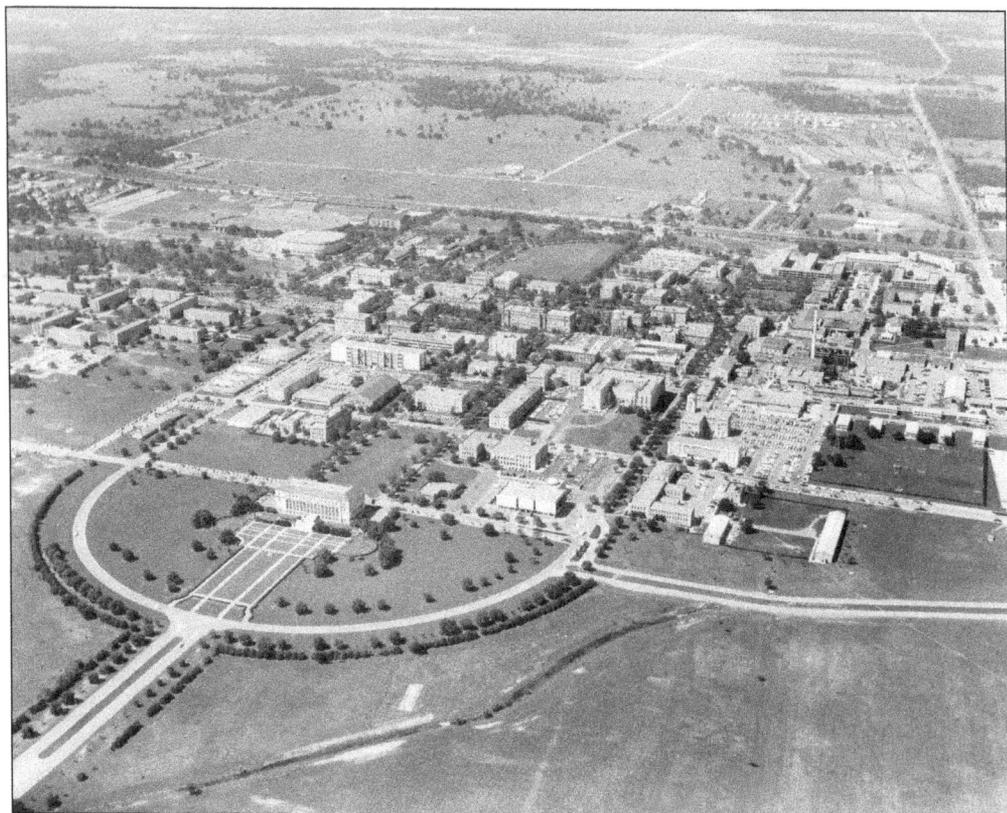

CAMPUS EXPANSION. The floodgates really opened when Texas A&M moved in the 1960s to become a full-fledged university, which made joining the corps voluntary and allowed women and minorities to attend. Such rapid expansion is visible in this aerial shot of the campus from the 1960s. (PH.)

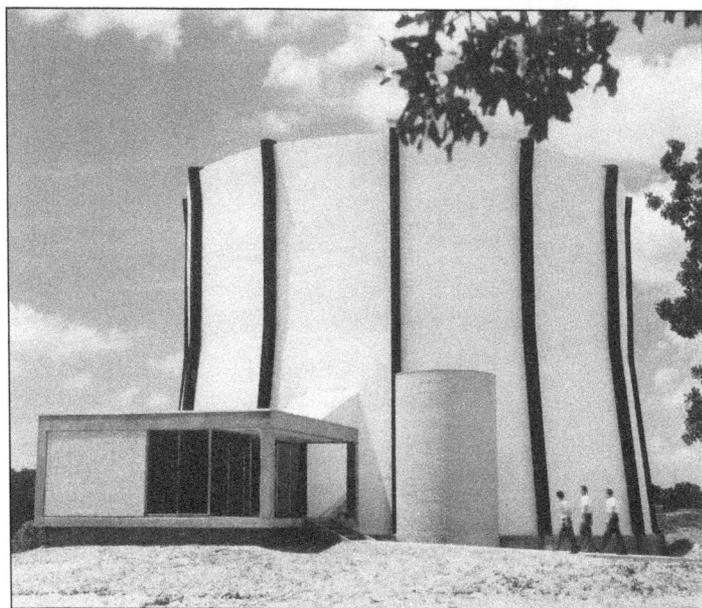

NUCLEAR PASSION. One reason for Texas A&M's fame as a research institution stems from the construction of its nuclear reactor in the 1960s. Ironically, the isolated site also became known as a parking area for dating students. (PH.)

MEMORIES. To service the growing student body and as a memorial to the Aggies who died while serving in both World Wars, a modern Memorial Student Center was built near the epicenter of the campus; some argue it *is* the epicenter. An early ad read, "Air-conditioned throughout. Eat, sleep and dance under the same roof. No other place like it. All rooms with private bath, three dining rooms, two ballrooms, four meeting rooms, bowling alley, barber shop and post office." All who enter are reminded to remove their hats, and no one is allowed to walk on the grass surrounding the building. (PH.)

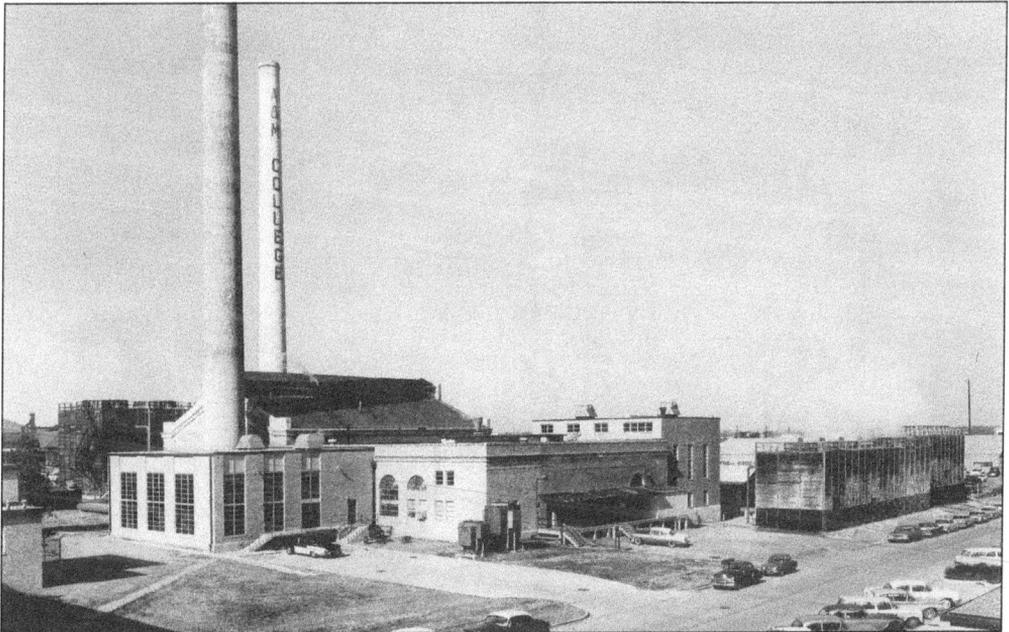

MORE POWER TO YOU. As the campus expanded, so did the need for heating and cooling. The power plant was expanded to accommodate this growing demand. Interestingly, there are slogans painted on the tunnel walls from decades before, but no one is allowed to enter the tunnels except for workers due to security reasons. (PH.)

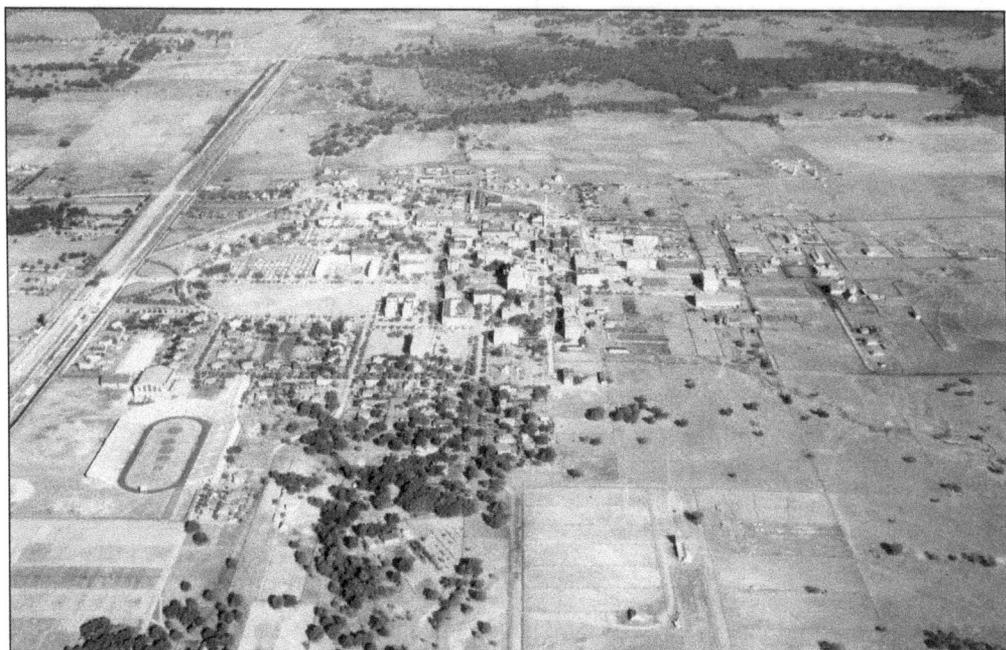

New Roads to A&M. A growing number of students meant more traffic, so roads had to be expanded to handle the influx. State Highway 6, which goes through College Station, was greatly expanded and renamed the Rudder Freeway after World War II hero and former A&M president Earl Rudder. (PH.)

Research. Texas A&M ranks among the top 20 research institutes in the United States in terms of funding. It has made notable contributions in such fields as space research, agriculture, and animal cloning. A&M is one of the few universities designated as a land, sea, and space grant institution. (PH.)

Seven

COLLEGE STATION AND AGGIE FOOTBALL

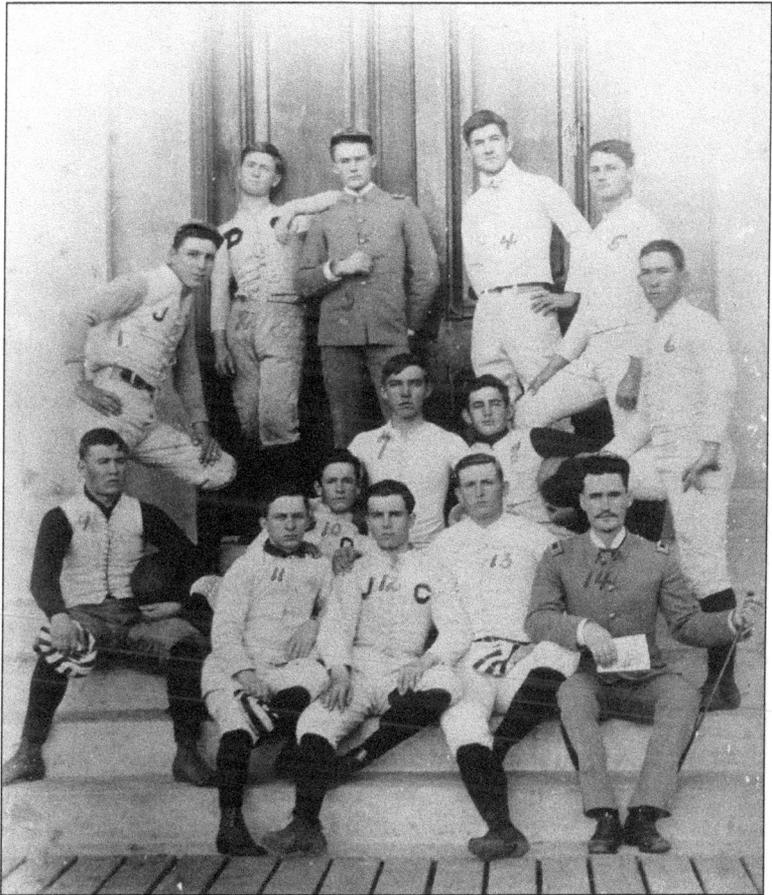

A&M's First Football Team. Aggieland football began in the fall of 1892. According to A&M historian Henry Dethloff, "In 1894, the 'Farmers' defeated Ball High School in Galveston, 14-6. That same year, in the first game with TU, the Aggies lost by a disastrous 38-0. The A&M 'Farmers' defeated Austin College 22-0, downed Houston High School 28-0, and tied Ball High School 0-0 in 1896." Interestingly, colleges played high schools in the early days on the gridiron.

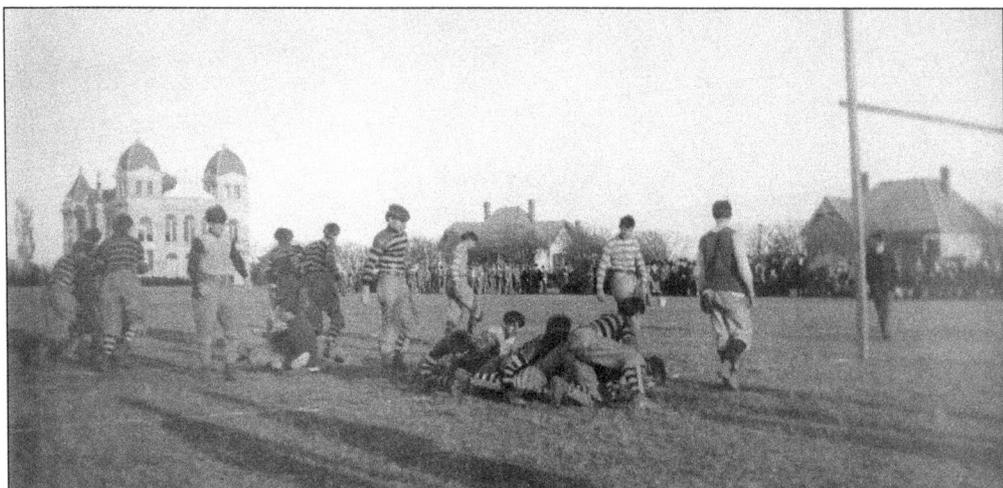

A&M vs. Baton Rouge, 1899. Football began under Pres. Sul Ross and, a year after his death, was picking up steam as a spectator sport. Aggies got an eyeful with the Baton Rouge game of 1899, as A&M won in a shutout with a score of 52-0; however, the team lost 0-6 to their archrival TU that year.

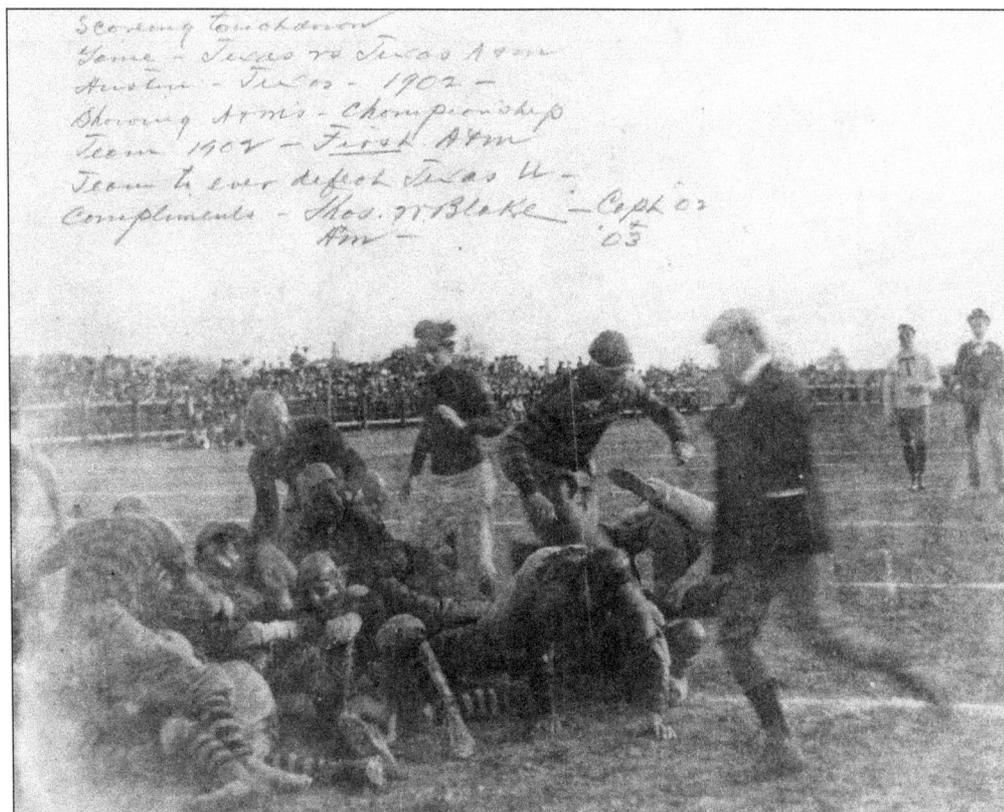

Champions. In 1902, the A&M team was named "Champion of the South" after beating Tulane, and football fever really caught fire. TU was already its chief rival and was played two to three times per year. The first home field for the Aggies was the Bryan Fair Grounds, but the bleachers there were later moved to the campus and the grounds renamed Kyle Field.

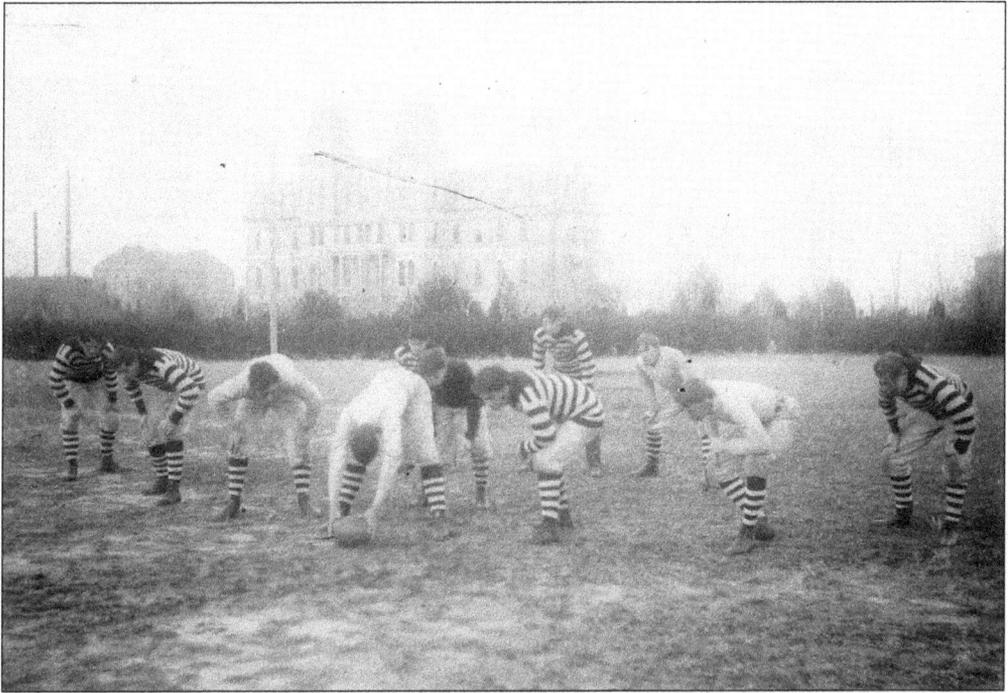

NOT EVERYONE CHEERED. Henry Dethloff wrote, "The A&M faculty did not share the cadets' enthusiasm for football. Prior to 1902, they had passed a ruling prohibiting the A&M team from meeting other institutions in competitive events. A vigorous student protest caused the faculty to rescind their action."

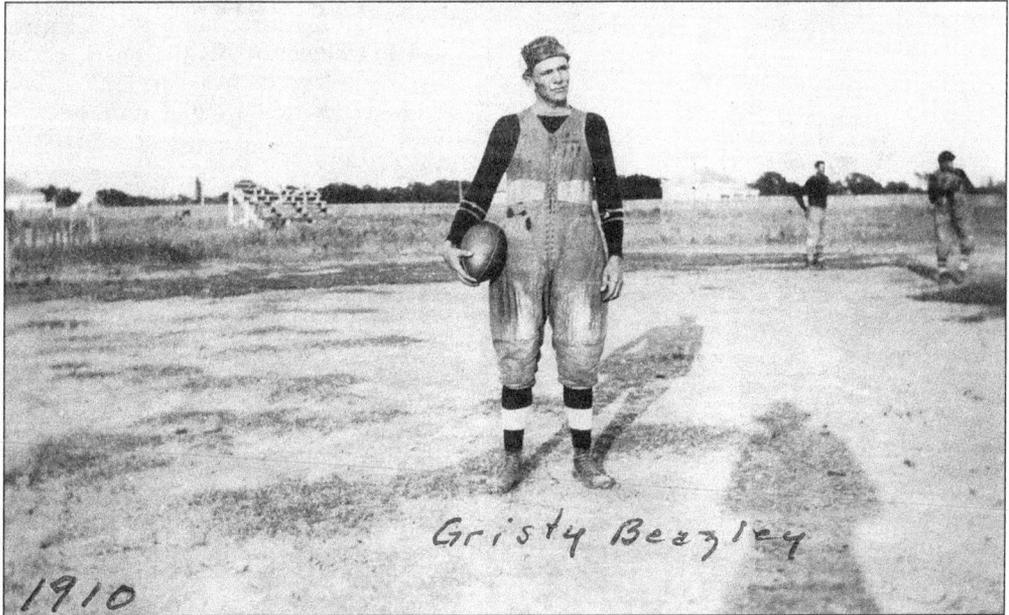

Gristy Beazley

1910

MINIMAL PADS. Football equipment of the past was extremely pared down by comparison to modern standards. The uniform seen here on Gristy Beazley in 1910 featured very few pads with a helmet made of flimsy leather and no face guard.

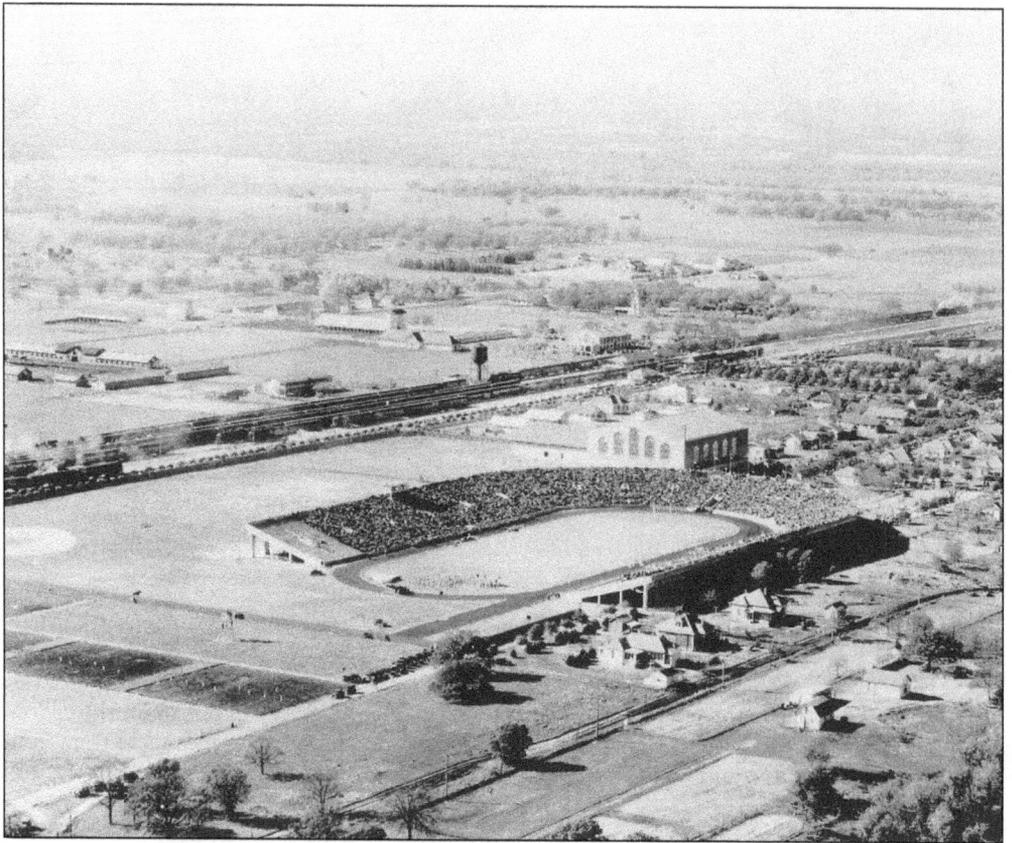

KYLE FIELD EXPANDS. The first modern stadium built on the A&M campus, Kyle Field, was constructed in 1927. Pictured here is the stadium in the late 1920s, with rows of passenger train cars in the background. Fans would travel from all over Texas, especially for the Thanksgiving rivalry game with TU. They would sleep overnight in the railcars since few hotel facilities were available.

NATIONAL CHAMPIONS. The first and only time A&M won a national championship in football was in the 1939 season. The star of that team was fullback Jarrin' John Kimbrough, as he was known in College Station. He also went by the nickname "Haskell Hurricane" in his hometown. A&M went undefeated and beat Tulane 14-13 in the Sugar Bowl.

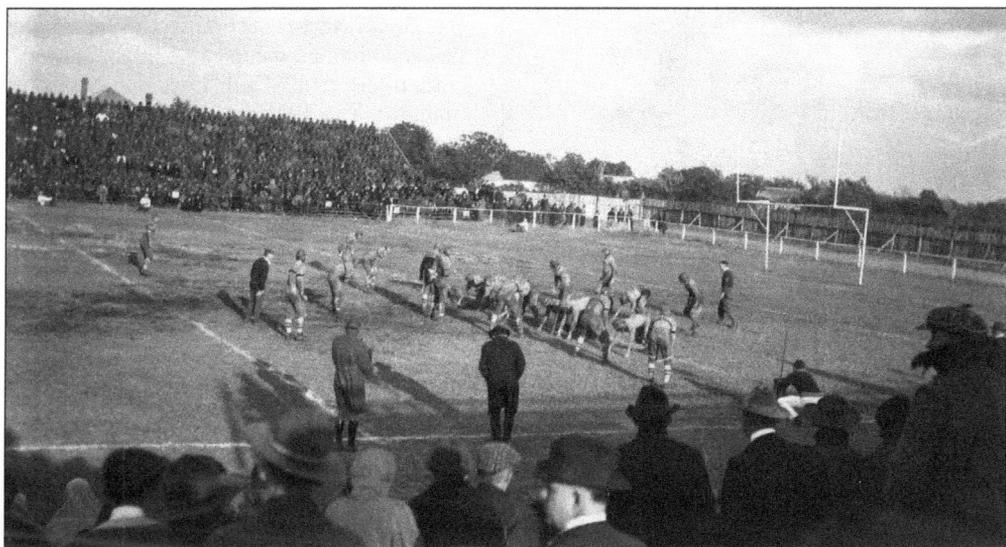

HORSESHOE. The first incarnation of Kyle Field was a single-deck, horseshoe-shaped field capable of holding only a few thousand spectators. As football gained in popularity, the size of the stadium expanded. The newest version aims to hold 100,000 fans. (CC.)

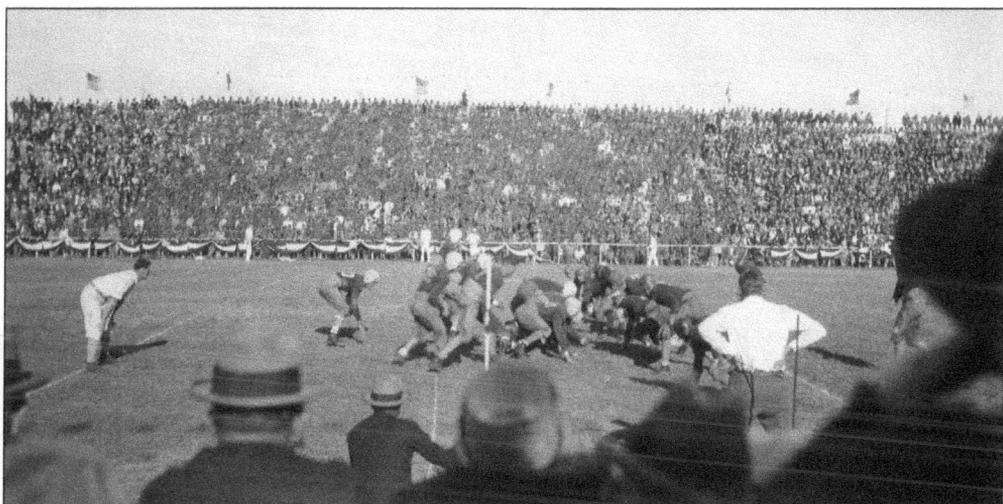

LINE OF SCRIMMAGE. In the 1930s, A&M football became more sophisticated, and the uniforms reflect a progression of the game. The A&M yell leaders, always men, are on the far side in their white outfits. This is still a characteristic of yell leaders at Kyle Field, although they sometimes wear farmer's overalls. (CC.)

THE BEAR. A&M's second chance at a national championship came in the mid-1950s under coach Paul "Bear" Bryant from Alabama. The 1956 team was on track to win another national championship title, when Bryant suddenly announced at halftime during the Rice game that he had "heard Mama calling" and was returning home to Alabama. The Aggies went on to lose that game 7-6 (and the next two games) as well as the national championship.

ASSISTANTS RISE. Many members and assistant coaches of the "Junction Boys" (named for their training location in Junction, Texas) team of Bear Bryant went on to become head coaches and mimic the Bear's style. Gene Stallings, who played on that team, went on to coach the Aggies and beat his mentor in the Cotton Bowl game in 1967, when the Aggies played the Crimson Tide of Alabama.

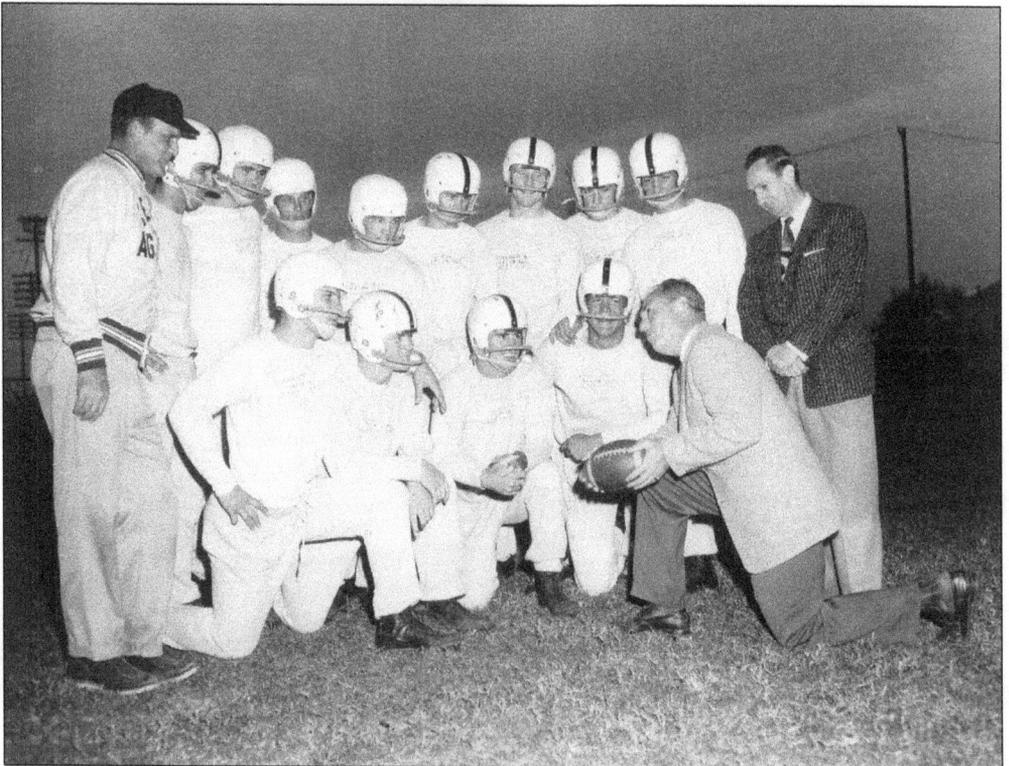

THAT HAT! Bryant's signature was the houndstooth hat he wore on game days (right). It must have brought him luck because the Bear was ten-time Southeastern Conference Coach of the Year and four-time National Coach of the Year. He earned a record of 232 wins and 46 losses. The NCAA Coach of the Year award is still named in his honor. At left is Billy Pickard, longtime athletic department staffer.

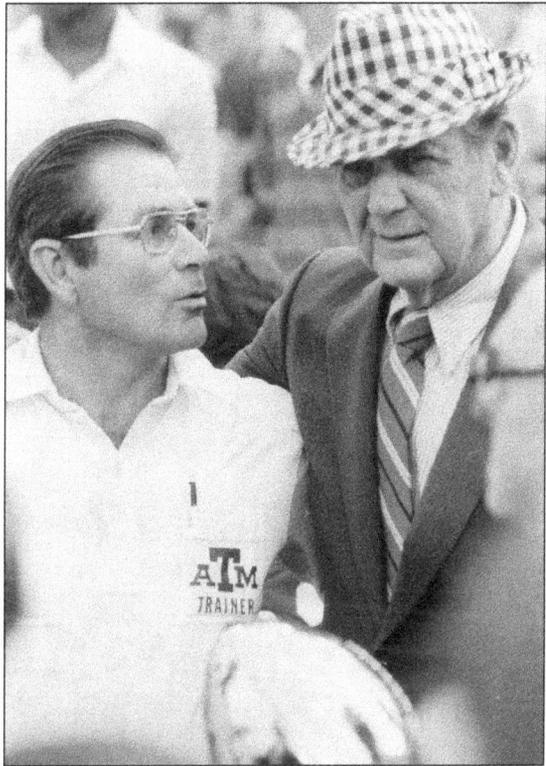

THE BEAR, THE MOVIE. Gary Busey (right) played the legendary coach (left) in a 1984 film by Embassy Pictures. The movie shows how the Bear got his nickname wrestling a real bear. Busey was nominated for an Academy Award for his portrayal of Bryant.

LARRY G. SPANGLER'S Production of

THE BEAR

An Embassy Pictures Release

The true story of Paul "Bear" Bryant: THE BEAR. Legendary Alabama football coach Paul "Bear" Bryant (L) will again be part of the grid season via a unique portrayal of the man by Academy Award nominee Gary Busey (R) in the Embassy Pictures release of THE BEAR. The motion picture, which opens September 28, not only captures Bryant's winning ways, but illustrates his dedication to developing the boys he coached into men.

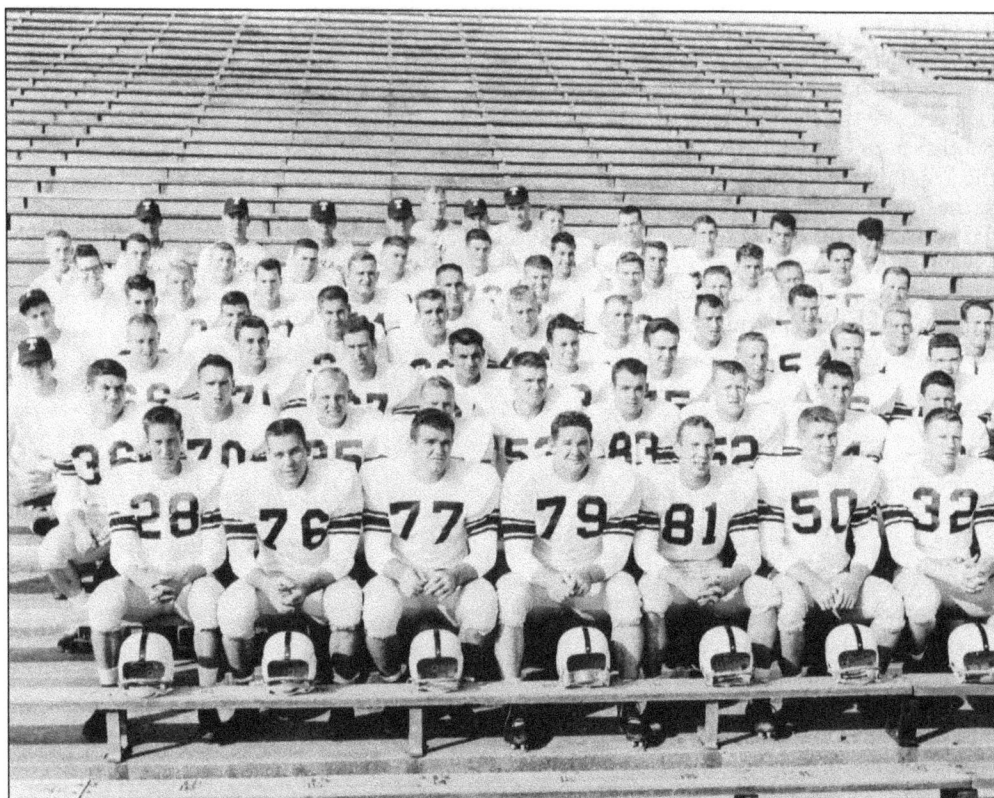

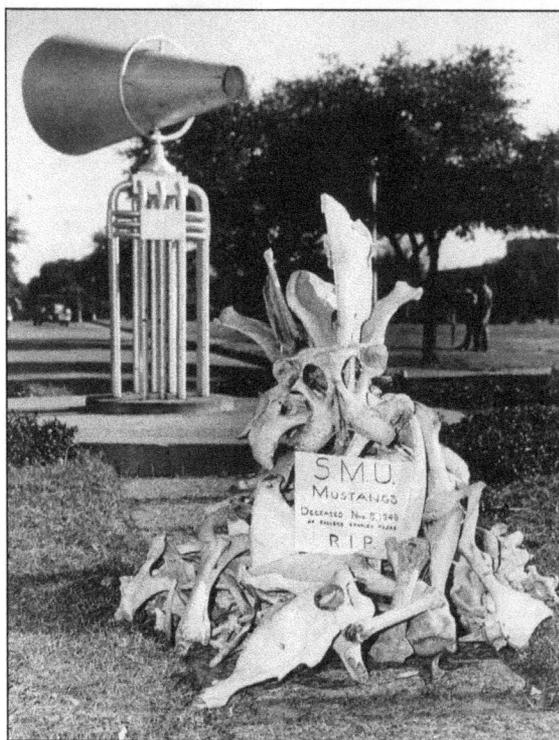

JUST SHY OF VICTORY. The 1955–1956 team coached by Bear Bryant almost went all the way. Seated in the first row at far right is running back No. 32, Jack Pardee. Other standouts on that team were All-American Charlie Krueger and Heisman Trophy winner John David Crow.

PONY BONES. During the years of the Southwest Conference, just about every team badly wanted to beat A&M. One of the Aggies' toughest opponents was the Southern Methodist University (SMU) Mustangs, especially when Heisman Trophy winner Doak Walker played for the Ponies. A&M felt just as strongly about beating SMU, as the picture suggests. A popular slogan on campus was "Today SMU (pronounced shmoo), tomorrow glue!"

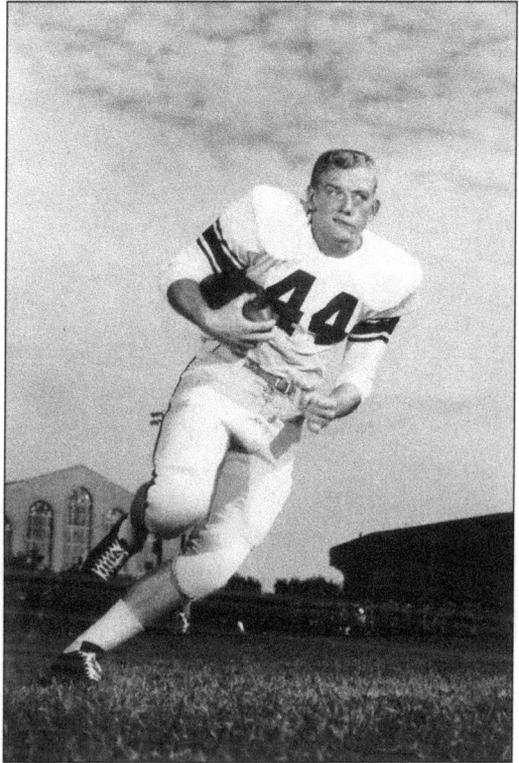

HEISMAN TROPHY. The only Aggie to ever win the Heisman Trophy was running back John David Crow, No. 44, of the 1955–1956 team. Crow was an awesome runner and a key element of that team since quarterback Roddy Osborne was not known for his passing (or running) skills.

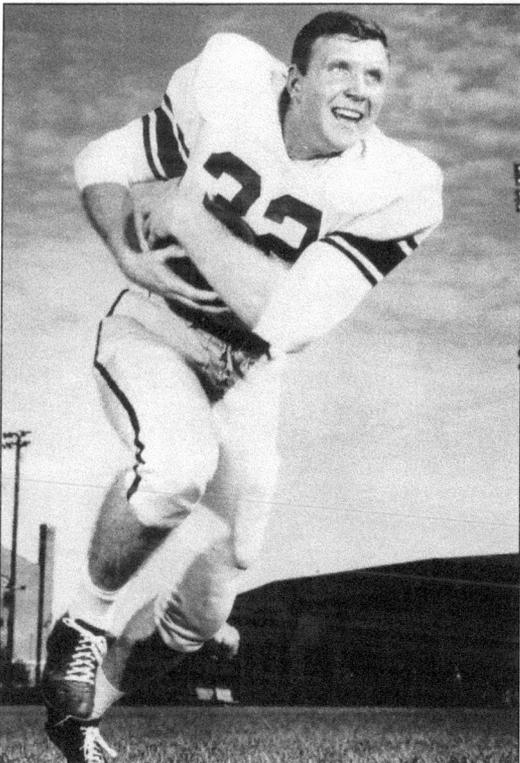

FULLBACK. Jack Pardee was the other running power on that 1955–1956 team. Pardee went on to play professional football for the Los Angeles Rams and coached the Houston Oilers (now the Tennessee Titans) in the 1990s. He currently lives on a ranch between Hearne and Caldwell, Texas.

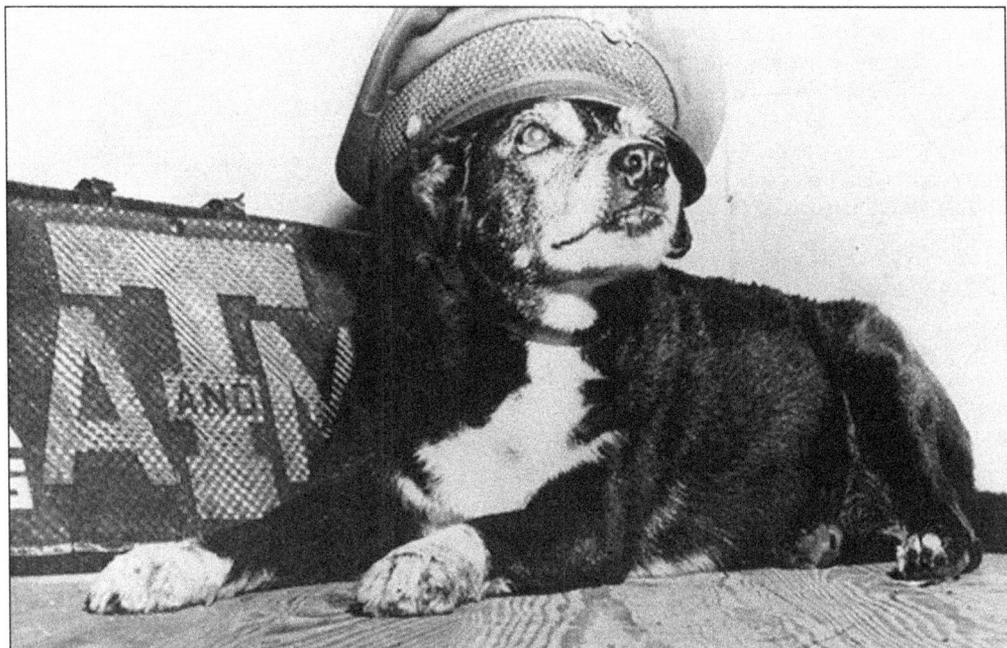

REVEILLE. Every college football team has a mascot, and A&M's is a dog named Reveille. When a group of Aggies was returning to campus from Navasota in their Ford Model T in 1931, they discovered a stray puppy and took her to the barracks. The next morning, the puppy howled in tune with the bugle call, and thus her name. A tradition was born. The reflective A&M logo on the suitcase in the background was used by Aggie hitchhikers to catch rides to and from campus and football games.

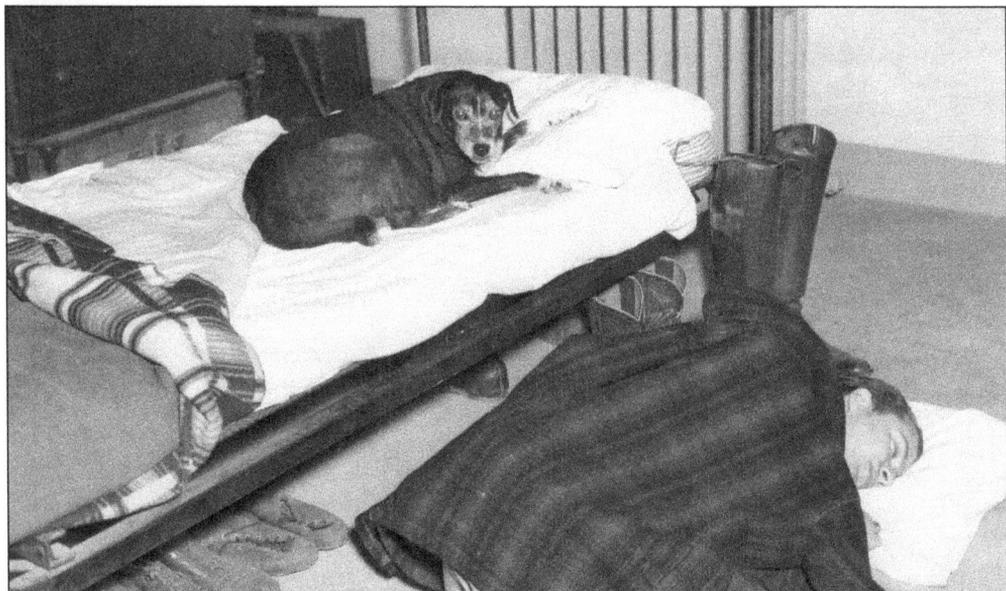

ON THE FLOOR. It became customary for the (always) female dog to have the run of the campus. She slept where she wanted, so a cadet slept on the floor if she chose his bed. Protected by cadet guards from Company E-2 wherever she goes, Reveille (now a collie) is indeed the queen of the campus.

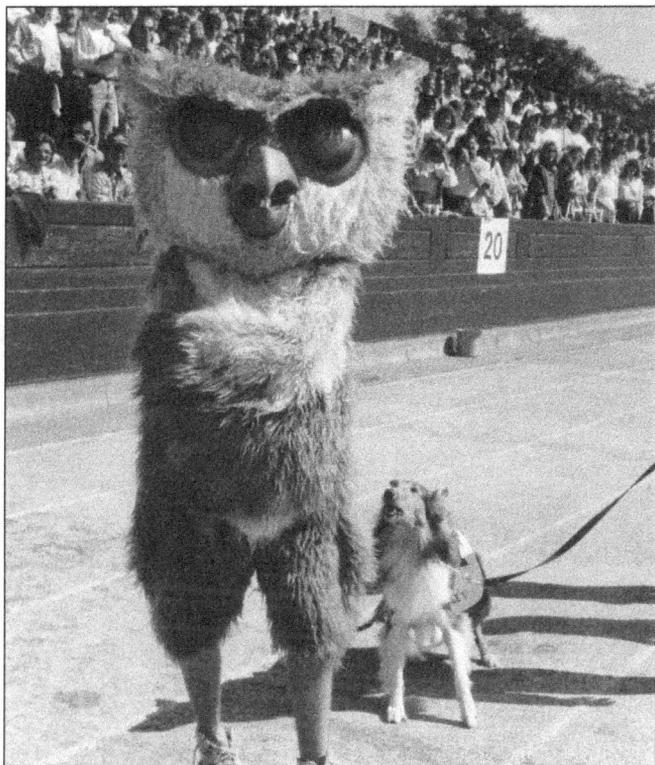

FIELD-CLEARING. One of Reveille's duties is to clear the football field of the rival mascot at halftime performances. Here Reveille chases the Rice owl off the turf to the roar of the crowd at Kyle Field.

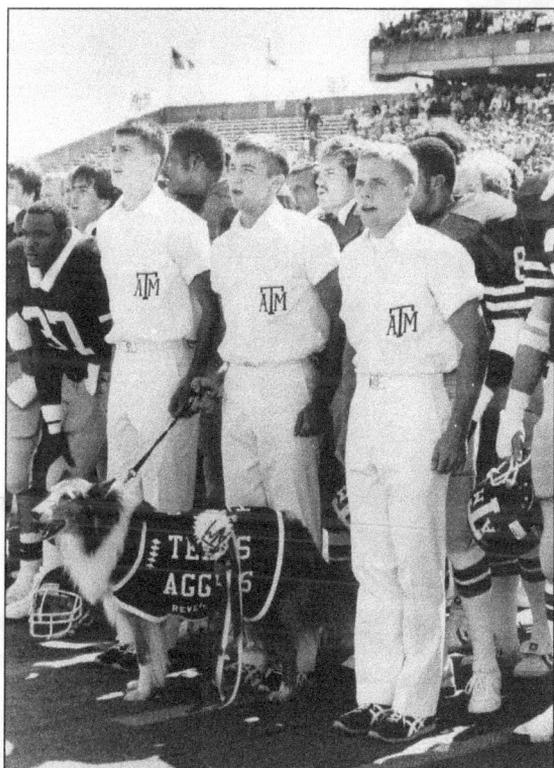

HIGHEST-RANKING. Reveille is considered a cadet general of the highest rank, wearing five diamonds on her maroon-and-white (Aggie colors) blanket. She is the only animal on the campus (except service types) permitted to enter buildings. By tradition, a class is canceled if she barks. Reveille has her own cell phone and ID card. The current mascot is Reveille VIII, who assumed her duties in August 2008. Reveilles I through IV are buried side by side in front of Kyle Field with their paws and noses pointed to look through the north gate at the scoreboard. This way they can forever see the Aggies outscore their opponents, or so the tradition goes.

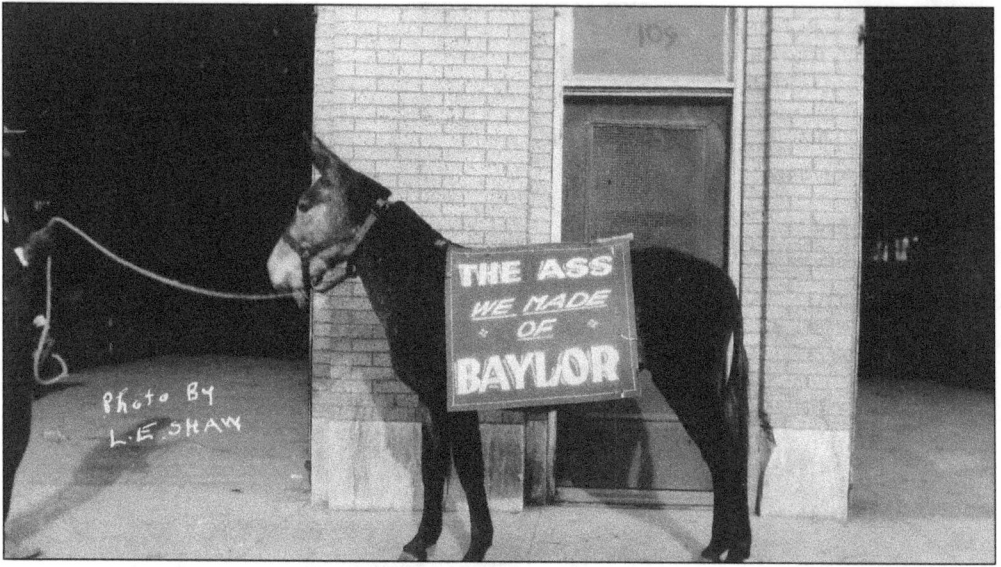

ASS-ININE? Another great rival for A&M has been Baylor. Their games are called the Battle of the Brazos since both campuses are located near the Brazos River. After one game, the Aggies demonstrated their cocky sense of humor by coming up with this gem.

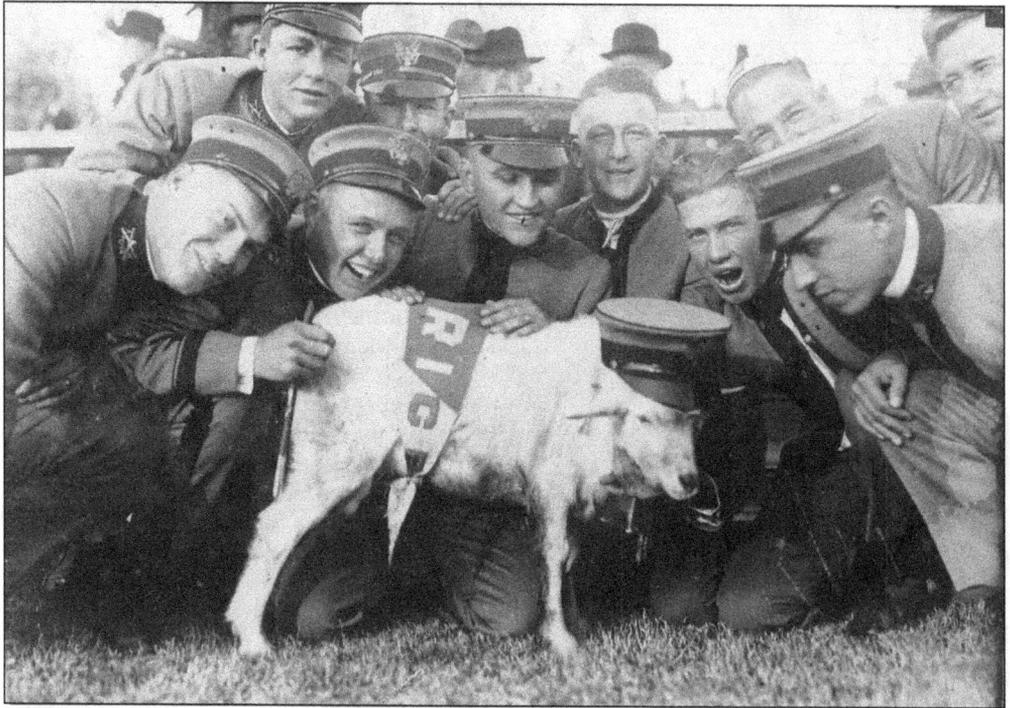

MASCOT NABBING. A great sport was stealing a rival team's mascot before, or after, a big game. In this 1917 photograph, the Ags have got Rice's goat. Although the Aggies look like they have really accomplished something, the goat looks bored to death. The Aggies stole the Rice owl in 1917 and are credited with stealing every Southwest Conference mascot at least once over the years.

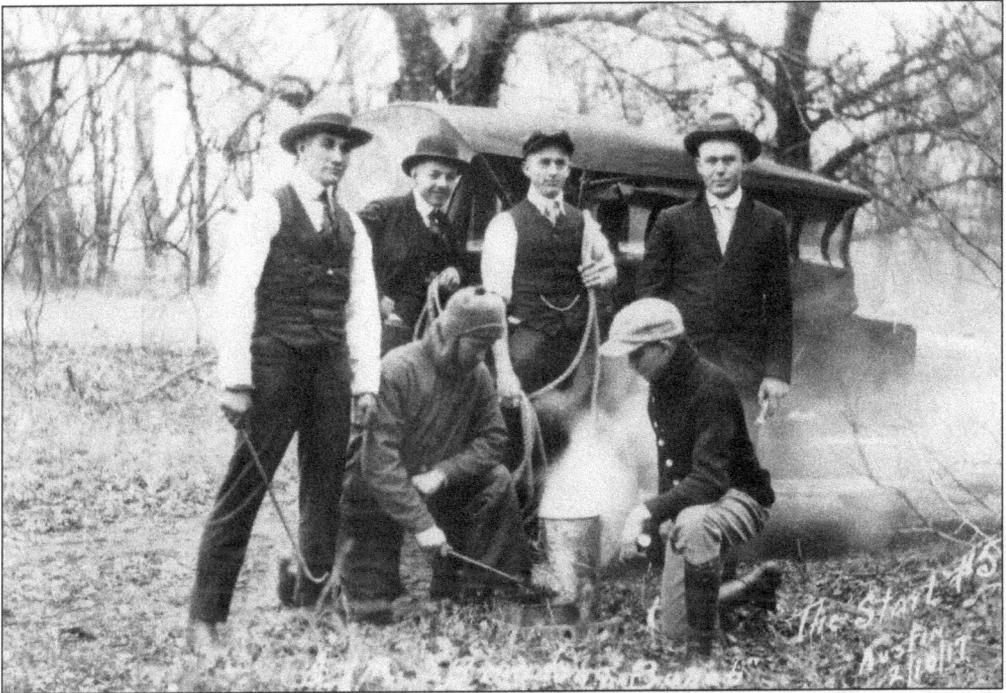

BEAT TU! After the famous 1915 game in which A&M beat TU by a score of 13-0, the rivalry became white hot, especially when the Aggies stole the TU mascot (a longhorn steer) and decided to brand the score on its side. The hit squad, pictured here, is heating up a branding iron for the job.

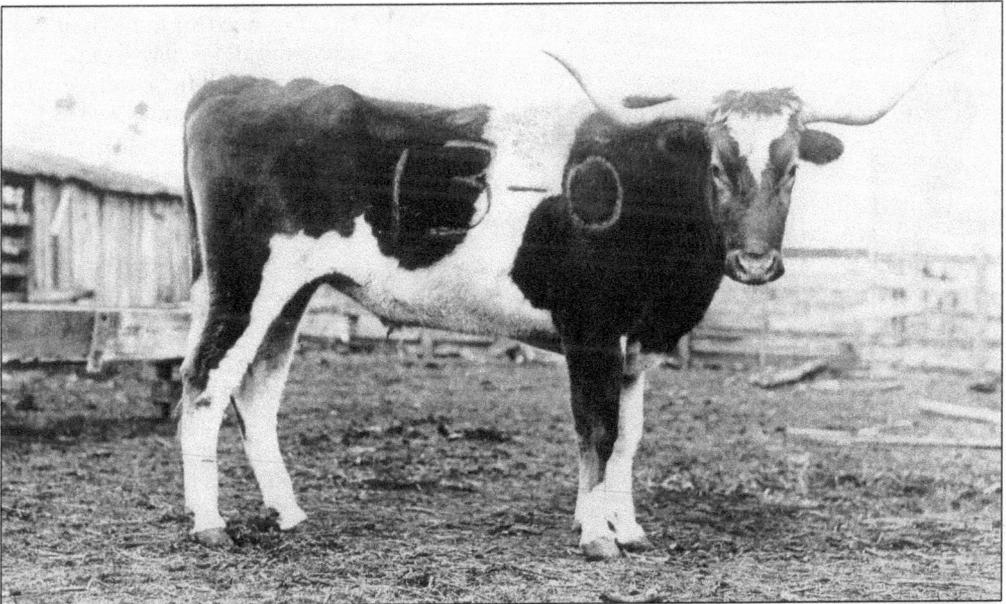

BRANDED! The teasippers (TU), embarrassed by the Aggie prank, found a way to remedy the situation. The score was transformed into the word *BEVO*, and that is how the TU mascot got its name. Aggies still love to "saw off the horns" at Kyle Field games by locking arms and moving back and forth to mimic a saw's motion as they sing the "Aggie War Hymn."

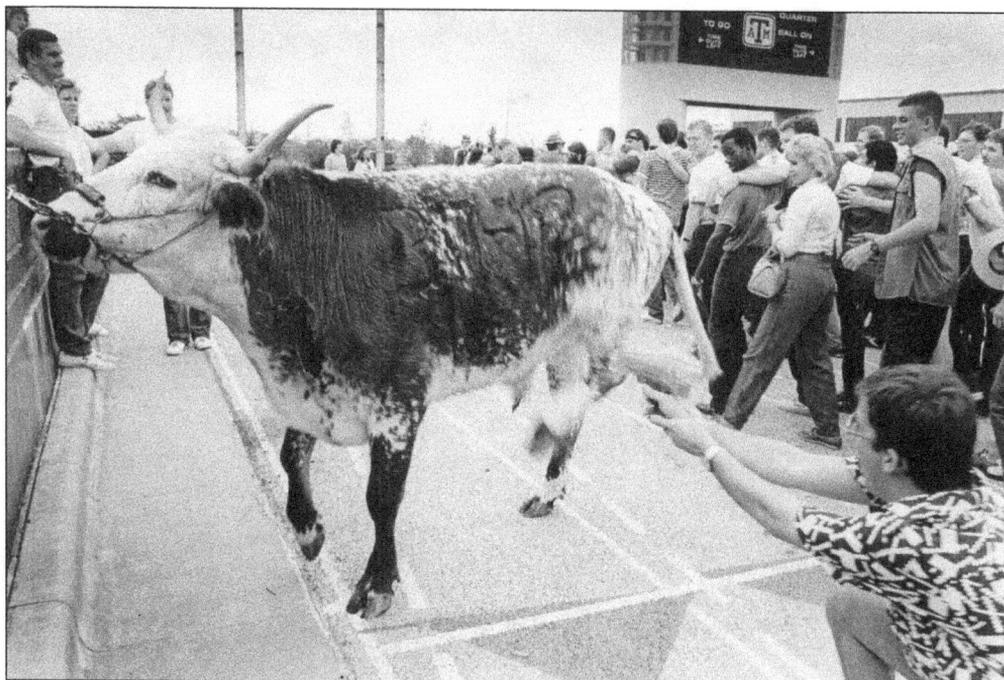

SQUIRT! An Aggie takes a potshot at BEVO with a water pistol while the animal's guards are not looking. The intense rivalry between the two schools has continued for more than 100 years and is played out on the football field every Thanksgiving Day, as well as in other sporting events.

A FAMILY AFFAIR. Many Aggies go to football games with their families and dress for the occasion. This family is on the press box side of Kyle Field so they can sit if they wish, but the other side is called the 12th Man side, where cadets and their dates stand up for the whole game. Cadets get a kiss when their team scores while a cannon fires in the south end zone.

Pads. Modern football's line of scrimmage has progressed to the point of players wearing heavy padding. The style of play has also changed dramatically, with violent tackles making injuries much more frequent.

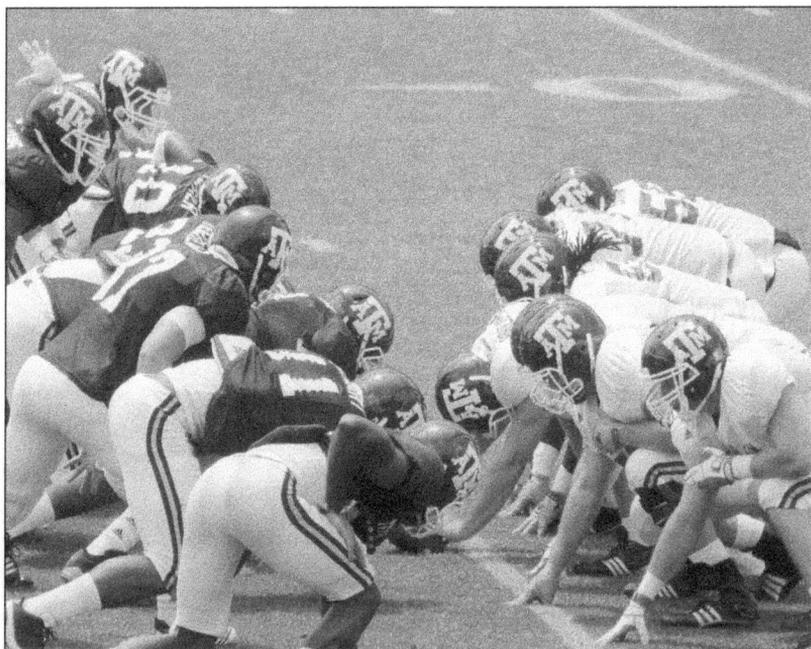

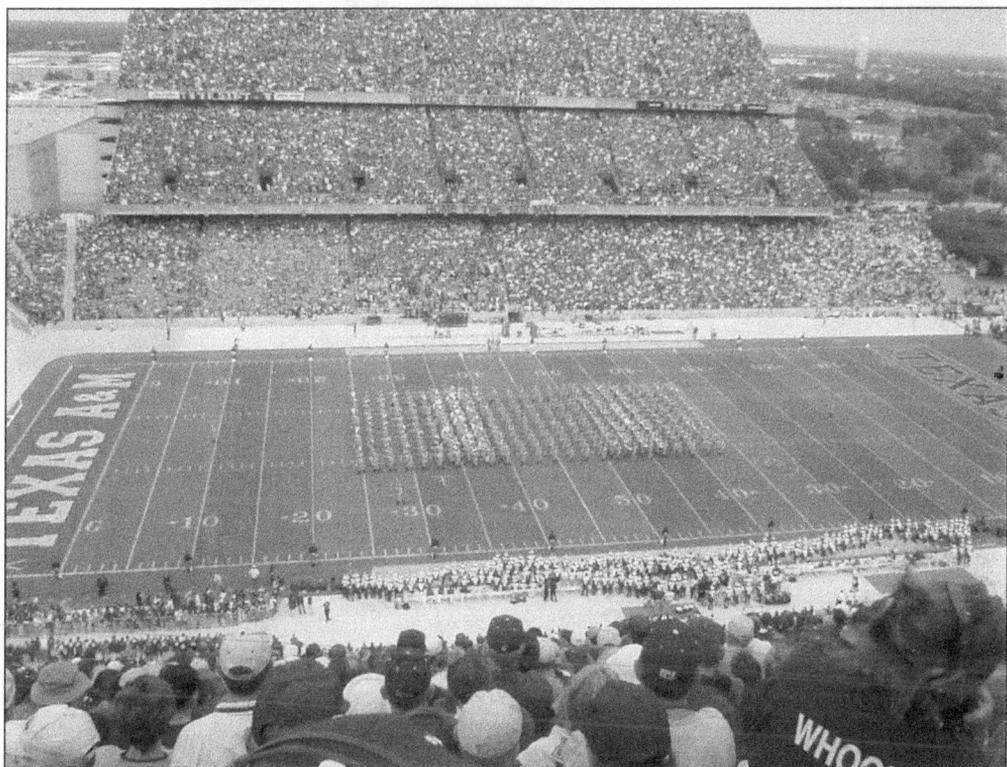

More Decks. Kyle Field has repeatedly added decks to the original horseshoe design. Plans are afoot to add another section in the south end zone to turn the horseshoe into a full circle, thus bringing capacity to 100,000 seats or more. Gone are the $1 knothole bleacher seats in the south end zone from years ago. (Photograph by Glenn D. Davis.)

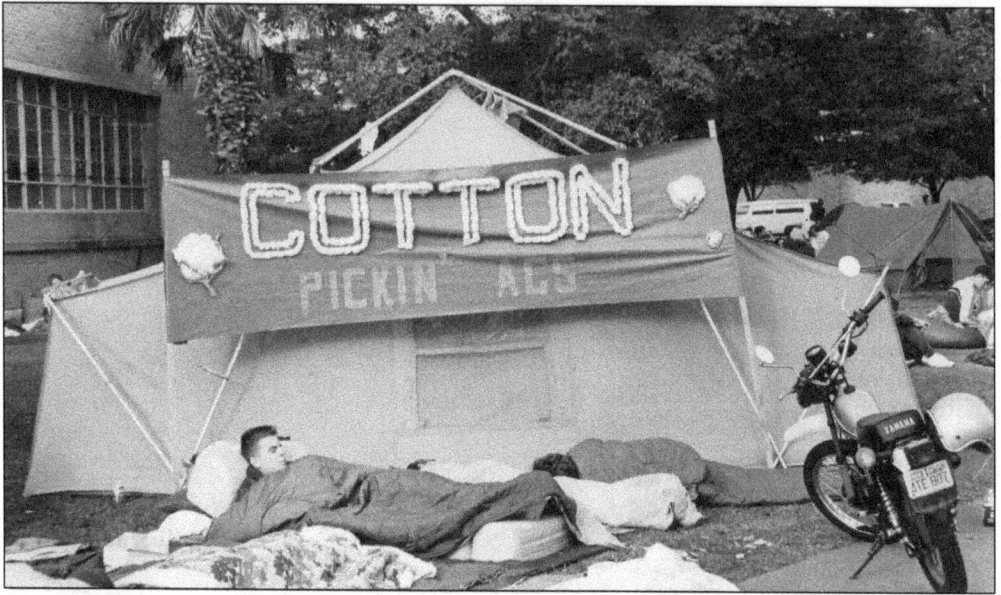

COTTON BOWL. Back in the days of the Southwest Conference, the winner went to the Cotton Bowl game to play a high-ranked team from another conference. Tickets were hard to come by, so some students camped out in line to make certain they got one.

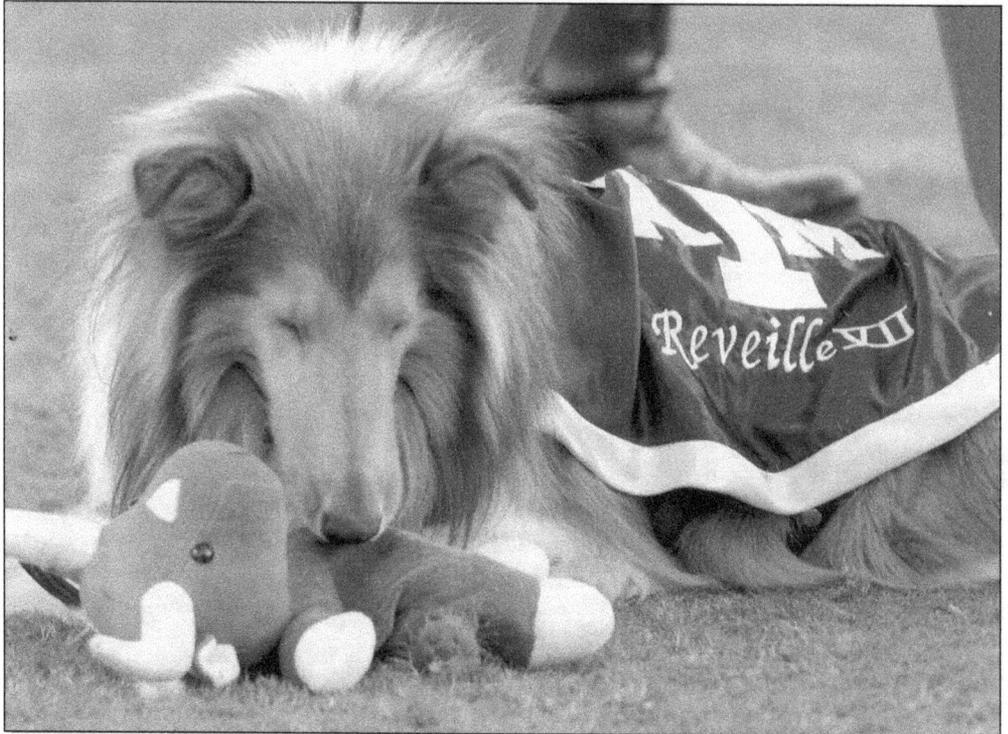

AGGIE SPIRIT. Here Reveille VII shows the Aggie spirit by taking a bite out of the TU mascot. Sparks fly each time the Aggies and Longhorns square off on the field, making for a great game. The Ags and their fans in attendance can almost hear the ghosts of the 1915 team yelling for their team. (PH.)

Eight

COLLEGE STATION SCHOOLS

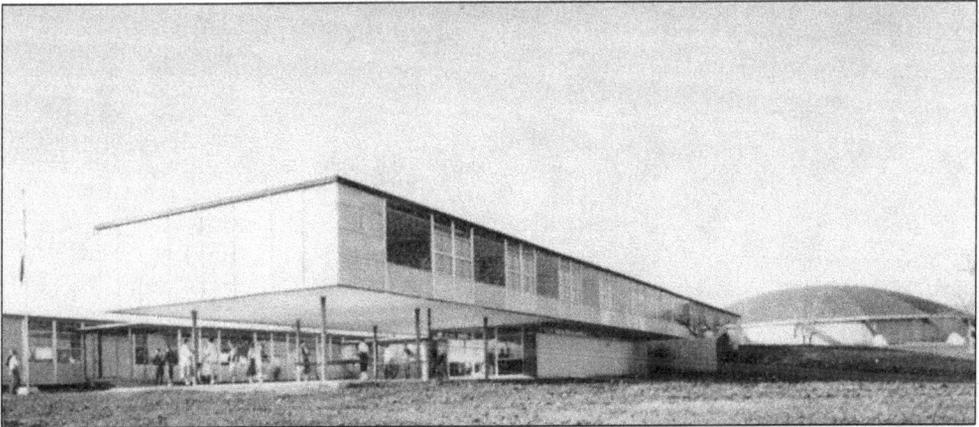

A&M CONSOLIDATED HIGH SCHOOL. Before integration came to College Station in the mid-1960s, there was Consolidated for whites and others and Lincoln High for African Americans. Here Consolidated's award-winning design is visible in the modular, functional building. Eventually the domed auditorium was torn down, and the existing high school was remodeled into the current A&M Consolidated Middle School. (PH.)

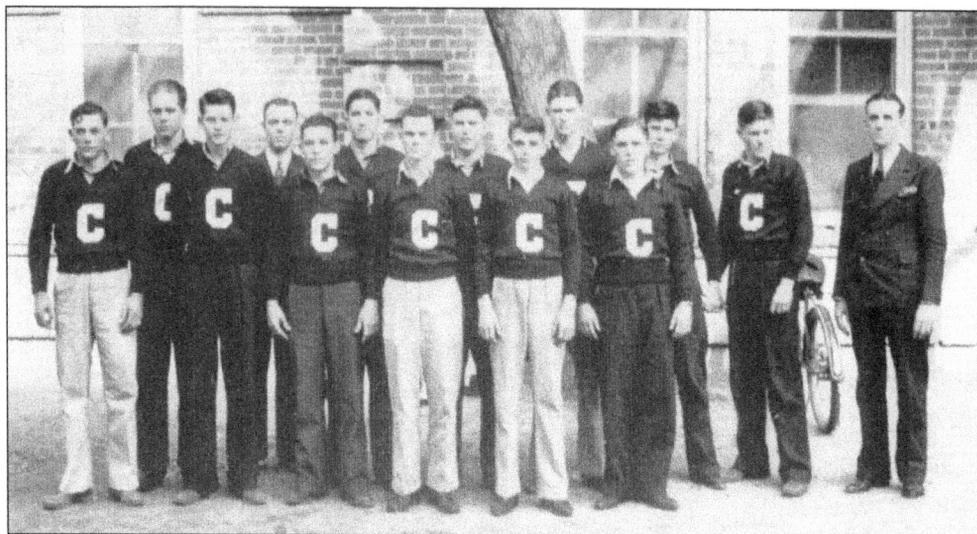

TIGER CUBS. Members of the first football team formed at A&M Consolidated are, from left to right, Clarence Vitopil, Frank Brown, Jack Miller, coach Thomas Ferguson, David Shelton, Ben Youngblood, Curtis Holland, Barker Allen, Mit Schultz, unidentified, J. O. Alexander, Sidney Redmond, and two unidentified individuals. (PH.)

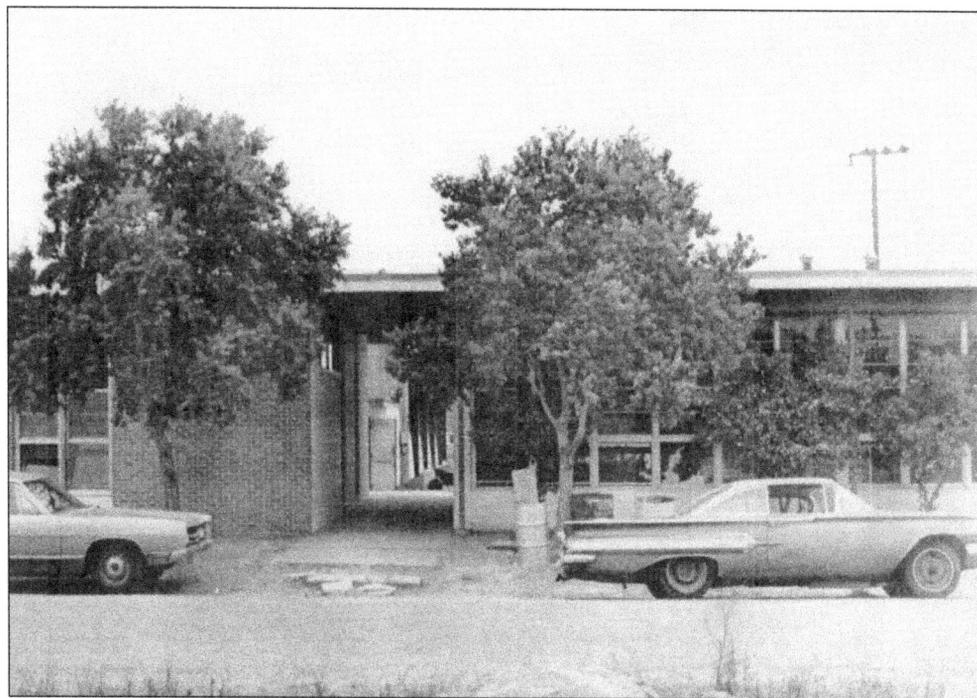

LINCOLN HIGH. In 1946, the old A&M Consolidated Negro School changed its name to Lincoln School. The school mysteriously burned in January 1966. Some say the fire was set by Lincoln students wanting to move to better quarters at A&M Consolidated, but this allegation was never proven. (PH.)

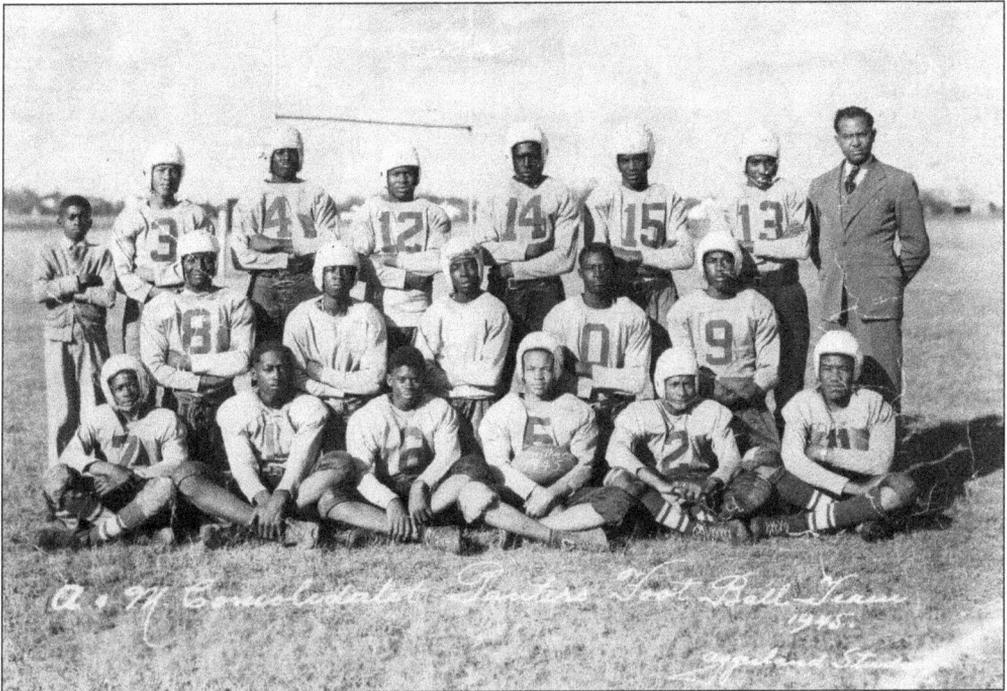

PANTHERS. Shown here is the Lincoln High School football team in 1946. Called the Panthers, the team did not have proper uniforms until much later, when head coach Jerome Delley Jr. got up enough courage to ask Bear Bryant, head coach at Texas A&M, for some hand-me-downs. The Bear complied, and a home economics teacher at Lincoln High dyed the uniforms purple and gold, the Panthers' colors. (PH.)

CHEERLEADERS. Shown here is the pep squad for the 1953–1954 Lincoln High School teams. The cheerleaders are doing some yells on the practice field at Lincoln High, near County Road (now Holleman Drive). The football team did not play there; it used the A&M Consolidated Tiger field on Thursday nights, as the Tigers played on Friday nights. (PH.)

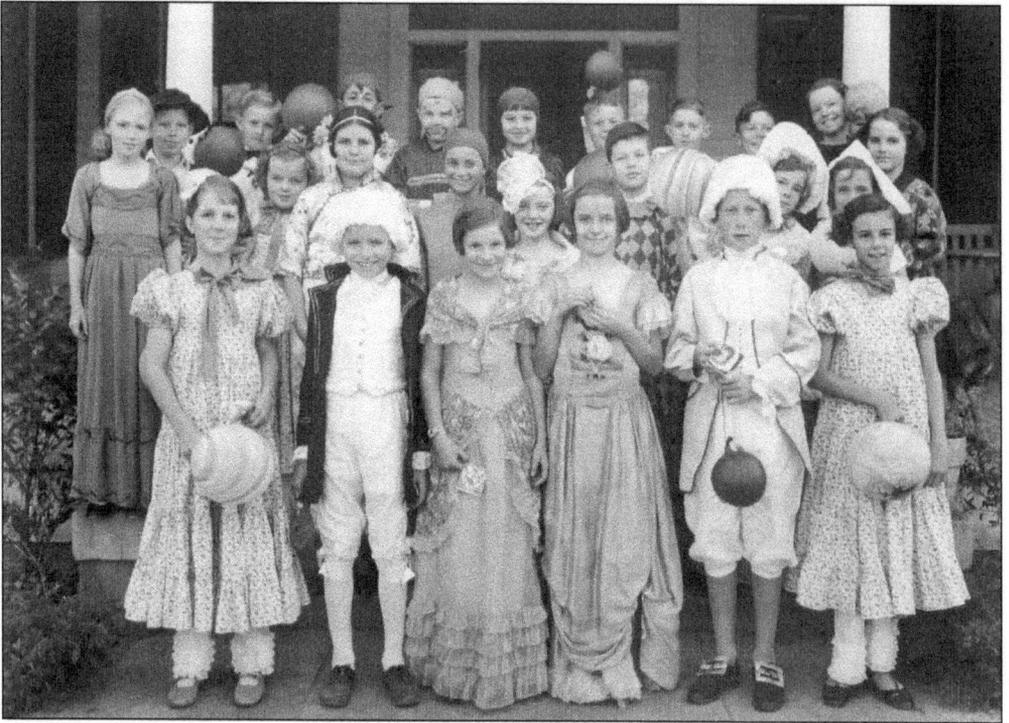

CAMPUS KID PARTY. A costume birthday party in 1933 honored Thomas and Paul Manglesdorf. All these children, called campus kids, grew up on the A&M campus because their fathers served on the faculty or staff. Many here are dressed like Martha or George Washington. The second grade classes traditionally danced the minuet dressed in period costumes. (Bill Lancaster.)

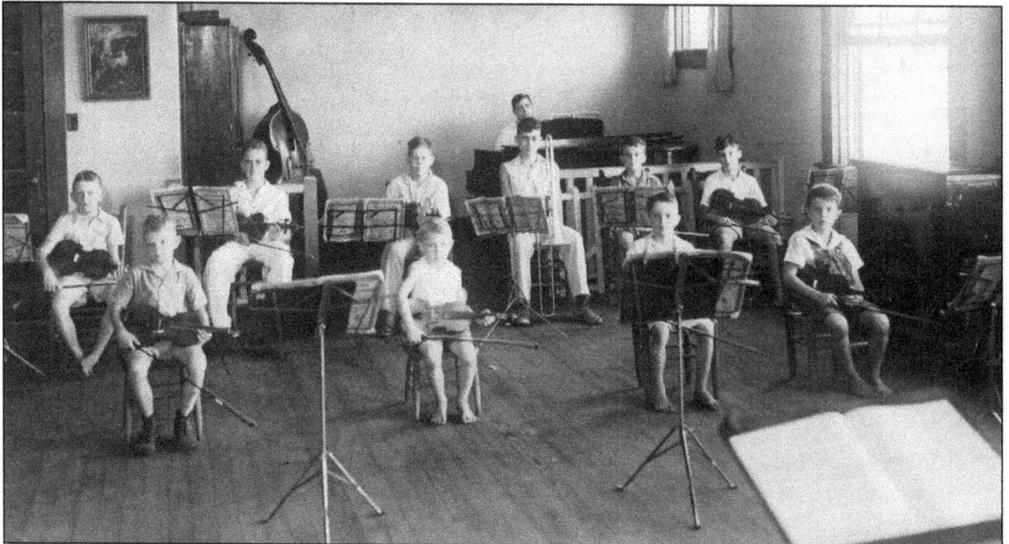

VIOLIN CLASS. Shown is a rare look into a classroom of A&M Consolidated in the 1930s, when students met on the A&M College campus. In this image, from left to right, are Jim Bonnen, John Sykes, Earl Vezey, Pete Yarnell (in front), Martin Hughes (in back), Robert Paine (in front), Preston Bolton (at the piano), Jim Lancaster, Jerry Bonnen, James Boone, and Bill Lancaster. (Bill Lancaster.)

96

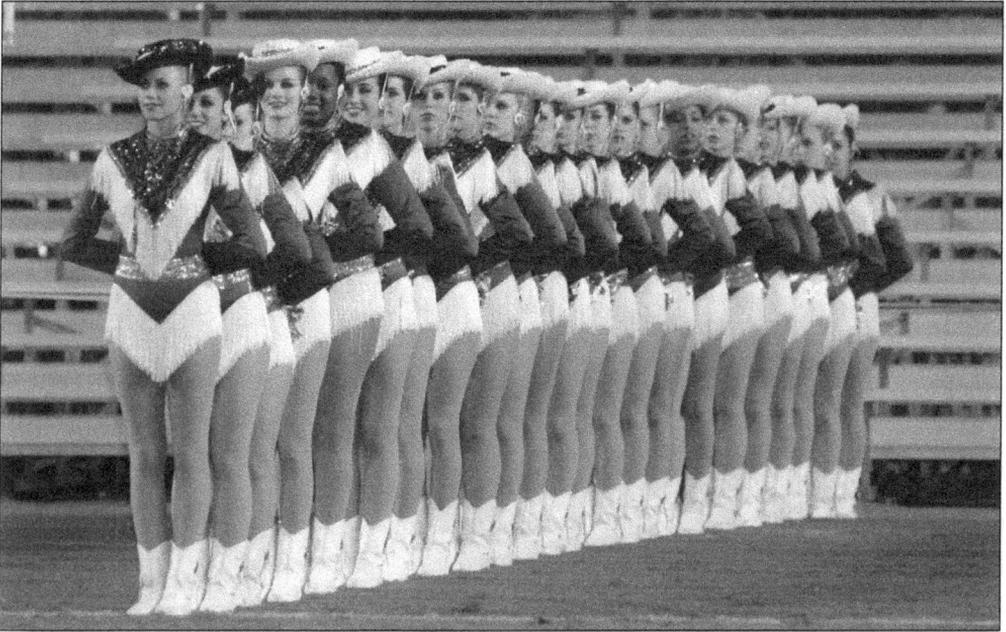

DRILL TEAM. The current A&M Consolidated High School Drill Team, called the Bengal Belles, is patterned after the nationally famous Kilgore Rangerettes originally led by Gussie Nell Davis. (Photograph by Bill Meeks.)

ROAR! Pictured here is the tiger statue in front of the new and greatly expanded A&M Consolidated High School campus. A second high school is on the planning boards and is slated to open in 2012, reflecting the explosive growth of College Station. (College Station Independent School District.)

SONGWRITER. Lil Munnerlyn wrote many Aggie-related songs such as "The Twelfth Man," "I'd Rather Be a Texas Aggie," and the A&M Consolidated fight song.

MUSIC HALL. The old music hall on the Texas A&M campus was once used as classrooms for the campus kids and others. It was torn down many years ago to make room for larger buildings as classes grew in size.

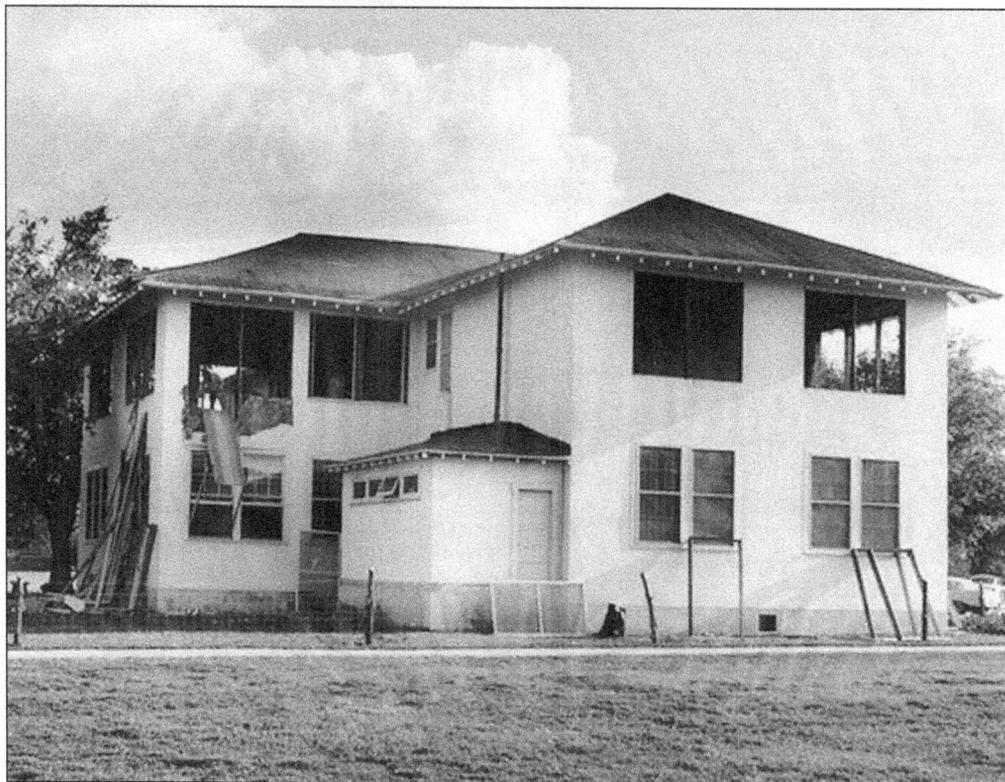

Nine

AGGIES AND TRADITION

MIKE FOSSUM, CLASS OF 1980. Fossum was born in South Dakota, but grew up in McAllen, Texas. He flew on a 13-day flight of the space shuttle *Discovery* in 2006 and walked in space to help repair the shuttle. Fossum again flew a shuttle mission in 2008 to the International Space Station. (NASA.)

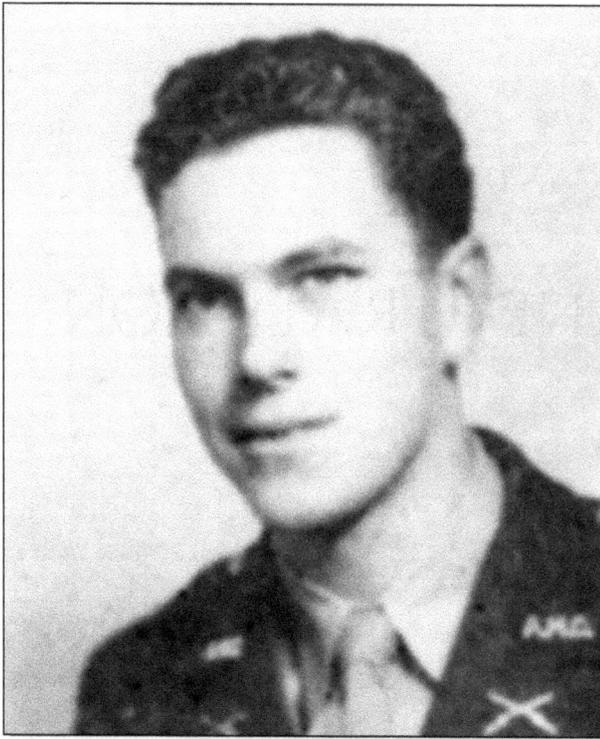

RIP TORN, CLASS OF 1952. Torn has constantly been in demand as a character actor in supporting, second lead, and occasional lead roles. His best performance on film came in 1973 for *Payday*, and he was nominated for a Best Supporting Actor Oscar Award for *Cross Creek* (1983). Torn is best remembered for his role as the boss in the 1997 film *Men in Black*.

RICK PERRY, CLASS OF 1972. James Richard "Rick" Perry was a yell leader for the Texas Aggies and graduated with a degree in animal science. Perry became governor by default when George W. Bush was elected president in 2000. Perry won the governor's race in 2002 and has held the office ever since. (PH.)

LYLE LOVETT, CLASS OF 1979. Lovett studied German and journalism, but soon went into country singing. He has won four Grammy Awards, including Best Country Album in 1996. Lyle has also acted in several films and was briefly married to actress Julia Roberts.

WALLY MOON, CLASS OF 1951. Wallace Wade Moon earned a master's degree in administrative education at Texas A&M while playing baseball in the minor leagues. He went on to a long career in the big leagues with the St. Louis Cardinals and Los Angeles Dodgers. His home runs were so impressive they were called "Moon shots." (*Sports Illustrated*.)

MARTIN TORRIJOS, CLASS OF 1987.
Panamanian president Martin Erasto
Torrijos Espino (left), escorted into the
Pentagon by Secretary of Defense Robert M.
Gates on February 16, 2007, studied political
science and economics at Texas A&M. He
is the son of Omar Torijos, Panama's social
reformer and military strongman from
1968 to 1981. Torrijos has also embarked
on social reform, including a program to
expand the Panama Canal. (Department
of Defense photograph by R. D. Ward.)

SQUARE DANCERS. Manning Smith, class
of 1938, and his wife, Nita, of College
Station, were nationally known square
dancers for 35 years from about 1945. They
conducted dance classes at the Memorial
Student Center and put on demonstrations
across the country and internationally.
The couple was considered the "Neiman
Marcus" of the round dance world. Nita
designed square dance clothes for men
and women, while Manning coached the
A&M baseball team for years. (PH.)

TWELFTH MAN. This may be the most famous tradition in Aggieland. It started in 1922 when A&M played Centre College in football. As Aggie injuries piled up, coach Dana X. Bible called for E. King Gill to come down from the press box and suit up, which he did. That is why students on the 12th man side of Kyle Field still stand for the entire game, ready to go in the game if called.

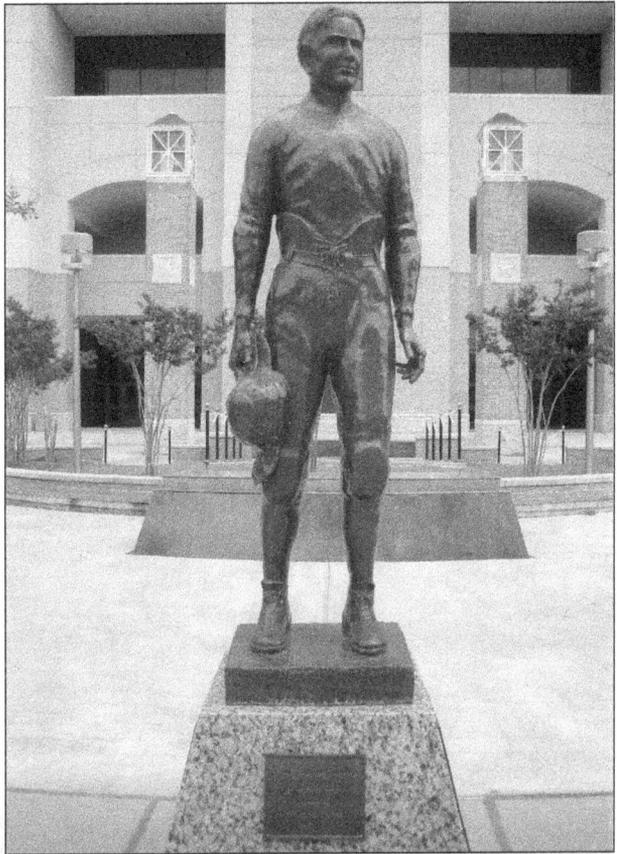

YELL PRACTICE. Midnight yell practice on the Friday night before a Saturday football game is an enduring tradition at A&M. Freshmen in the corps had their fish matches, the number of which corresponded to their graduating year. The matches, of course, were to provide enough light for kissing their girlfriends in the dark.

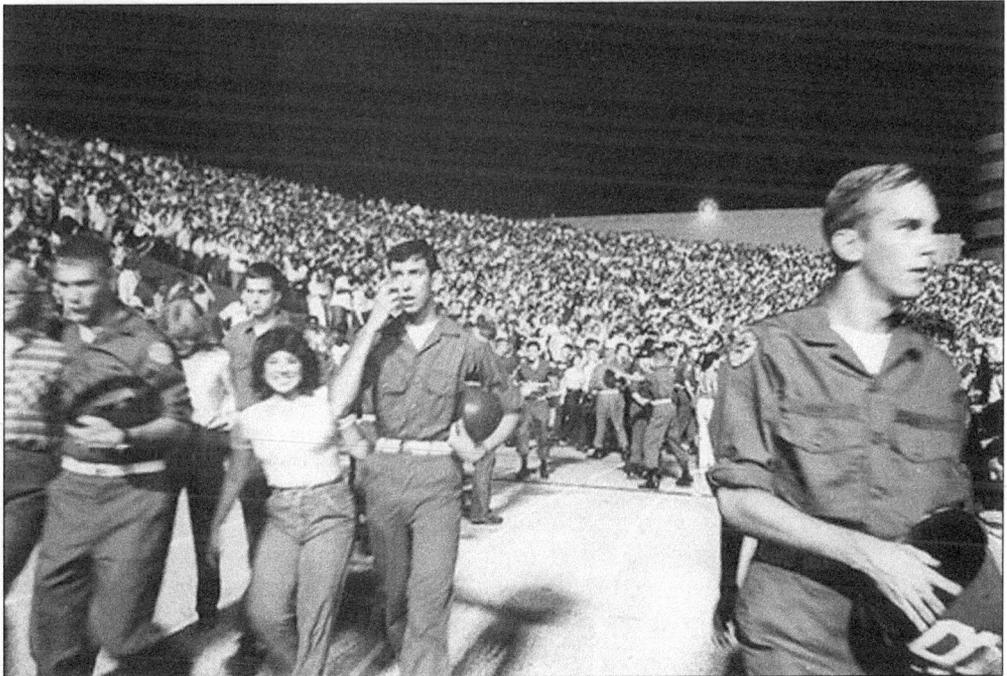

BONFIRE. Since 1909, Aggies had constructed a bonfire on the drill field each year before the game with TU. Legend had it that if the outhouse on top of the bonfire toppled after midnight, the Aggies would win and vice versa. The cadets building the bonfire often had a tin of Skoal in their pockets. Others had a pack of Red Man or a Swisher Sweet cigar in their shirt pockets—all manly stuff.

DISASTER STRIKES. The bonfire tradition was halted after the disastrous collapse of the 1999 structure in which 12 students died. The tragedy made world headlines, and a memorial to these students was constructed on the grounds where the bonfire used to be burned to show Aggies' burning desire to "beat the hell out of TU." (Photograph by Glenn D. Davis.)

SILVER TAPS. One of the most moving traditions is held at midnight in front of the Academic Building. Buglers stand atop the building next to the dome and play taps for an Aggie who has recently passed away. Someone, usually a family member, answers "here" when the deceased's name is called, and a rifle salute is fired. Nobody speaks during the austere ceremony.

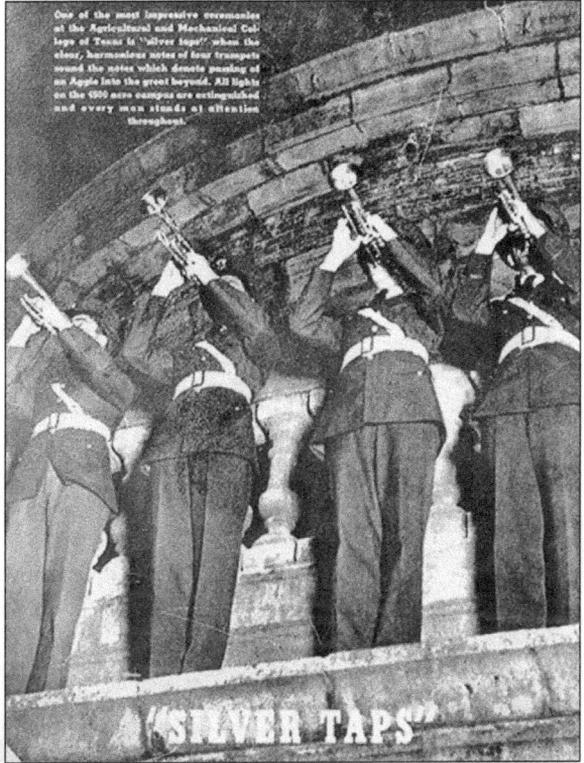

One of the most impressive ceremonies at the Agricultural and Mechanical College of Texas is "silver taps" when the clear, harmonious notes of four trumpets sound the notes which denote passing of an Aggie into the great beyond. All lights on the 4300 acre campus are extinguished and every man stands at attention throughout.

"SILVER TAPS"

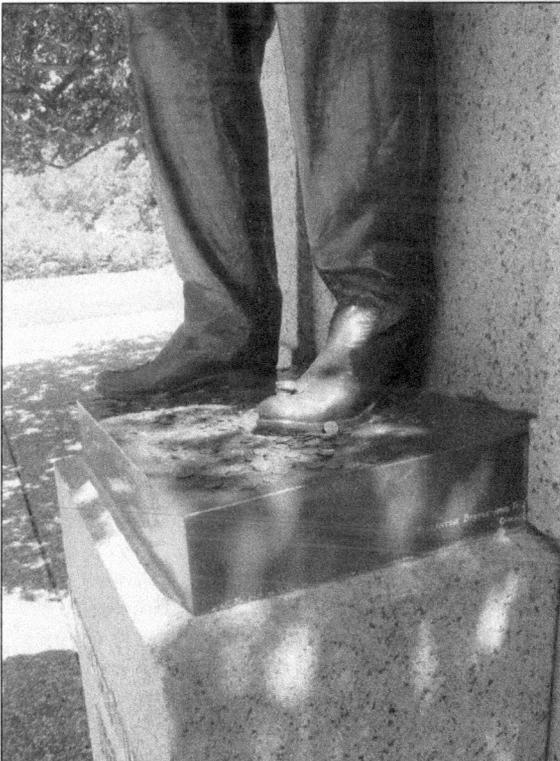

ASKING FOR LUCK. Students place coins at the feet of the Sul Ross statue hoping it will bring them luck on upcoming exams. Other more creative students turn to a surefire method for improving their scores, namely the infamous quiz files. These are quizzes collected over the years through serendipitous techniques perfected by members of the corps. (Photograph by Glenn D. Davis.)

CENTURY TREE. This very old oak tree on campus symbolizes how the university has grown and flourished since 1876. It also has romantic overtones: Many Aggies still propose under its branches. (Photograph by Glenn D. Davis.)

ELEPHANT WALK. On the last week before the TU football game, seniors form a human chain and visit important places on campus. The custom symbolizes the last time these students will stand together as the 12th man.

Ten

THE FUN CITY OF COLLEGE STATION

CURRENT ACADEMIC BUILDING. Still the center of Academic Plaza and the backdrop for the Sul Ross statue, the dome of the proud building can be seen from far away. That copper dome seems to symbolize a connection with the past to many Aggies. (Photograph by Glenn D. Davis.)

PRESIDENT'S HOUSE. Although it burned down in 1963, the president's house has been restored to its original glory, this time with white brick instead of wood. The home, designed by the late architect Dede Matthews, stands proudly on campus near Kyle Field.

CENTRAL PARK. One of College Station's landmarks, Central Park features baseball fields, basketball courts, walking trails, and other attractions. At Christmas the park is lit up with bright lights. (PH.)

CAMPUS THEATER. Although the Campus Theater building is now a bar, it once was a cultural event unto itself. Seeing a movie there was an experience as Aggies hooted and hollered. One learned not to sit in the seats under the balcony as various missiles were known to be thrown down from above. The theater had a cry room for Aggies with small children, but after midnight was "Midnight Frolic," which offered more risqué material like *Debbie Does Dallas*.

POST OAK MALL. This is a shot from the 1980s when the mall opened, giving Aggies and others in College Station a more modern place to shop. The center recently celebrated its 25th anniversary.

KYLE FIELD. One of the oldest landmarks of College Station is Kyle Field, where the Aggies play football. Shown here is George H. W. Bush's private train *41* zipping past the famous stadium. (Photograph by Brian Blake.)

RIBBON CUTTING. Barbara and George H. W. Bush cut the tape on his presidential library in 1997. George and Barbara maintain an apartment on the grounds and divide their time between their Houston home and the Texas A&M campus. (Photograph by Brian Blake.)

PRESIDENTIAL LIBRARY OPENS. In 1997, Texas A&M University became the home of the George H. W. Bush Presidential Library and Museum, one of the 13 presidential libraries in the United States.

BUSH SCHOOL. The Master's Program in International Affairs (MPIA) at the Bush School of Government and Public Service prepares students for professional careers in global affairs. The block at the foot of the horses is a piece of the Berlin Wall.

LOUPOT'S BOOKSTORE. J. E. Loupot, class of 1932, founded his bookstore before World War II. Ole Army Lou's, an A&M landmark for decades, is no longer the official bookstore of Texas A&M, as Barnes and Noble has now won that distinction. (PH.)

CITY HALL. Opening in December 1947, this structure at 101 Church Street behind the strip at Northgate was the first dedicated city hall building. It was all-inclusive with offices and a jail. The city now rents the building to Café Eccell. Seating is still available in the "jail." (PH.)

DIXIE CHICKEN. The Dixie Chicken is the most recognizable restaurant in College Station and is known as the Aggies' favorite watering hole. The oldest and most famous bar in the Northgate district, it has a live snake on the premises and is home to a weekly domino tournament. Founder Don Ganter died in 2004, just days after the Chicken's 30th anniversary. It is said that the Dixie Chicks got their name from the Dixie Chicken. (PH.)

VETERANS MEMORIAL. Constructed in Veterans Park, this monument is a tribute to all Brazos County veterans who served in foreign wars. The statue itself was modeled from the father of a World War II veteran, carried by his son (the sculptor) on his back, so the proportions would be just right. (PH.)

AGGIE SPIRIT. Strong senses of loyalty and respect are hallmarks of the Aggie spirit, which "insiders cannot explain and outsiders cannot understand," as the saying goes. All rise and sing "The Spirit of Aggieland" before games, a tribute to this emotional tie. Being at Kyle Field when 85,000 sing this ode in unison is moving indeed. (PH.)

HOT RODS. Every spring, hot rod fans get revved up when the classic cars are dusted off and either displayed or put up for sale at Central Park. It is a hot-rodder's dream come true just to mill around and look at all the great customized cars from the past. (Photograph by Bill Meeks.)

FOURTH OF JULY. Fireworks, music, and costume parties are all the rage during Fourth of July celebrations at the George Bush Presidential Library and Museum. In earlier days, the Fourth of July fireworks were held at Tiger Field. (Photograph by Bill Meeks.)

ICE-SKATING. In 2005, a unique addition to the community came in April with the opening of the Arctic Wolf Ice Center, a 42,000-square-foot recreation and ice-skating facility in the Wolf Pen Creek Corridor. Built at a cost of approximately $4.5 million, it provides year-round public skating, hockey sessions, skating lessons, youth hockey leagues, figure skating competitions, hockey tournaments, and other services previously unavailable in the area. (Photograph by Bill Meeks.)

THE STRIP. Northgate is the first shopping district to spring up at A&M. Originally this area was the business district of College Station, across from the Northgate entrance to campus, but it rapidly turned into a drinking and entertainment center after A&M opened to coeds in the 1960s. (Photograph by Bill Meeks.)

STARLIGHT SERIES. A series of open-air concerts occur at Wolf Pen Creek Park each summer, offering music from well-known groups like Willie Nelson and Family and not-so-well-known local groups. Fans bring a blanket or lawn chair and enjoy the music under the stars. The events are free and sponsored by the City of College Station and College Station Utilities. (Photograph by Bill Meeks.)

MUSIC INSIDE. Northgate also offers a lot of live music venues with bands who play in the various pubs in the area or other musical concerts, such as the one shown here with spectators lining up to purchase tickets. Many Aggies, wanting to let off steam, head straight for the conveniently located Northgate. The city recently added additional parking and restrooms to the promenade. (Photograph by Bill Meeks.)

WORLD WAR II REENACTMENTS. In College Station, each spring brings bluebonnets (the state flower) and World War II reenactments. Shown here is Denny Hair, a former police officer and current drum teacher, portraying Gen. George S. Patton. He is so good in this role that he has recently been chosen as the official Patton impersonator for Europe. General Patton participates in the Museum of the American G.I. educational programs. The living historical museum is south of College Station on Highway 6. (PH.)

INTERNATIONAL WEEK. Every April, internationally minded students from Texas A&M open booths in downtown Bryan to show off the customs and dress of different nations. A&M has more than 49,000 students and is home to students from 130 nations. The oldest Hillel organization in the United States was established on the A&M campus in 1920. Another annual event is Worldfest, sponsored by A&M and local businesses to celebrate the cultural diversity of the Brazos Valley. (PH.)

CIVIC-MINDED STUDENTS. Texas A&M students are renowned for their civic-minded orientation. For instance, the student-run CARPOOL has provided about 150,000 free rides for wheel-less students. Shown here is the mascot for the Bee a Good Neighbor program that promotes good will between off-campus students and their neighbors. (PH.)

SAWIN' HORNS. Showing their Aggie spirit by symbolically sawing Varsity's horns off at an Aggie baseball game on April 9, 2009, are, from left to right, Glenn Brown, city manager; Lynn McIlhaney, council member and former mayor; David Massey, electric utilities director; Ben White, mayor; and James Massey, council member. (PH.)

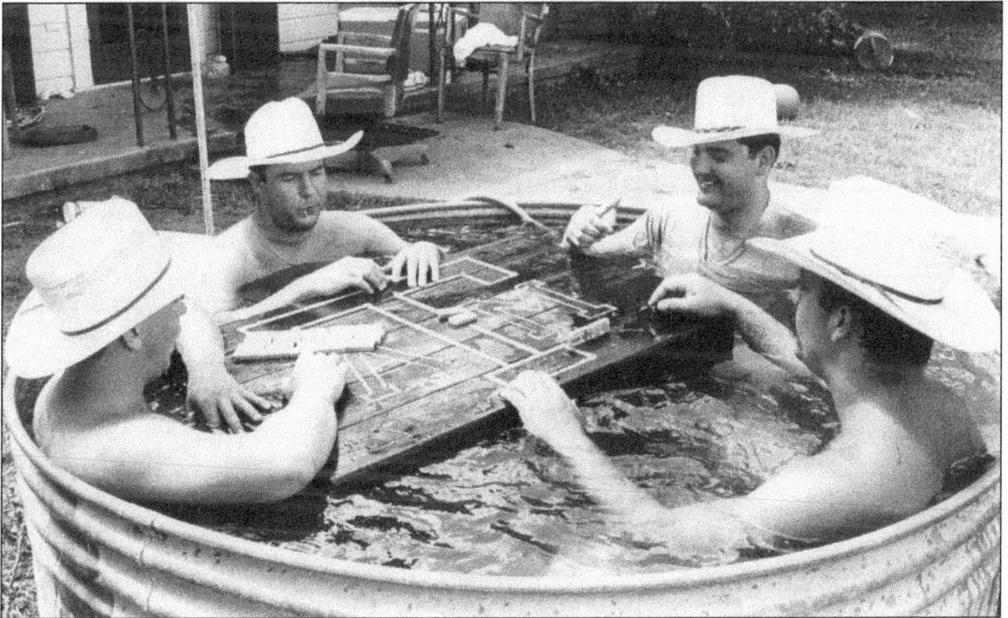

BEAT THE HEAT. Everybody knows it gets hot in Texas in summer. These students found a way to relax and beat the heat. Dominoes is popular but not too many people play the game in this fashion.

KISS A PIGGY. When you lose a bet, you have to pay up. Olivia Burnside, a College Station government employee, was the low person in a contest promoting United Way and, as a result, had to kiss a pig. (PH.)

DEAD WEEK. The week before tests, students are supposed to study without interruption. This Aggie girl, who looks as though she is either deeply meditating or asleep, poses in a literal interpretation of finals dead week. Cramming, alas, is still alive and well.

RANGER, THE DOG. University president Earl Rudder had a bulldog named Ranger, who had the run of the campus during Rudder's tenure. Ranger got painted by students and slept wherever he wanted. He was fed pizza and beer, and it is said his emissions of methane cleared many a classroom. Ranger was buried near the president's house. Shown here is Ranger III.

GOOD BULL. Charley Goodnight, one of the most famous cattle drivers in Texas in the 1880s, had a lead steer named Old Blue, who wore a bell around his neck. Where he went, other cattle followed. A tough leader, Old Blue was a gentle pet at home. Sul Ross was Goodnight's neighbor, and after all had passed away, a statue of Old Blue's head ended up on the wall of A&M's Animal Industries Building to perpetuate the legend of Old Blue. (Photograph by Glenn D. Davis.)

SINGING CADETS. This is an all-male choral group of 70 members, which was formed 107 years ago. The national spotlight shined on the cadets at the Sugar Bowl in 1940, when the cadets sang during halftime. The group was headed for years by Robert L. "Bob" Boone (standing at far right), who assumed leadership in 1960. The Singing Cadets tour nationally and internationally. The group sang in South Africa in 2007. The pianist, June Biering, accompanied the group for many years.

WHIFFLE BALL. Eric Bryant (pitcher) and Robert Watson (batter), both mechanical engineering students from Baytown, play a game they invented by slicing a tennis ball in half and using it as a baseball. A plus is no broken windows!

PLAYING CHICKEN. In 2007, Larry Johnson (left), of the College Station Police Department, squared off on the basketball court against his unidentified Bryan counterpart. A couple of "chickens" played a game of "horse." The event was held at Reed Arena before the Aggie women's basketball game. City employees are good-natured about supporting area events.

CHRISTMAS LIGHTS. An unidentified young mother introduces her wide-eyed daughter to the wonders of Christmas at the Christmas in the Park light display held in Central Park. Children and adults alike love this free annual spectacle sponsored by the College Station Parks and Recreation Department. (Photograph by Bill Meeks.)

A House Divided. This house in College Station, depicted in a drawing by a neighbor, was so famous it appeared in *Ripley's Believe It or Not*. A judge, acting more like King Solomon, settled a divorce suit by splitting the distressed couple's house down the middle, giving a half to each. (PH.)

Olympic Torch. College Station mayor Larry Ringer carries the 1996 Atlanta Olympics torch through College Station. The Ringer Library, near A&M Consolidated High School, was named in his honor. (PH.)

A&M Clones. Researchers at the College of Veterinary Medicine and Biomedical Sciences at Texas A&M University successfully cloned a colt named Paris Texas in March 2005 from the adult skin cells biopsied from its genetic donor. Texas A&M is the first academic institution in the world to have cloned six different animal species, including cattle, goats, pigs, deer, and a cat named "cc." (Texas A&M Biomedical Sciences.)

Future Sport. Texas A&M researchers take alternative energy sources seriously, having developed solar houses for such competitions as the International Solar Decathlon. Solar-powered cars are another strength. A&M's entry into Australia's World Solar Challenge in 2007 was its *Night Rider* vehicle. (Photograph by Glenn D. Davis.)

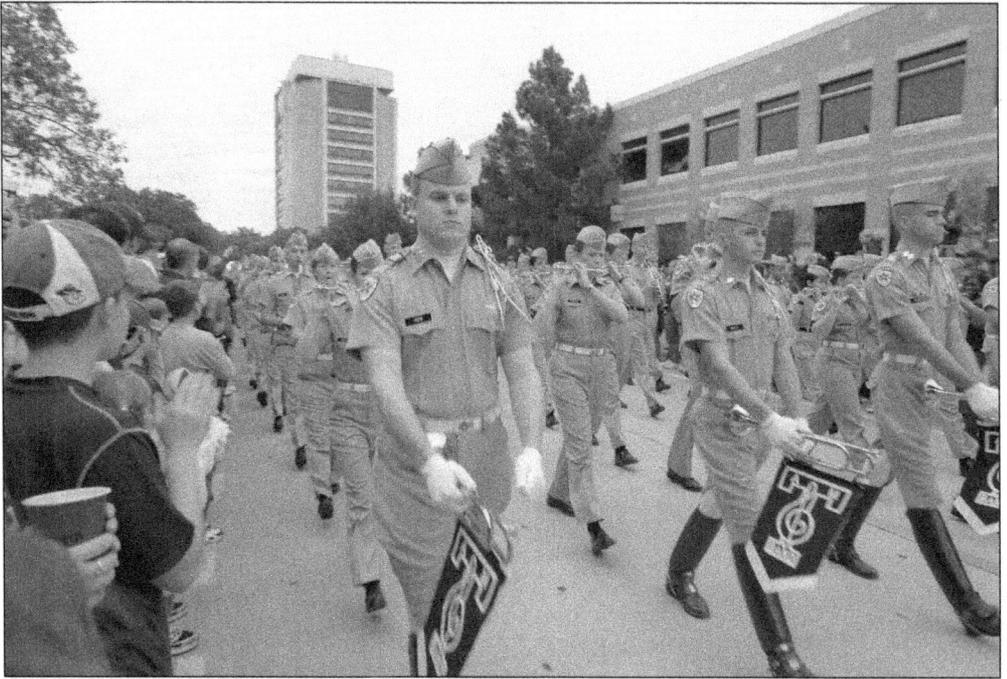

THE BAND MARCHES ON. College Station residents in general and A&M students in particular never tire of seeing their Fightin' Texas Aggie Band march. They line the streets on both sides to see the band enter Kyle Field before a game. (Photograph by Glenn D. Davis.)

COLLEGE STATION'S BIG HEAD. This huge inflatable head (and body), by Advanced Inflatables of America, was seen in 2006 in the Post Oak Mall parking lot. The head served as an entrance to the 7,000-square-foot inflated giant and the human anatomy exhibit going on inside. Talk about getting into one's head! (PH.)

DRAWING THE LINE. Although Bryan and College Station are often thought of as the same city (B/CS), there is a boundary line, which is clearly visible near the Texas Avenue and University Drive crossroads. (Photograph by Glenn D. Davis.)

COLLEGE STATION MEMORABILIA. Over the years there have been many images that represent College Station and Texas A&M University. Pictured here are just a small few that epitomize College Station's past. (PH.)

Visit us at
arcadiapublishing.com

www.ingramcontent.com/pod-product-compliance
Lightning Source LLC
Chambersburg PA
CBHW080614110426
42813CB00006B/1504